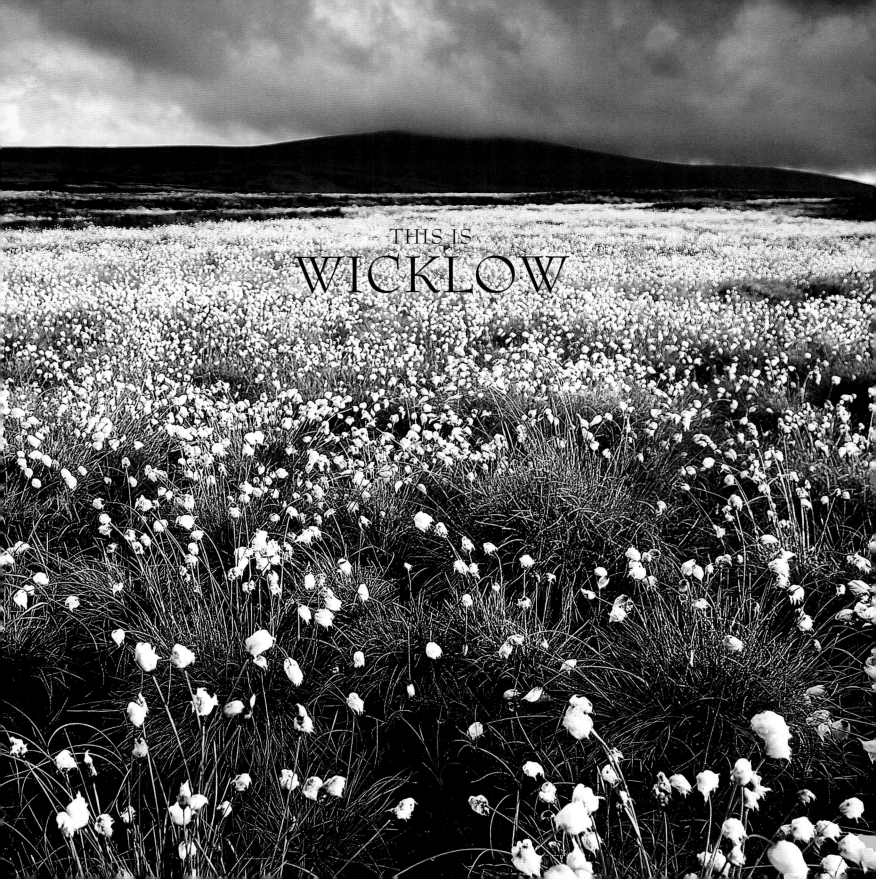

THIS IS
WICKLOW

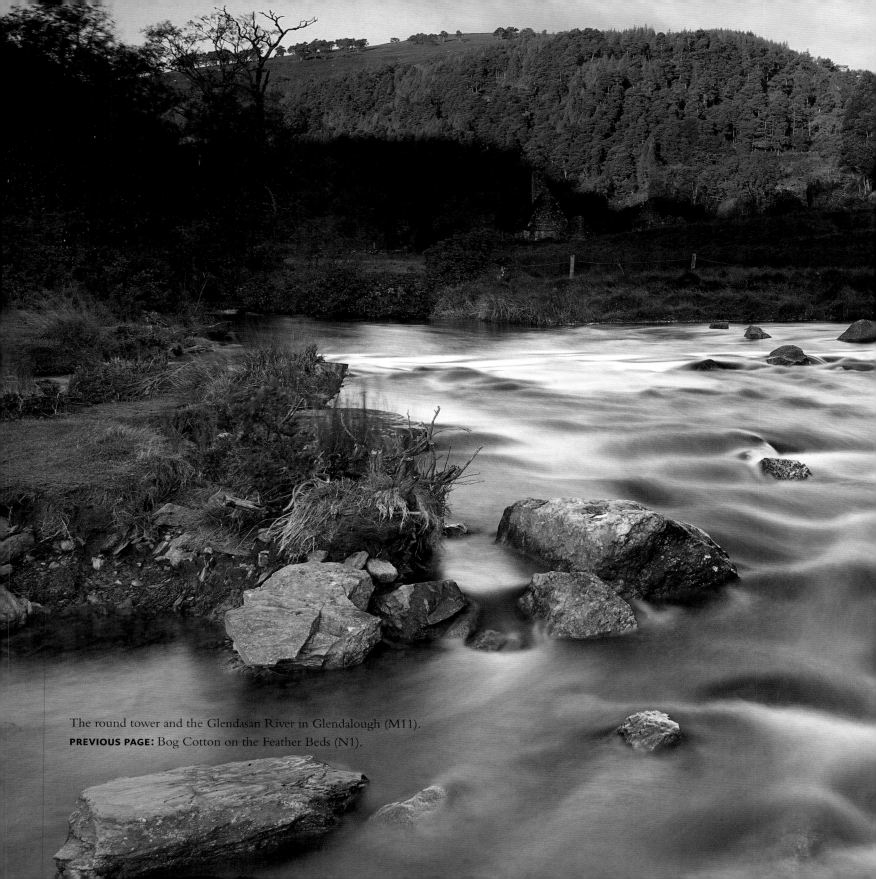

The round tower and the Glendasan River in Glendalough (M11).
**PREVIOUS PAGE:** Bog Cotton on the Feather Beds (N1).

# THIS IS
# WICKLOW

## MICHAEL DELAHUNTY

The Collins Press

First published in 2014 by
The Collins Press
West Link Park
Doughcloyne
Wilton
Cork

A CIP record for this book is available from the British Library.

ISBN: 978–184889–203–3

Design and typesetting by Hugh Adams, AB3 Design

Typeset in Bembo and Foundry Sterling

Printed in Dubai by Oriental Press

# Introduction

Wicklow – *Cill Mhaintáin* in Gaelic – means 'the church of Mhaintáin'. According to a popular local myth, St Patrick, the patron saint of Ireland, landed at Travailahawk Beach, just south of Wicklow town. Hostile natives hurled stones at him and his entourage – one of the saint's friends was hit and all his teeth knocked out. In the long tradition of Ireland he was promptly given a nickname: 'Maintáin' or gummy, the toothless one. All is now changed and Wicklow people always welcome visitors, whether they come from near or far.

Local history contends that the town of Wicklow was founded by the Vikings probably around AD 795. The name 'Wicklow' comes from *Vikinglow*, meaning 'Meadow of the Vikings', or Wykynlo meaning 'Viking Loch'.

County Wicklow is located just south of Dublin. It has the most extensive area of continuous upland in Ireland, with domed granite mountains dating back some 500 million years to a coming-together of American and European tectonic plates. The uplands run from north to south with many mountains, rivers, lakes and valleys. The highest mountain in the range is Lugnaquilla, which rises to 925m. On the eastern side of the county there is a strip of fertile farmland and the major towns of Bray, Wicklow and Arklow are located on the coast. There are also some fine beaches along the coast, the largest of them being the 4km-long Brittas Bay.

Wicklow is known as the Garden of Ireland although it could also be called Dublin's Great Outdoors because of the diversity of outdoor activities found there. Most popular is hillwalking but one also finds rock climbing, bouldering, canoeing, horse riding, mountain biking, windsurfing, surfboarding, fishing and much more.

At the heart of Wicklow is Glendalough, with more visitors than any other part of the county. It is an extraordinary place. The name Glendalough means 'valley of two lakes'. The present remains of the monastic city in Glendalough only tell a small part of its story. The monastery in its heyday included workshops, areas for manuscript writing and copying, guest houses, an infirmary, farm buildings and dwellings for both monks and the large lay population. The buildings which survive probably date from between the tenth and twelfth centuries. In 1214 the dioceses of Glendalough and Dublin were united and from that time onwards the cultural and ecclesiastical

**OPPOSITE:** Autumn colours in Mount Usher Gardens in Ashford (S11).

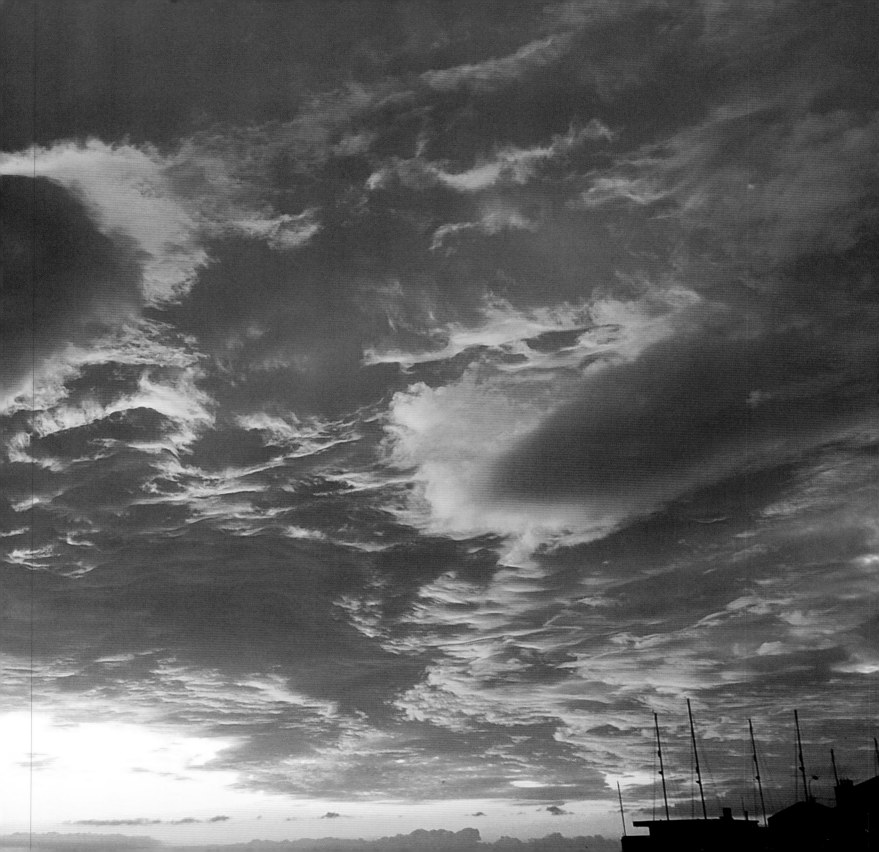

status of Glendalough diminished. The destruction of the settlement by English forces in 1398 left it a ruin but it continued as a church of local importance and pilgrimage. Descriptions of Glendalough from the eighteenth and nineteenth centuries include reference to 'riotous assembly' on 3 June, the Feast of St Kevin. There is a wonderful painting in the lobby of Lynham's Hotel in Laragh depicting the celebrations.

Wicklow is rich in tradition, with great Irish music, particularly around Roundwood, and great local stories. The one I like most relates how St Kevin came to get the lands around Glendalough to build his monastic city: when Kevin came to Glendalough first he met with King O'Toole who was grieving over his pet goose, which had taken ill with a dreadful malaise. The goose was the king's pride and joy.

Every day he would sit and watch it fly over the lakes and in the evening the goose would join him at dinner. Every night the king sat at his table with the goose by his side, boring his courtiers with stories of what the goose did and said during the day, telling them the minutest details. When Kevin arrived in Glendalough he saw the king with the goose in his arms, sobbing uncontrollably over the poor sick creature. Kevin, being a jolly type when he wanted to be,

**OPPOSITE:** Sunrise at Bray Harbour (S2).

**ABOVE:** The sun rising over Bray Head (T2).

enquired of O'Toole after the well-being of the goose. On hearing of the plight of the bird and realising its importance to the king, Kevin explained that he was an aspiring saint and offered to restore the goose to health if the king gave him all the lands that the goose flew over in the next 20 minutes. Disbelieving, O'Toole readily agreed. Kevin took the goose from the king, said a little prayer in his ear, blessed him with a wave of his hand and, with that, flung the poor goose unceremoniously up into the air. Off it flew like an arrow. Up the valley, past the Upper Lake, down the valley past the Lower Lake and on almost as far as Laragh, then back up to where the king and Kevin were standing. The goose hovered over the king, gave out a gasp and, bouncing off the king's head, dropped to the ground stone dead; not a whimper

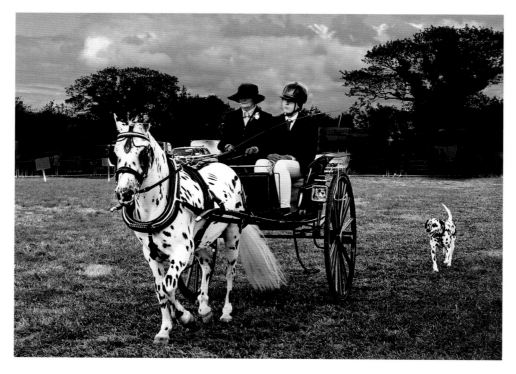

came from it. Kevin looked down at it and then up at O'Toole and said 'thank you'. And that is how Kevin got his land. The king felt mightily aggrieved. That night he returned with his six big ludrums of sons, hell-bent on running Kevin out of the place. Kevin saw them coming and, seeing they were up to no good, cast a spell on them and turned them to stone with which he built his seven churches.

So that is how Kevin came into all the land around Glendalough and built his seven churches there. There is an alternative story, which I believe to be wholly fictitious; however, I will repeat here for the sake of completeness: Kevin, a descendant of the ruling family in Leinster studied as a boy under three holy men, Eoghan, Lochan and Eanna. During this time he went to Glendalough and later when he wanted to set up a monastery he returned there with a small group of monks and established a church and monastery that flourished. He died in AD 618.

Apart from Glendalough, Wicklow has many other historical attractions, including the monastic settlement at Baltinglass, the megalithic tombs and cairns on the

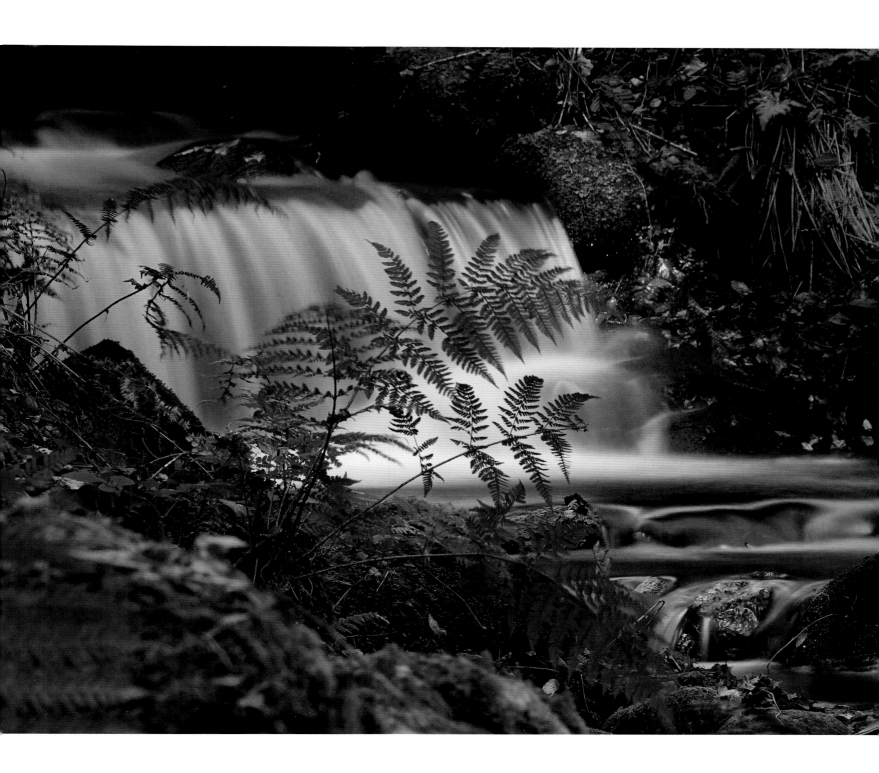

**RIGHT:** St Mary's Church of Ireland church in the centre of Blessington (G4).

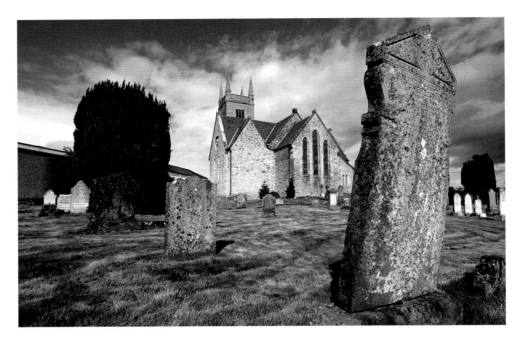

mountaintops, and the gaol in Wicklow town where many of the men of the 1798 Rising against British rule in Ireland were executed. A statue of Billy Byrne, one of the leaders, stands outside the gaol: he was executed in 1799. The Military Road, from Rathfarnham in south County Dublin to Aughanvanagh in the south of Wicklow, crosses the mountains from north to south. The road was built by the British army to assist them in crushing the rebels still active in the area following the 1798 uprising.

My fascination with Wicklow started when I was fifteen, when I was first trusted by my parents to cycle my bike into the hills by myself. This coincided with the acquisition of my first camera and the combination of cycling, walking and photography has stayed with me ever since. No two days in Wicklow are ever the same: the light and the weather are constantly changing, interacting with each other and with the varied landscapes such that one never tires of being in Wicklow. Some days I struggle to decide where to go in Wicklow to get the best picture and make the most of the light but it doesn't seem to matter as, wherever one goes it Wicklow, the magic follows and is there to enchant you.

*This is Wicklow* is my look at Wicklow and the diversity it offers.

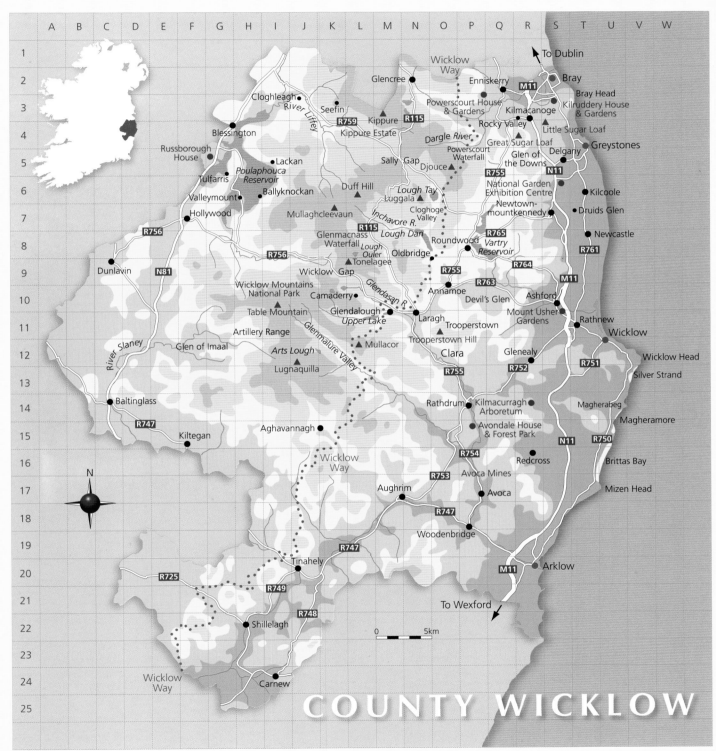

A B C D E F G H I J K L M N O P Q R S T U V W

1
2                        To Dublin
3
4
5
6
7
8
9
10
11
12
13
14
15
16
17
18
19
20
21
22
23
24
25

*Wicklow Way*

Glencree
Enniskerry
Bray
M11
Bray Head
Cloghleagh
*River Liffey*
Seefin
Powerscourt House & Gardens
Kilmacanoge
Kilruddery House & Gardens
R759
Kippure
R115
Rocky Valley
Little Sugar Loaf
Kippure Estate
*Dargle River*
Great Sugar Loaf
Delgany
Greystones
Blessington
Powerscourt Waterfall
Glen of the Downs
Russborough House
Lackan
Sally Gap
Djouce
R755
N11
Kilcoole
Tulfarris
*Poulaphouca Reservoir*
Duff Hill
*Lough Tay*
National Garden Exhibition Centre
Valleymount
Ballyknockan
Luggala
Newtown-mountkennedy
Druids Glen
Hollywood
Mullaghcleevaun
*Inchavore R.*
Cloghoge Valley
Newcastle
R756
R115
*Lough Dan*
Roundwood
R765
*Vartry Reservoir*
R761
Glenmacnass Waterfall
*Lough Ouler*
Oldbridge
R756
Tonelagee
Wicklow Gap
R755
R764
M11
Dunlavin
N81
Wicklow Mountains National Park
*Glendasan R.*
Annamoe
R763
Devil's Glen
Ashford
Camaderry
Glendalough
Mount Usher Gardens
Rathnew
Table Mountain
*Upper Lake*
Laragh
Trooperstown
Wicklow
Artillery Range
*Glenmalure Valley*
Trooperstown Hill
*River Slaney*
Glen of Imaal
*Arts Lough*
Mullacor
Clara
Glenealy
Wicklow Head
Lugnaquilla
R755
R752
R751
Silver Strand
Baltinglass
Rathdrum
Kilmacurragh Arboretum
Magherabeg
R747
Magheramore
Kiltegan
Aghavannagh
Avondale House & Forest Park
N11
R750
*Wicklow Way*
R754
Redcross
Brittas Bay
R753
Avoca Mines
Mizen Head
Aughrim
Avoca
R747
Woodenbridge
Tinahely
R747
M11
Arklow
R725
R749
To Wexford
R748
Shillelagh
0    5km
*Wicklow Way*
Carnew

N

# COUNTY WICKLOW

A grid reference is given in the caption for each photograph to help locate it on this map.

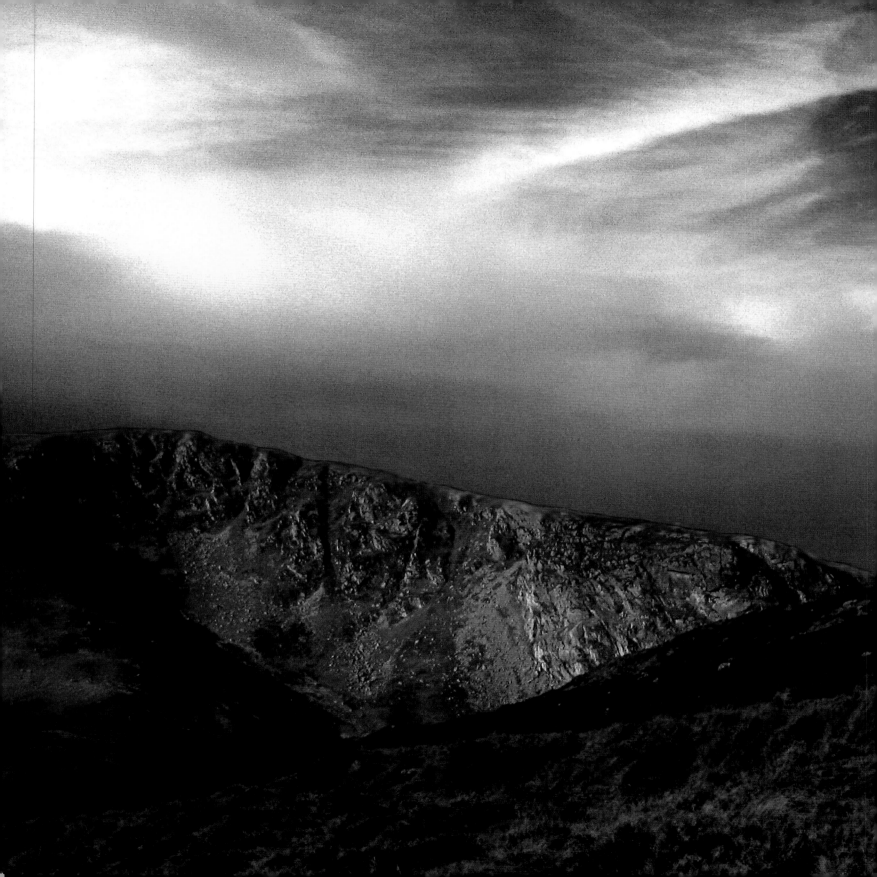

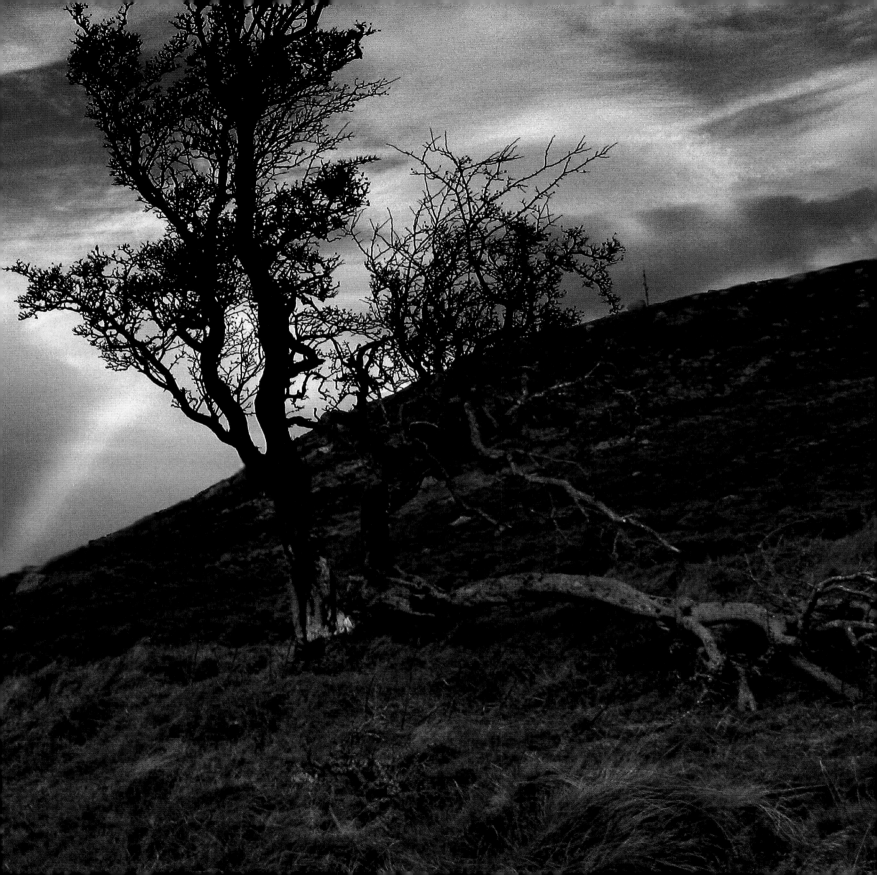

**PREVIOUS PAGES:** Rainbow at Luggala (O6).

**RIGHT:** The lakeside at Lough Tay (O6).

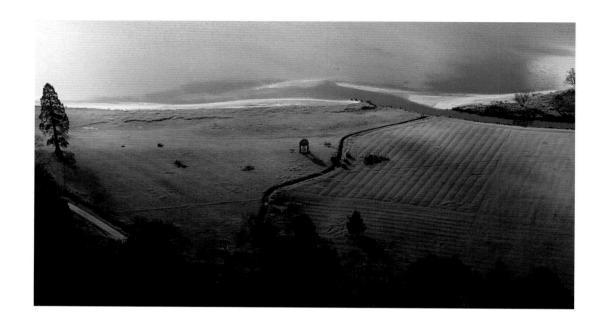

**RIGHT:** The Fancy and Lough Tay (O6).

**OPPOSITE:** A morning stroll at Lough Tay (O6).

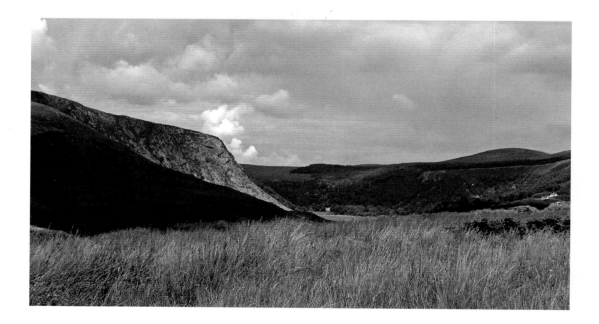

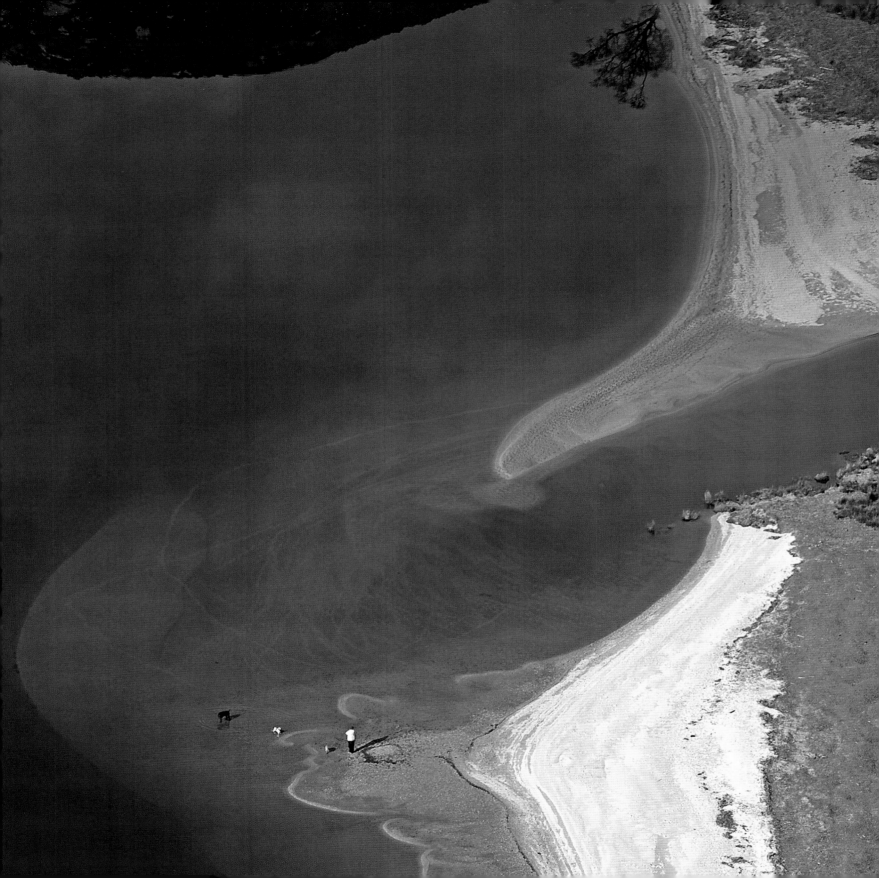

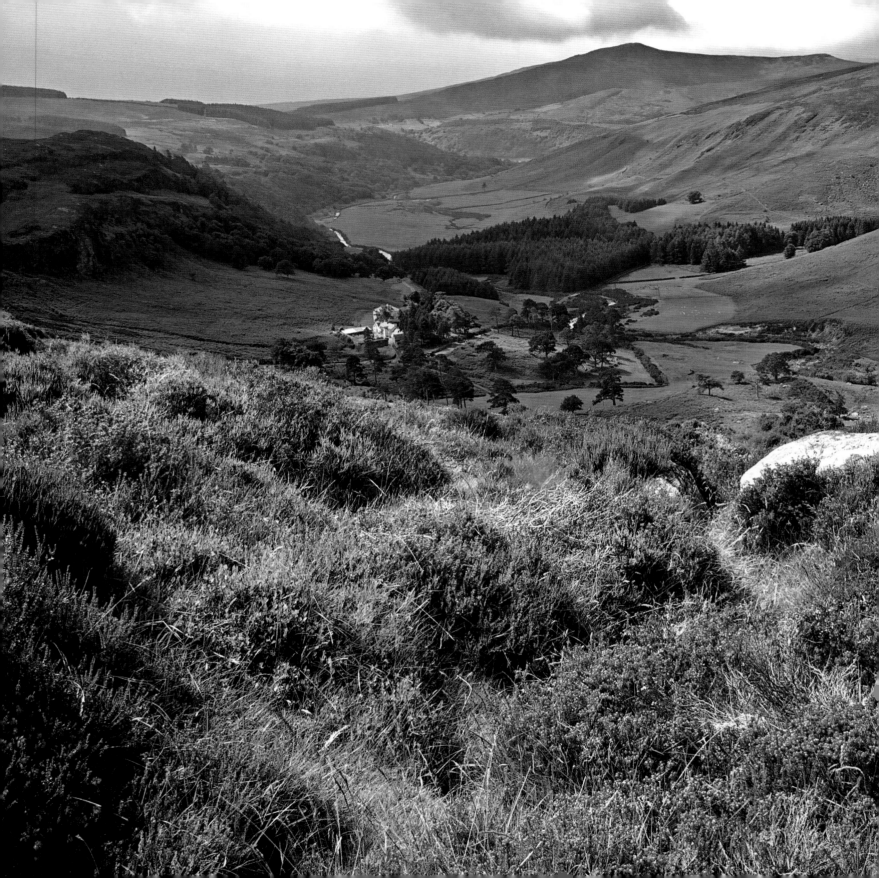

**OPPOSITE:** Cloghoge Valley in summer (O7).

**LEFT:** A track leading into the Cloghoge Valley from near the Pier Gates (O6).

**BELOW:** Lough Tay (O6).

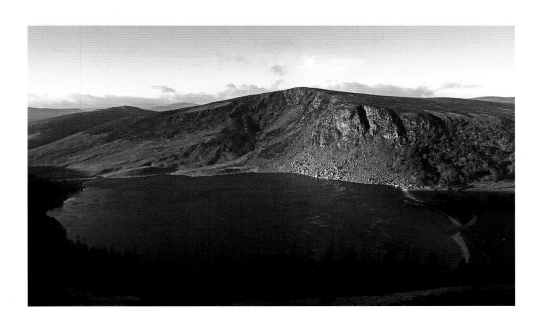

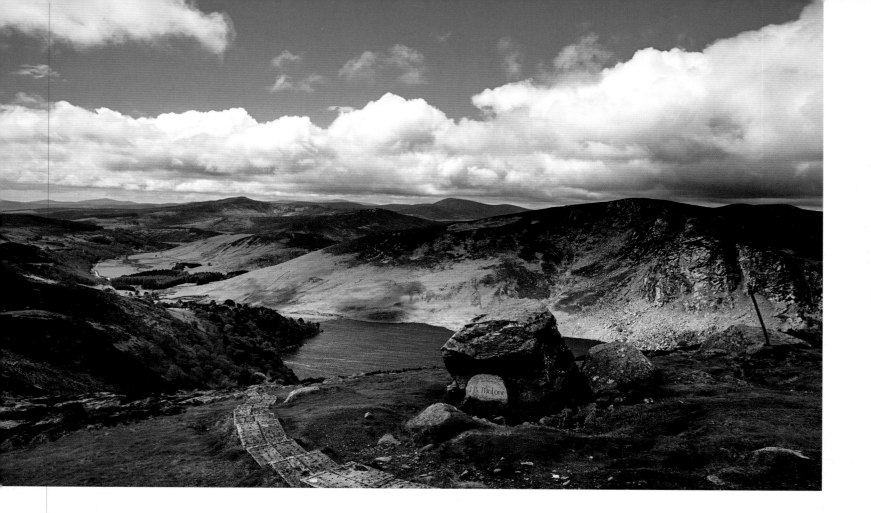

**ABOVE:** The J. B. Malone monument on the Wicklow Way at Boleyhorrigan (O6), which commemorates the first person to propose and champion The Wicklow Way. The route runs from Rathfarnham in south County Dublin to Clonegal in the north of County Carlow. Its route through Wicklow takes in some of the most beautiful parts of the uplands. At 127 km in length, it takes about a week to complete.

**RIGHT:** Early morning in the Wicklow Mountains near the Pier Gates (O6).

**OPPOSITE:** Lough Tay seen from Boleyhorrigan (O6).

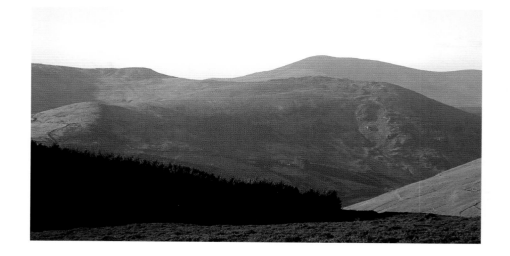

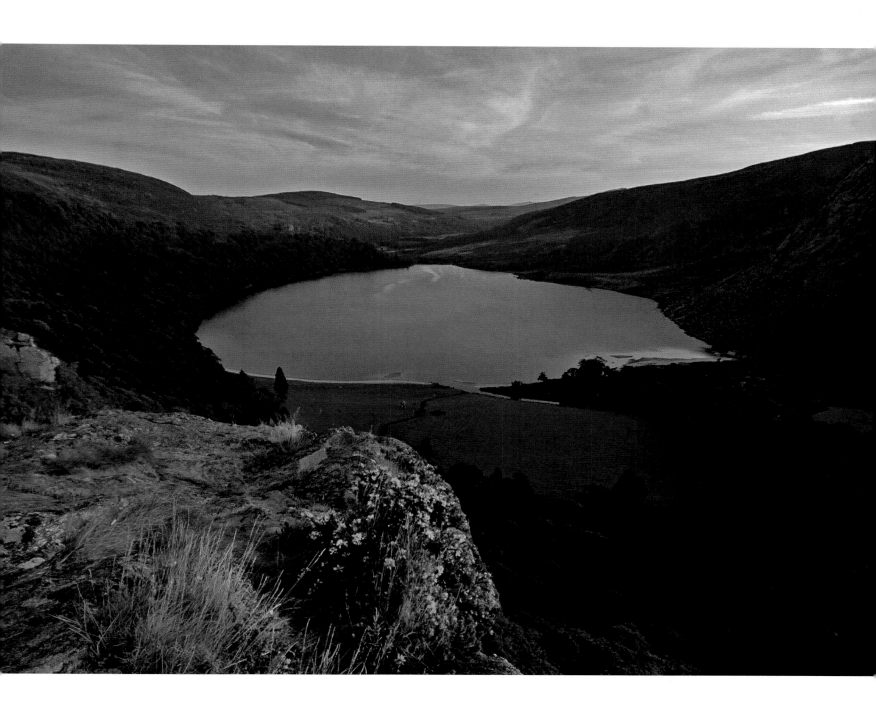

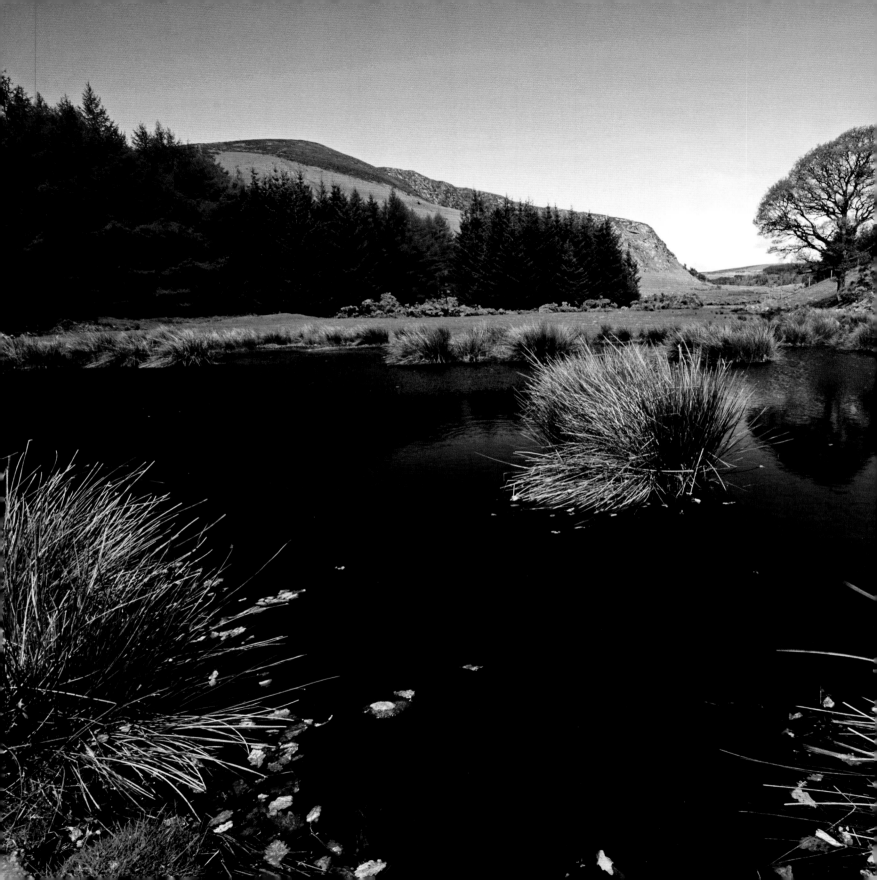

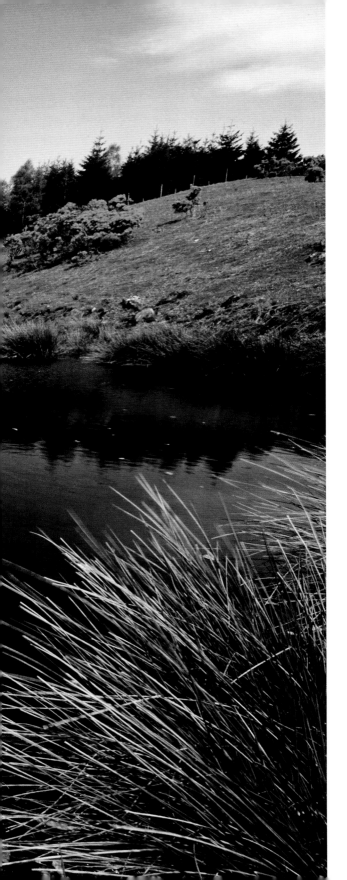

**OPPOSITE:** Pond in the Cloghoge Valley (O7).

**BELOW:** Ruined cottage, Cloghoge (O7).

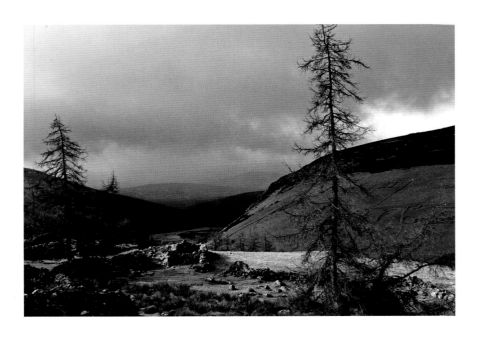

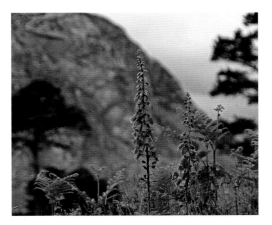

**LEFT:** Foxgloves in the Cloghoge Valley with the Fancy in the background (O7).

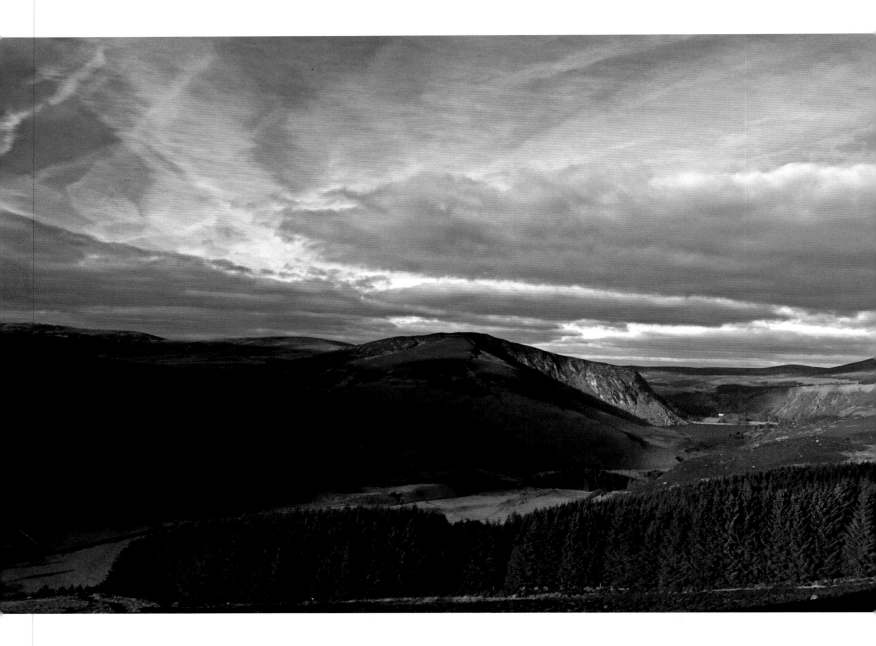

The Cloghoge Valley and Lough Tay (O7).

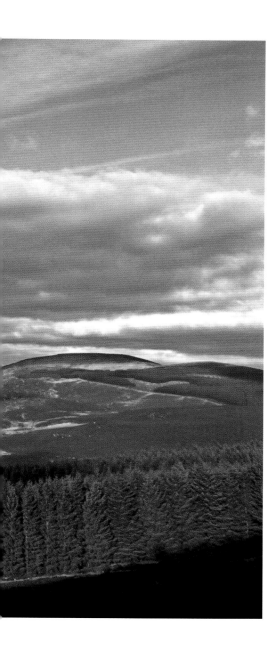

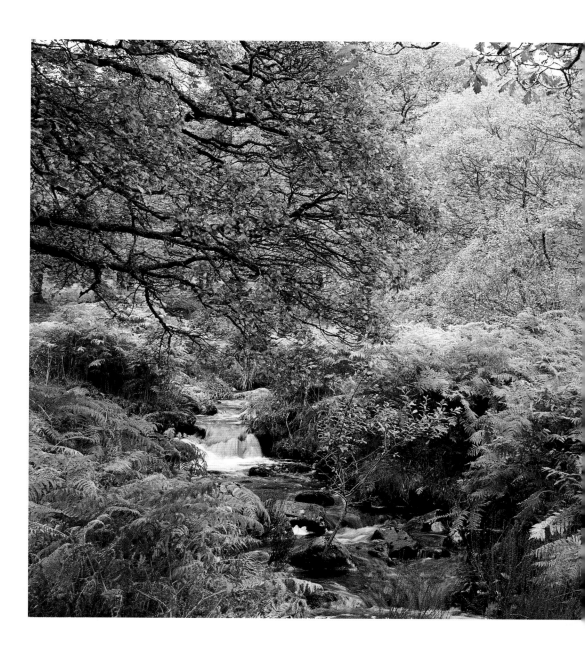

Autumn trees on the Inchavore River (M7).

**RIGHT:** Lough Dan, pictured from Slievebuck (O8).

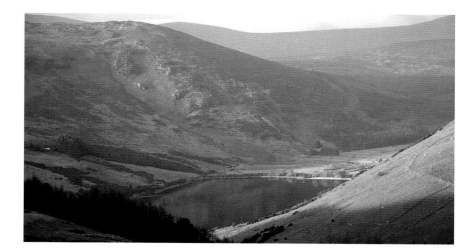

**BELOW:** Lough Dan and the Cloghoge Valley (N8).

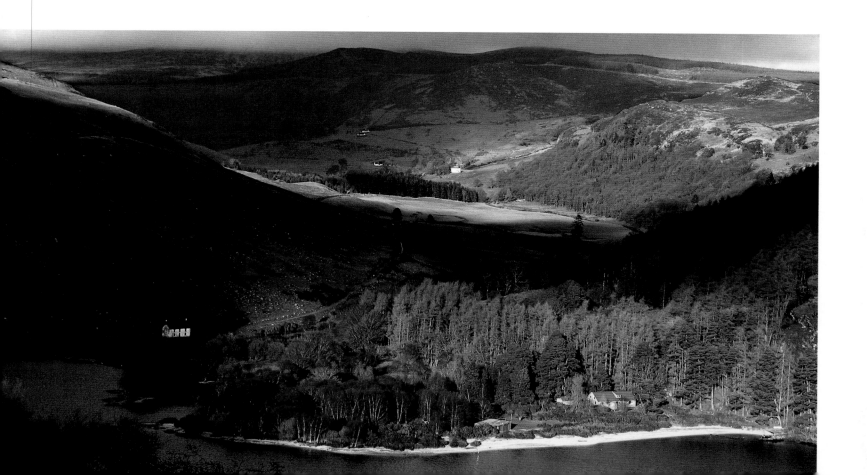

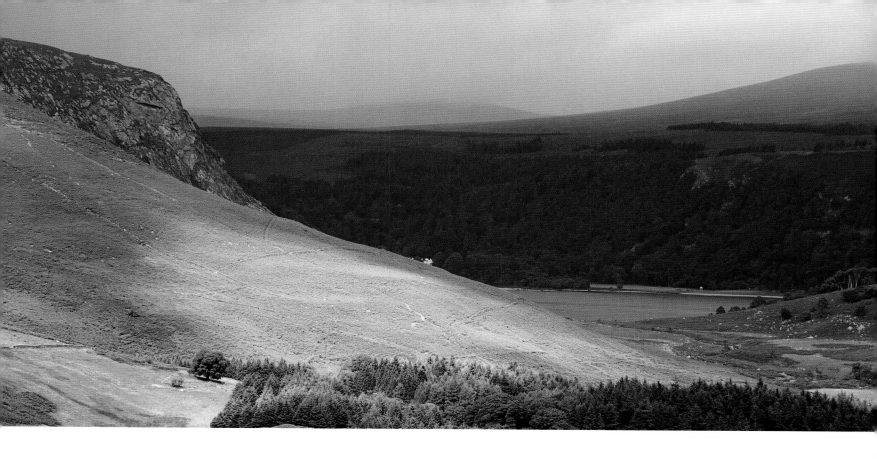

**ABOVE:** Luggala and Lough Tay (O7).

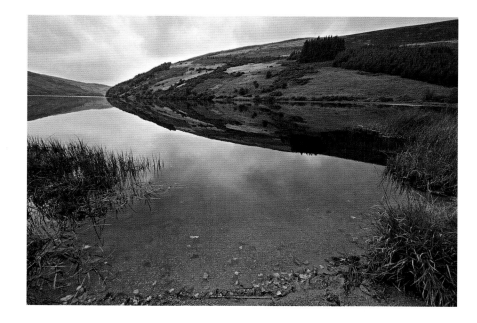

**LEFT:** A calm day on Lough Dan (N8).

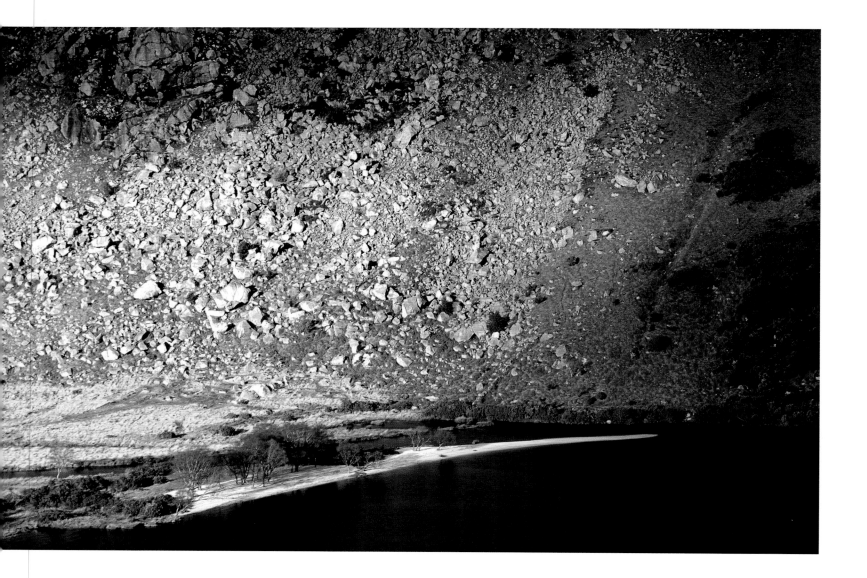

Inchavore Beach on Lough Dan (N8). Inchavore Beach can only be accessed on foot: walk from Oldbridge to the national scout campsite; 2km from the campsite you will reach the end of the road: turn left up a track. After about 100m, go right, through a small gate; follow this track to another small gate. At the gate turn right onto a track leading downhill. Continue to the ruins of the miners' houses, turn right across the fields towards the river. Before the river, turn right onto a track; continue on this track to the lake and the beach.

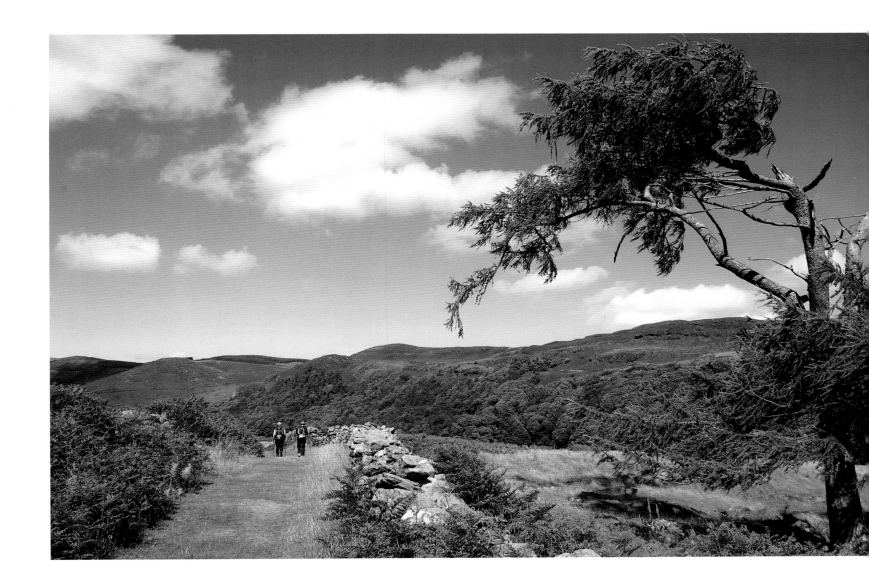

The green road to Lough Dan (N7). This green road is part of an easily accessible walk. At Pier Gates go through the pedestrian entrance to Luggala House. Continue downhill, veering left at the gate lodge; stay on the main track, cross the Cloghoge River and head towards a gate with a sign 'To Lough Dan'. The green road from this gate leads all the way to the lough.

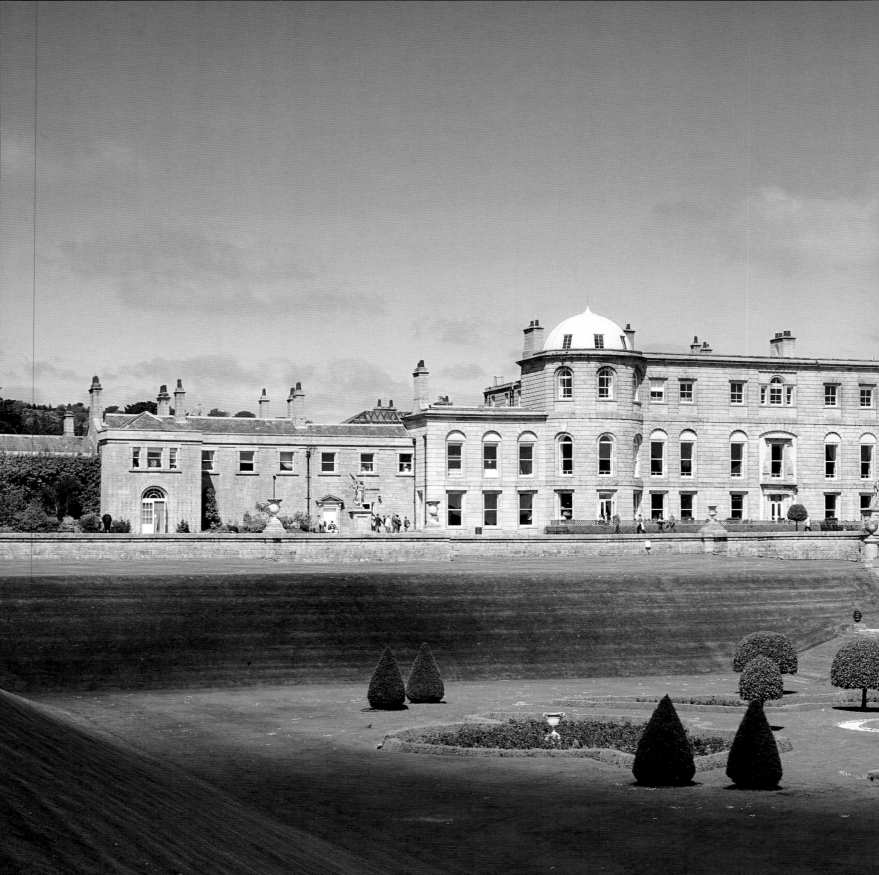

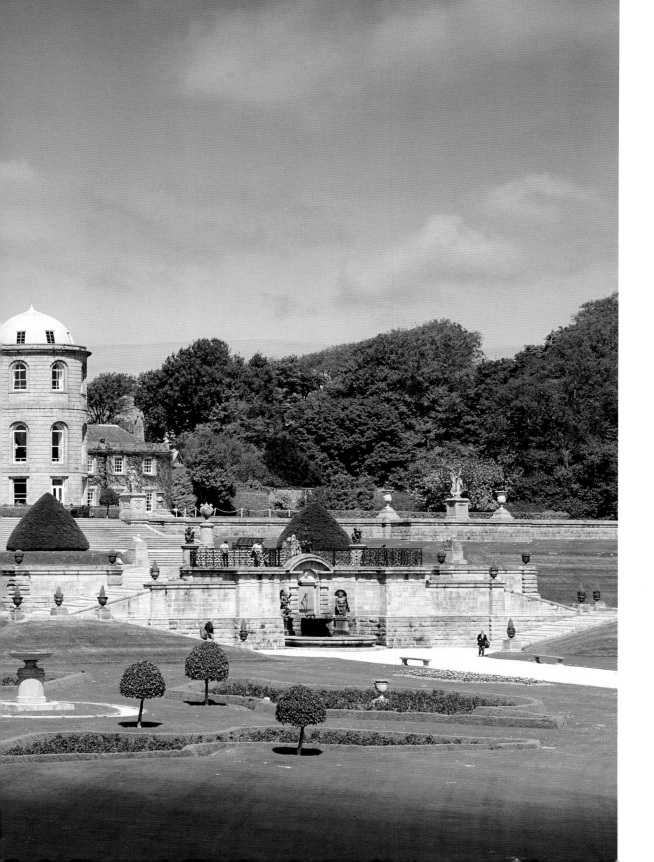

Powerscourt House (P3).
Renowned for its gardens,
Powerscourt House was
designed by German
architect Richard Cassels.
It was built between 1731
and 1741. The house
was destroyed by fire in
1974 but was restored and
renovated in 1996.

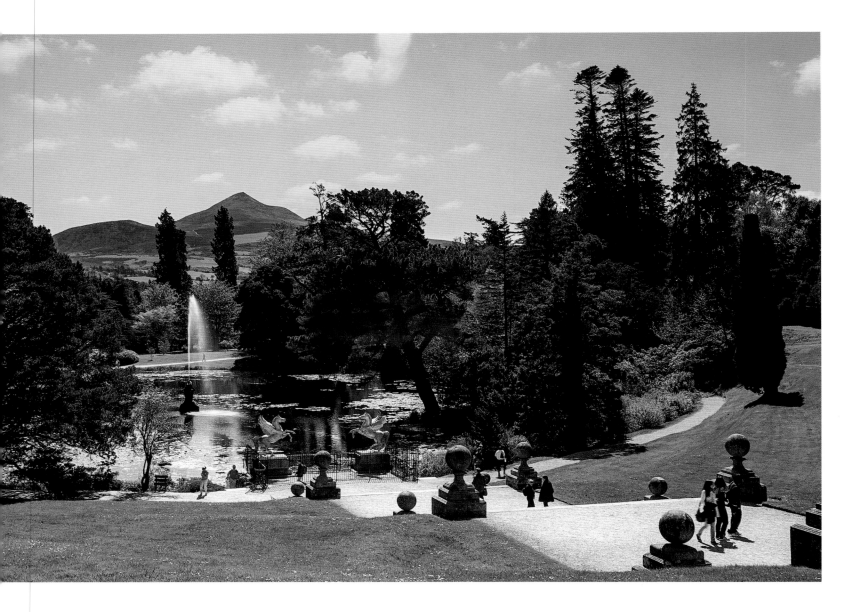

Powerscourt Gardens (P3).

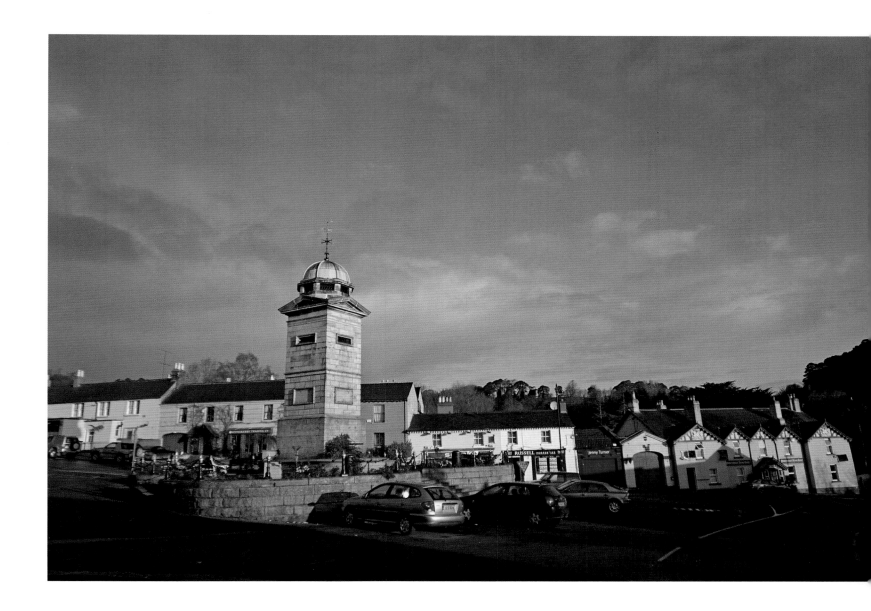

Enniskerry, a popular tourist town close to Powerscourt Estate (Q2).

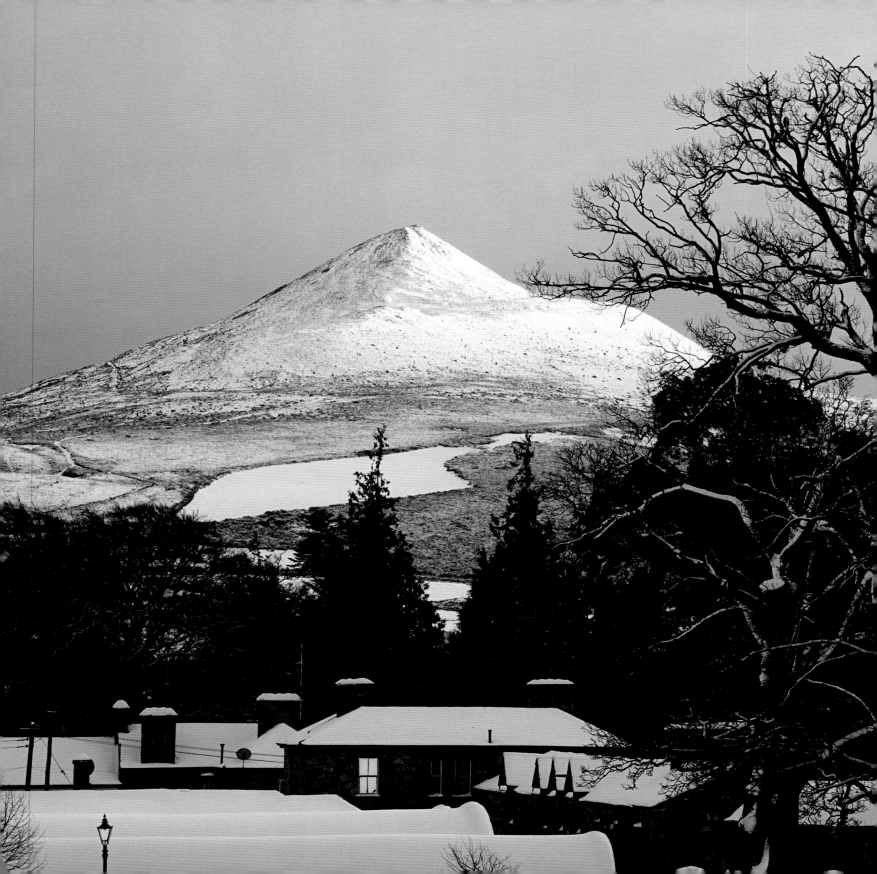

**OPPOSITE:** Winter in Powerscourt with the Great Sugar Loaf in the background (Q3).

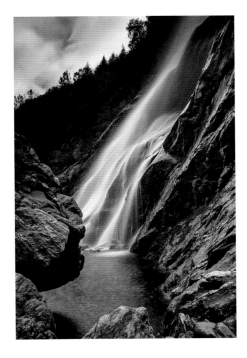

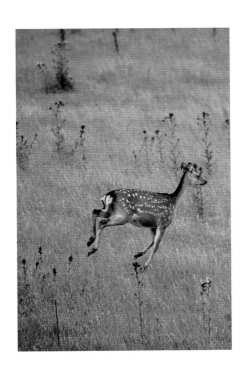

Spring near Powerscourt (P3).

Powerscourt Waterfall (P4) is Ireland's highest waterfall at 121m, set in beautiful parkland. In 1821 the river above the waterfall was dammed to create a spectacle for the visit of King George IV. The plan was for the king to stand on the bridge below and observe the torrents and cascades. Luckily, the king was delayed at a banquet and did not attend – when the water was released the bridge was washed away!

A young sika deer in the Cloghoge valley (O7). Sika deer are originally from Japan – the word 'sika' is actually Japanese for deer. They were introduced into Ireland by Lord Powerscourt in 1859.

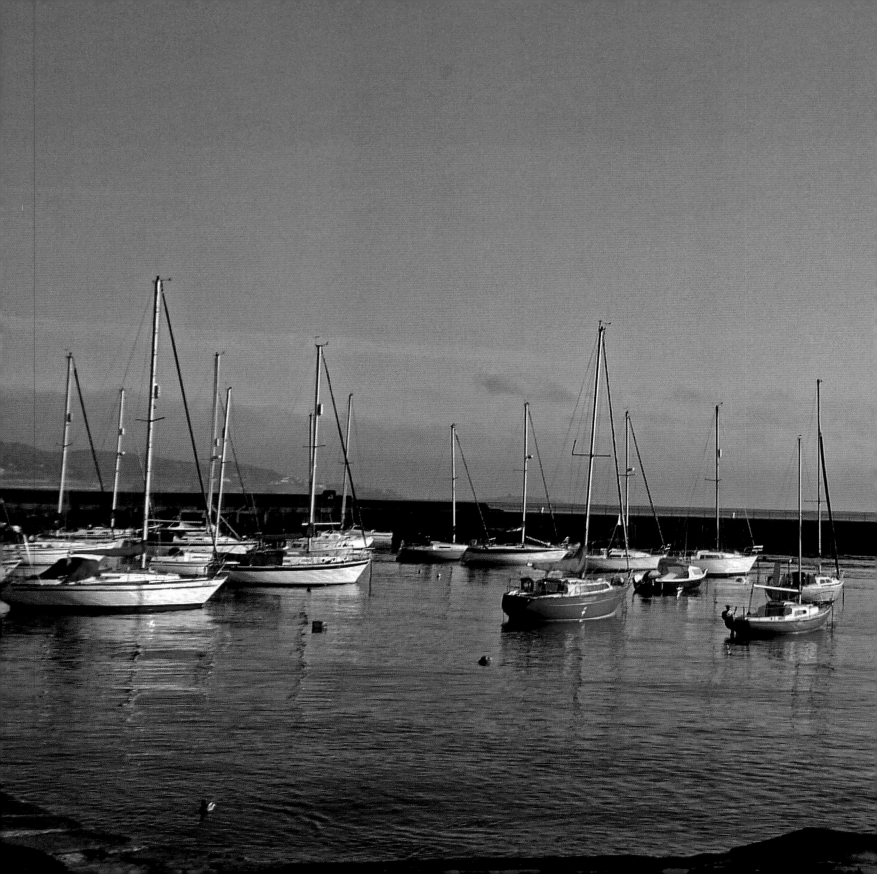

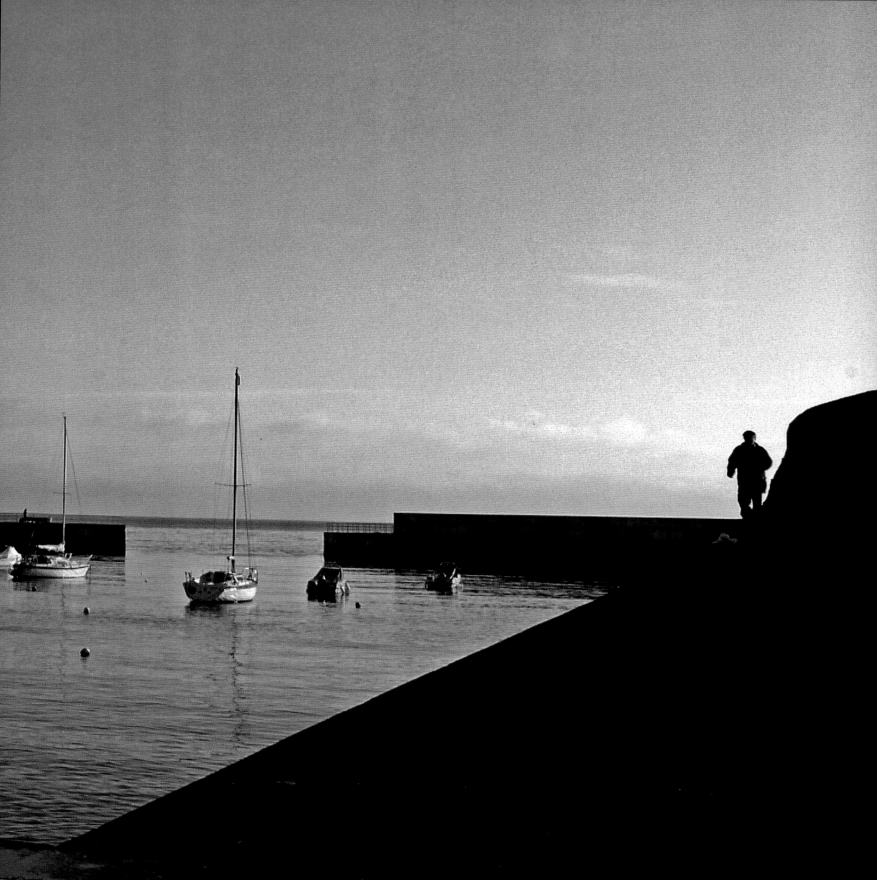

**PREVIOUS PAGES:**
Early morning,
Bray Harbour (S2).

**RIGHT:** A German
band marches past the
old town hall in Bray
during the St Patrick's
Day Parade (S2).

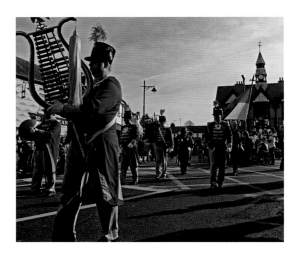

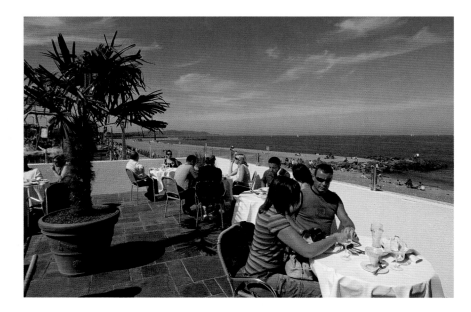

**ABOVE:** Dining al fresco
on Bray's seafront (S2).

**OPPOSITE:** Sunrise, Bray
seafront (S2).

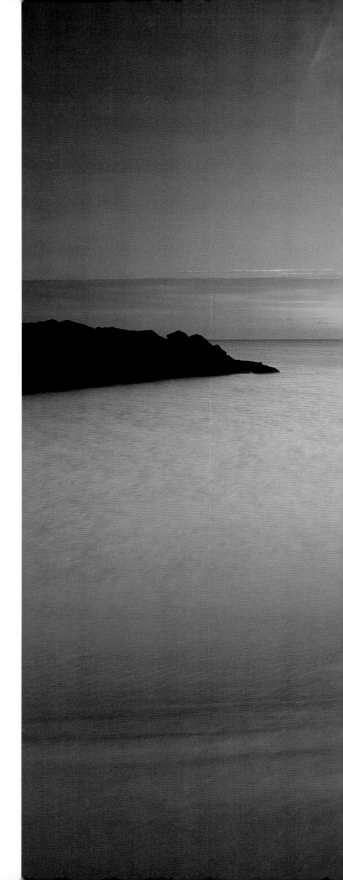

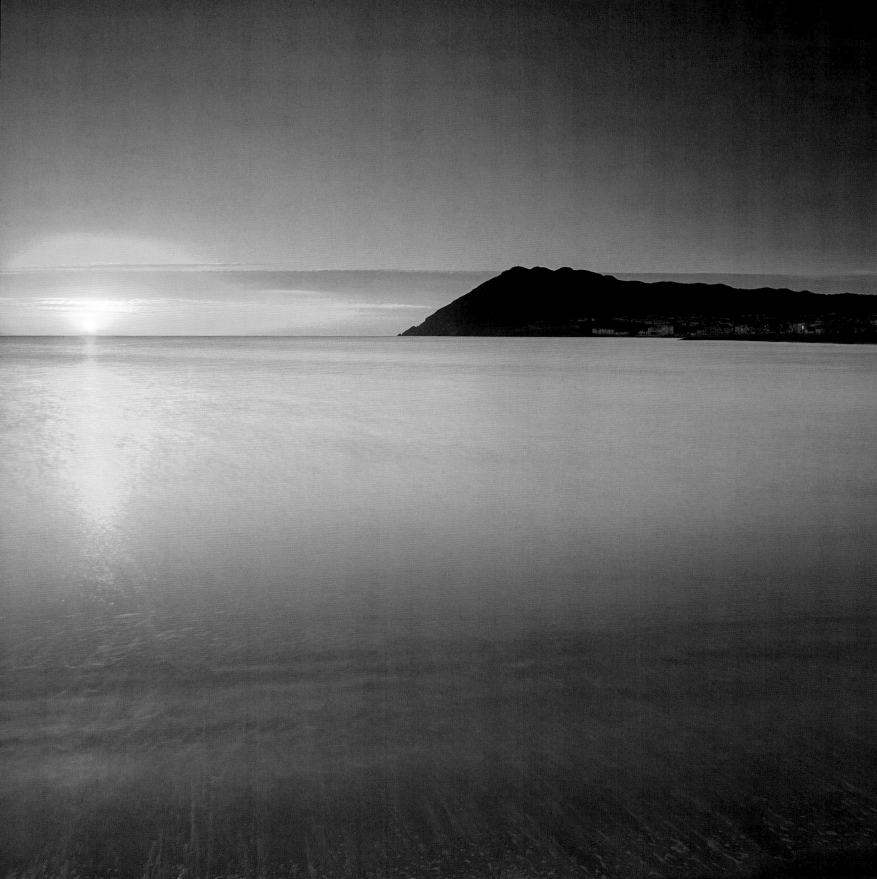

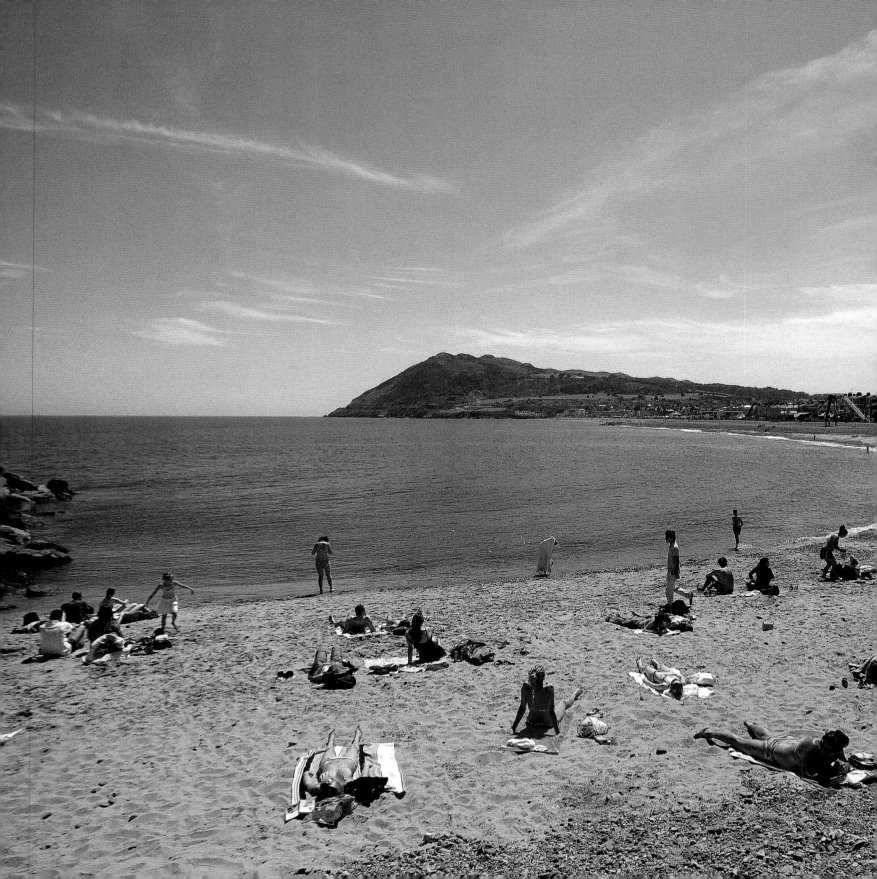

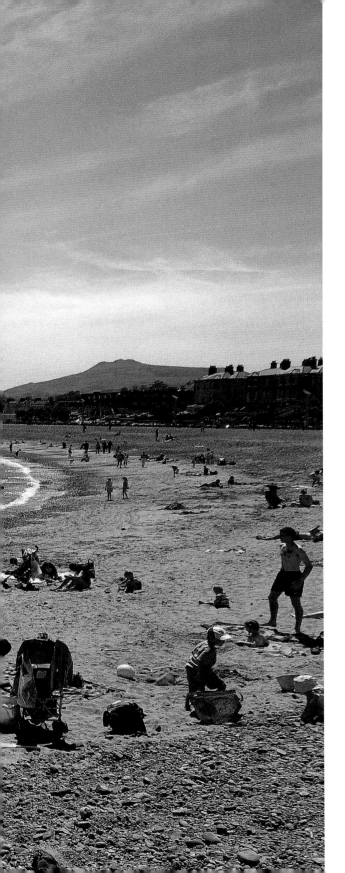

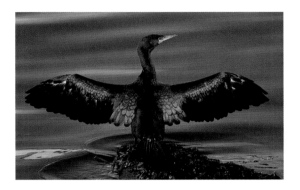

A cormorant drying its wings at Bray (S2).

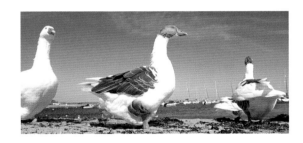

A gaggle of geese in Bray Harbour (S2).

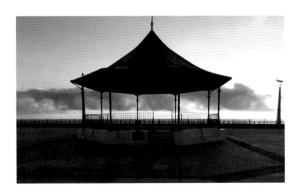

The bandstand on the Bray promenade (S2).

**OPPOSITE:** A summer's day on the beach at Bray (S2).

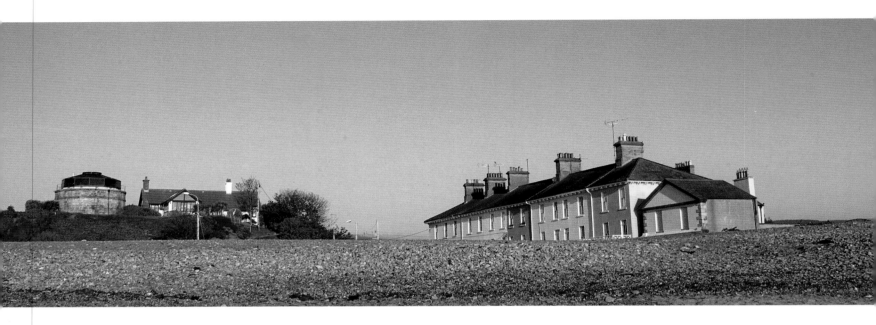

**ABOVE:** The Martello Terrace and tower (left) in Bray (S2).

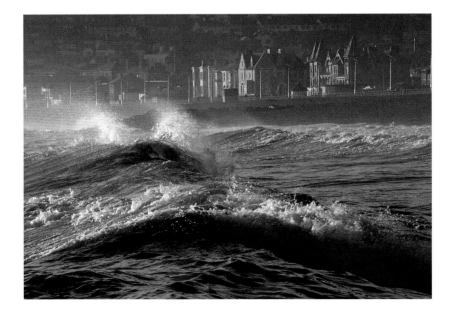

**RIGHT:** Rolling waves at Bray's seafront (S2).

**LEFT:** Autumn colours in the Dargle Glen (R3).

**BELOW:** Killruddery House and Gardens (S3). The gardens at Killruddery are immensely important, being among the last remaining seventeenth-century gardens in Great Britain and Ireland.

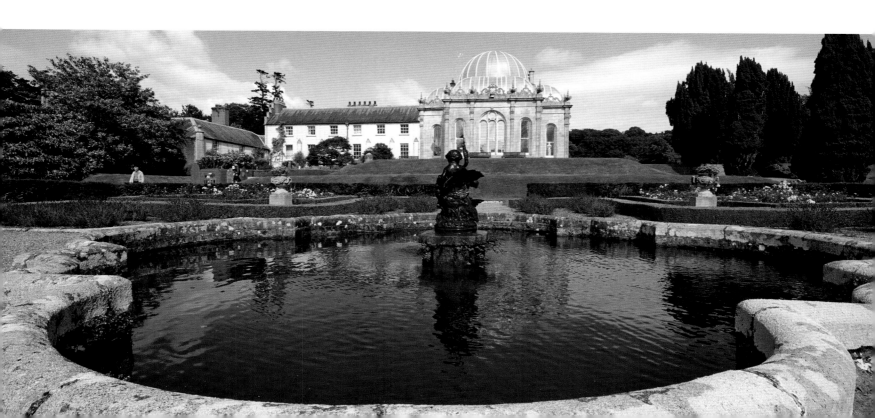

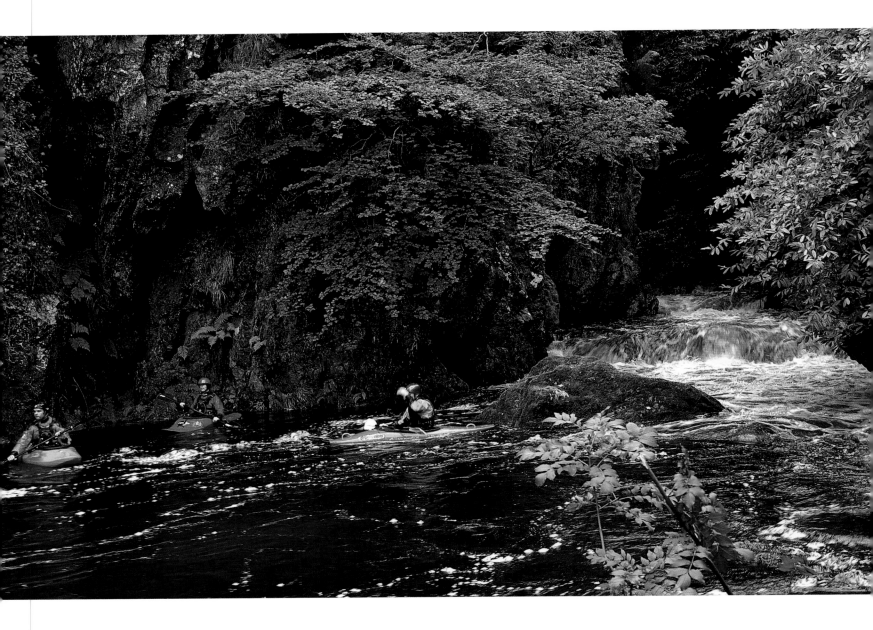

Canoeing on the Dargle River (R3).

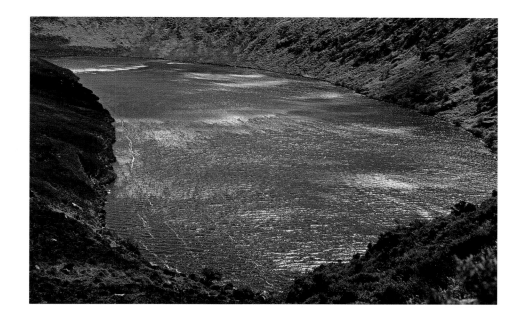

Upper Lough
Bray (N3).

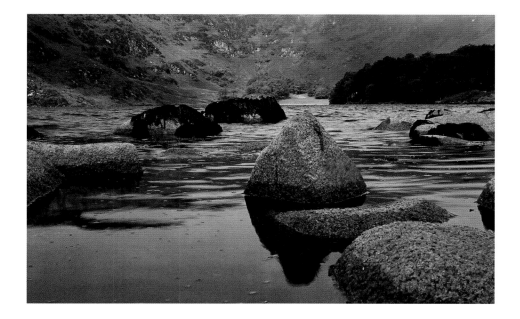

Lower Lough
Bray (N3).

**OPPOSITE:** A lavender field at Kilmacanoge (R3) the Great Sugar Loaf behind.

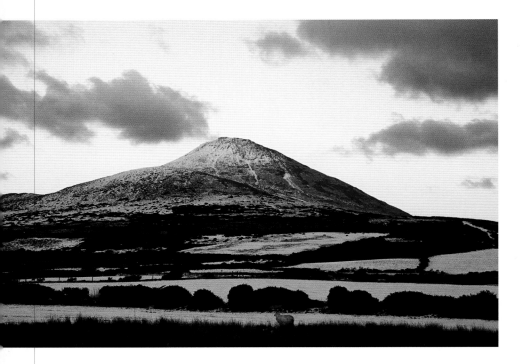

**ABOVE:** The Great Sugar Loaf in winter (Q4).

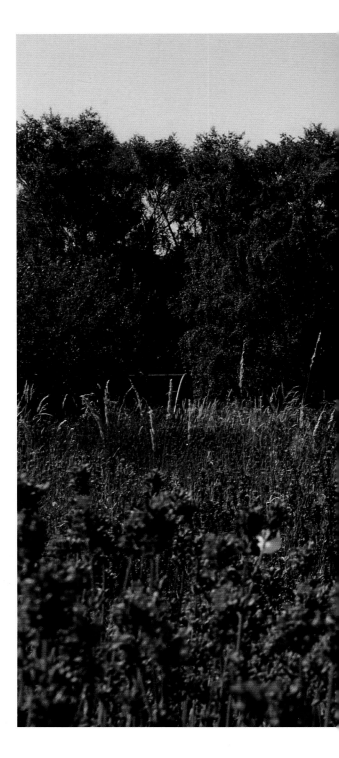

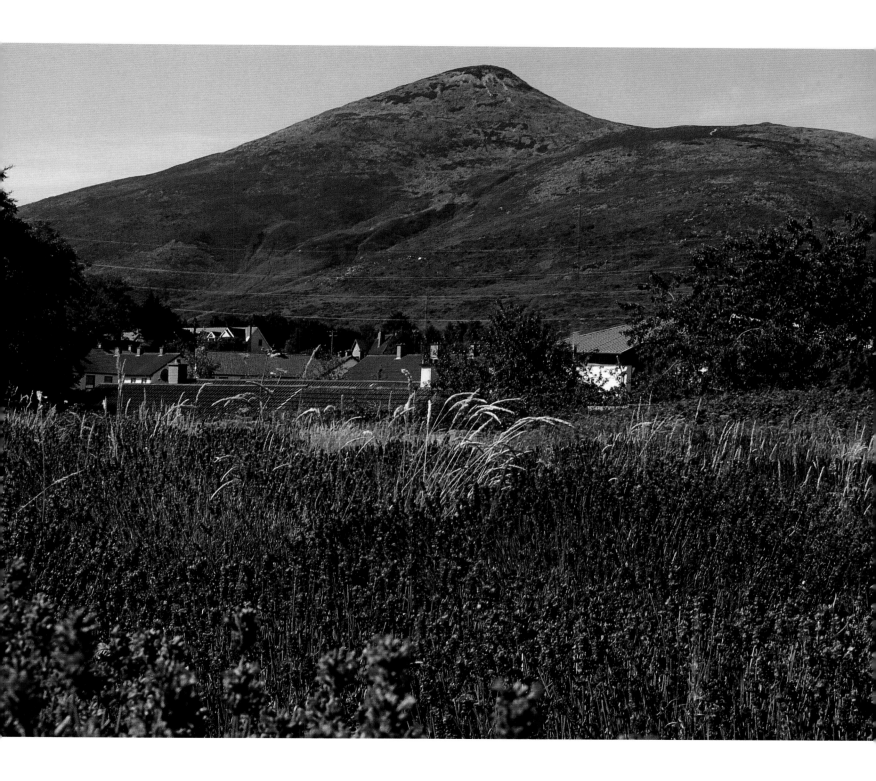

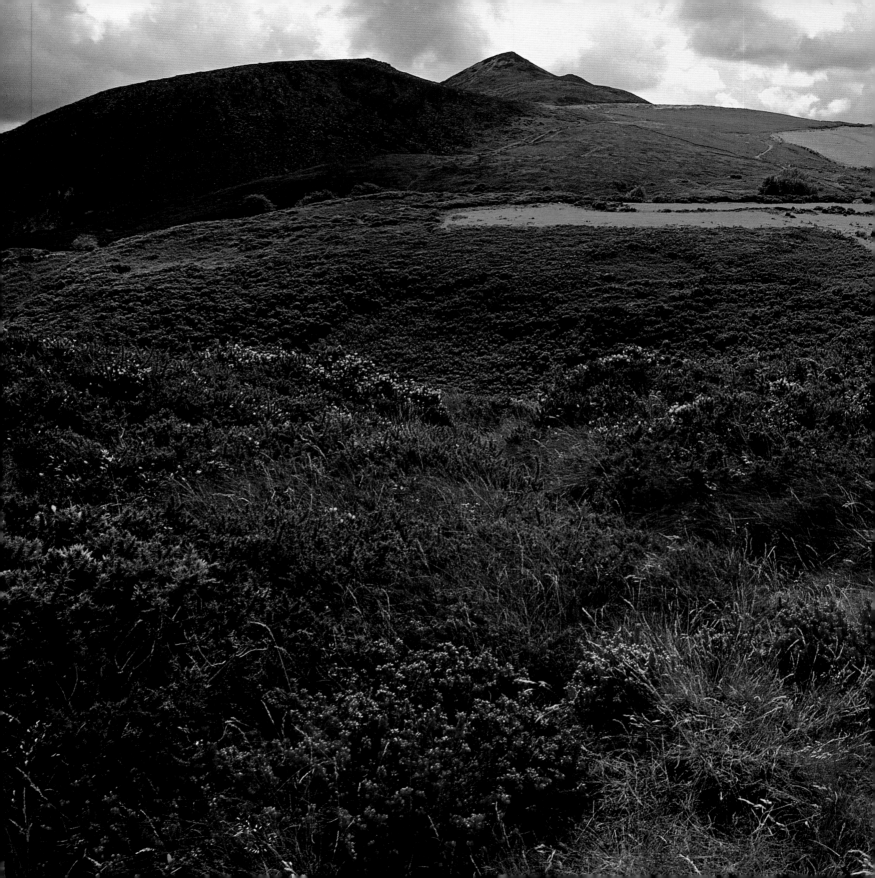

**OPPOSITE:** The Great Sugar Loaf, seen from Carrigoona in Rocky Valley (R3).

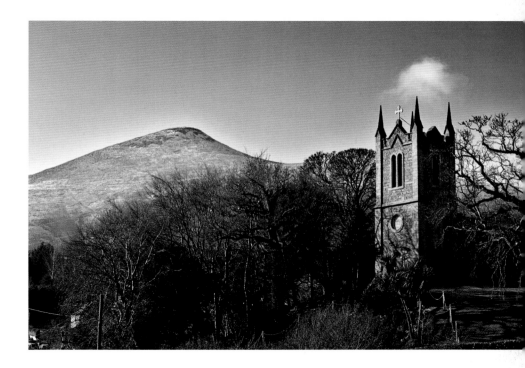

**ABOVE:** Kilmacanoge Church and the Great Sugar Loaf (R3).

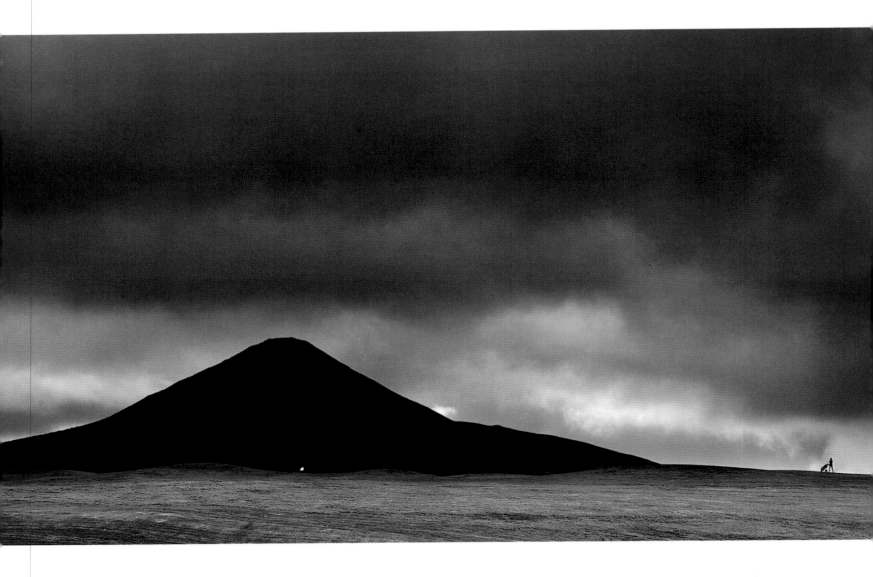

Golfers at the Glen of the Downs Golf Club
are dwarfed by The Great Sugar Loaf (S5).

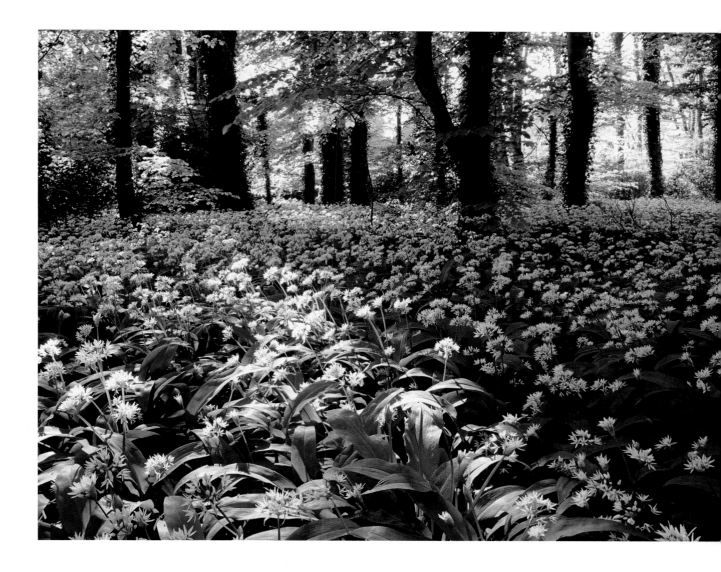

Wild garlic in the Glen of the Downs (S5). A relative of chives, wild garlic grows in great profusion in woodlands in Wicklow during May. The leaves and flowers are edible and can be used in salads or used to make pesto. My favourite recipe for wild garlic pesto is as follows: using a food processor, blend together 100g wild garlic, 200ml olive oil, 50g pine nuts, 2 garlic cloves peeled and crushed. Transfer the mixture to a bowl and fold in 50g grated parmesan cheese; season with salt and pepper; store in a covered, sterilised jar in the fridge and use within a week of opening.

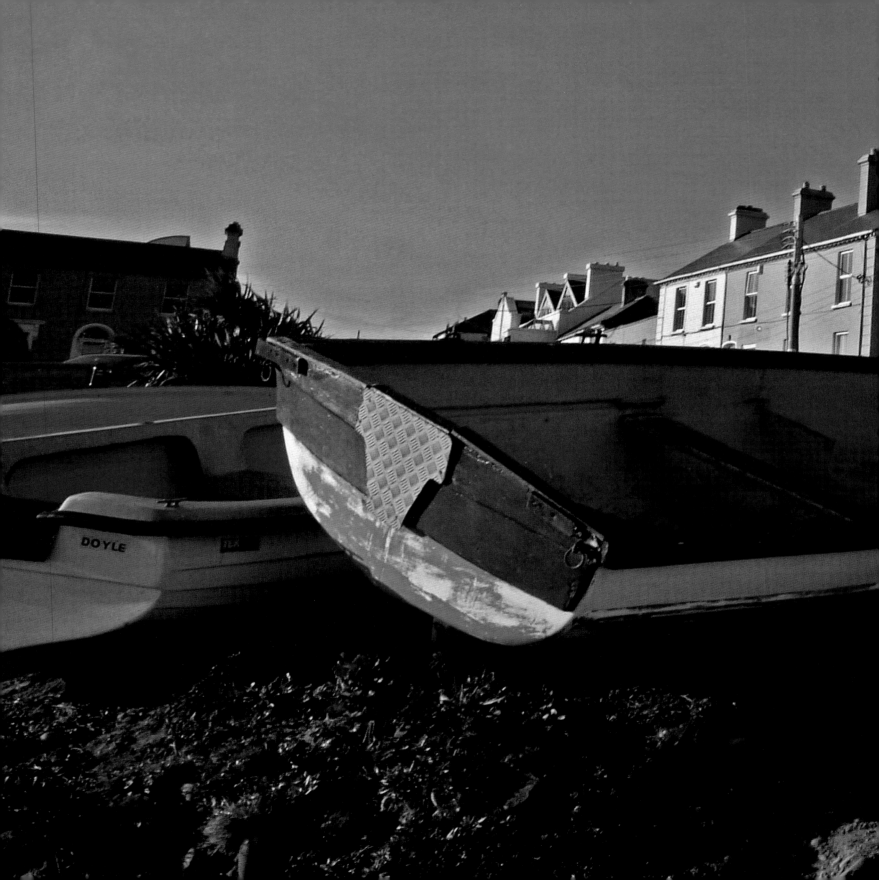

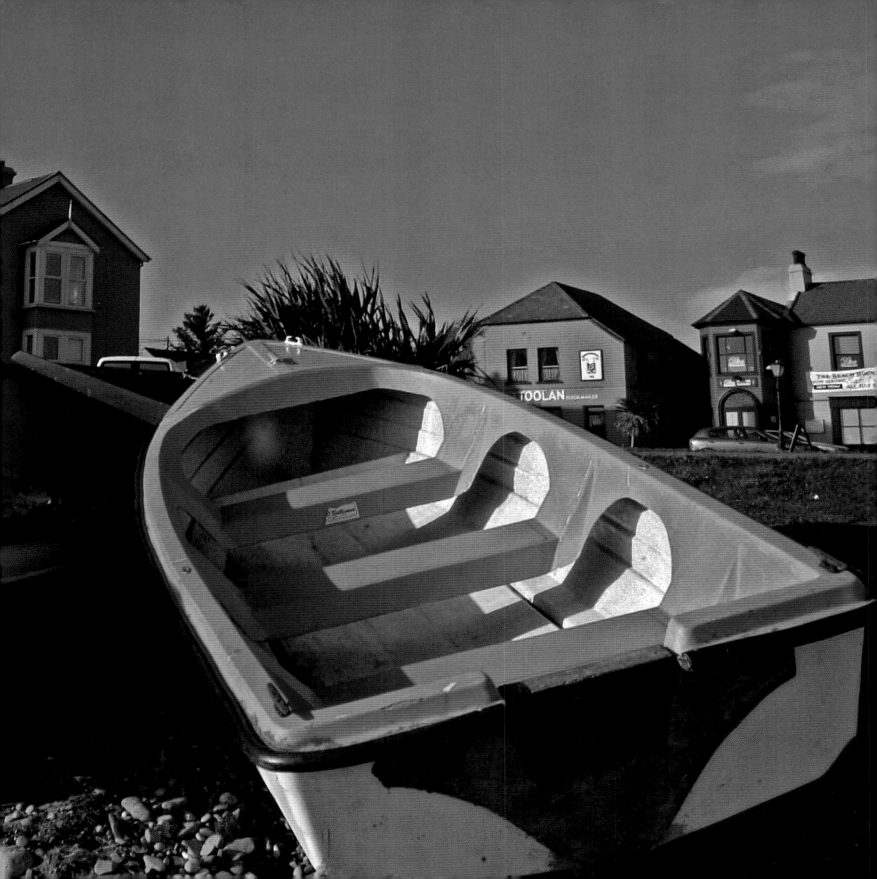

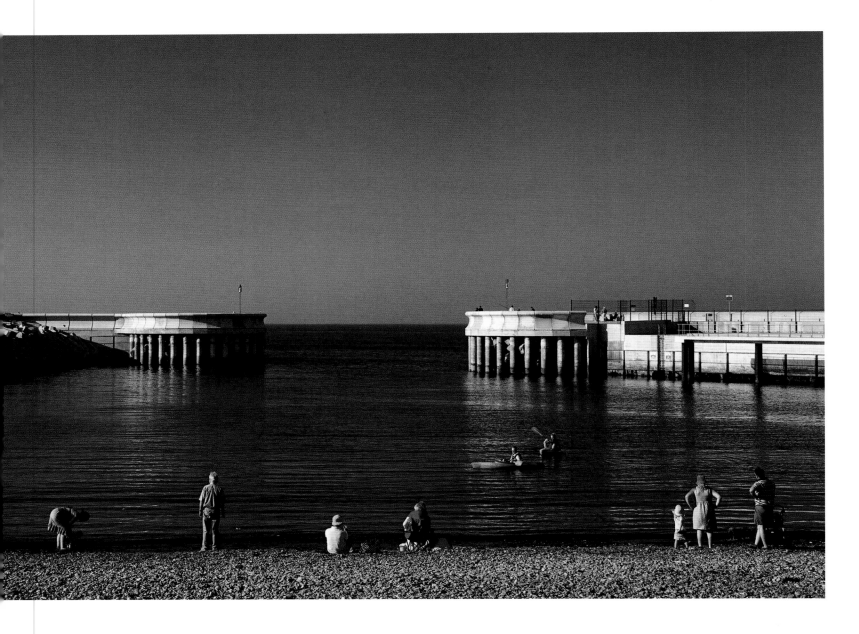

**PREVIOUS PAGES:** The Old Harbour at Greystones (T4) belongs to history. It has been replaced by a new harbour with modern marina facilities.

**ABOVE:** The new harbour at Greystones (T4).

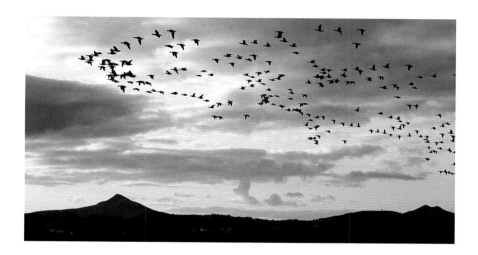

A rook on a rail in Greystones (T4).

Brent geese take to the air at Kilcoole (U6).

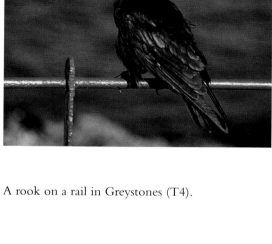

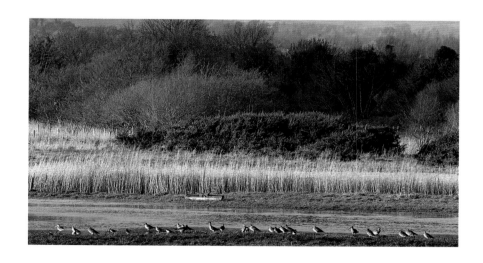

Street artists at the Greystones Festival (T4), which is held annually in August.

Common snipe on the marsh in Kilcoole (U6).

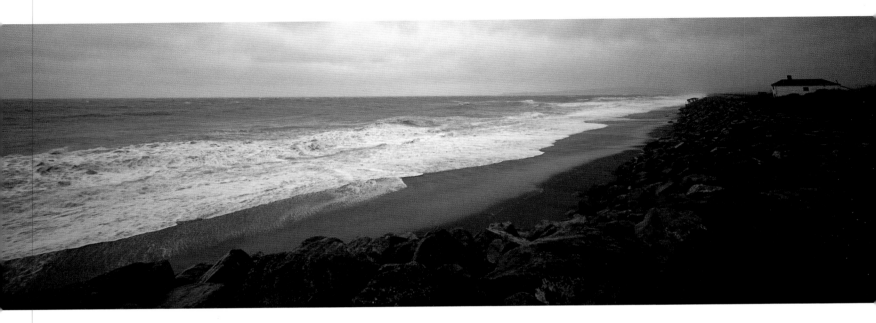

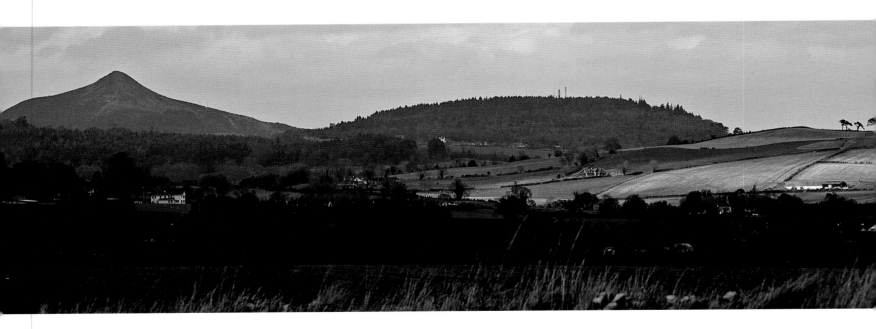

**OPPOSITE:** A storm on the Irish Sea at Newcastle (U8).

**LEFT:** The summer colours of Wicklow.

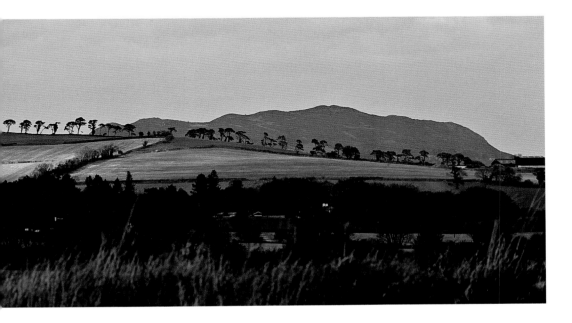

**LEFT:** Near Newtownmountkennedy (l–r): the Little Sugar Loaf, a field of corn and Bray Head (S7).

**BELOW:** A mute swan with her cygnets on a pond in the Druids Glen (T7).

**BELOW:** A lily in a pond in Druids Glen ((T7).

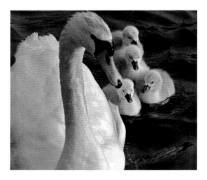

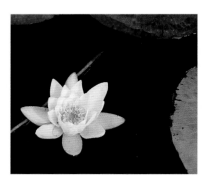

**ABOVE:** A quiet corner in the National Garden Exhibition Centre in Kilquade (S6).

**OPPOSITE:** Frenzied feeding of house martins at dusk (S7). The Common House Martin is a migratory bird of the swallow family; they breed in Europe and winter in sub-Saharan Africa. They feed on insects which are caught in flight and migrate to climates where flying insects are plentiful.

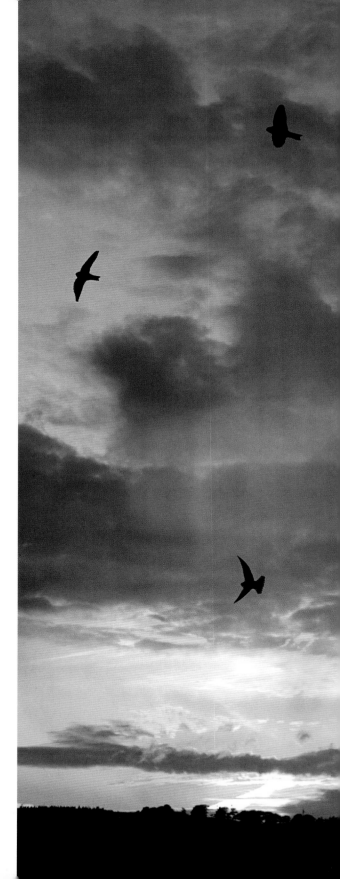

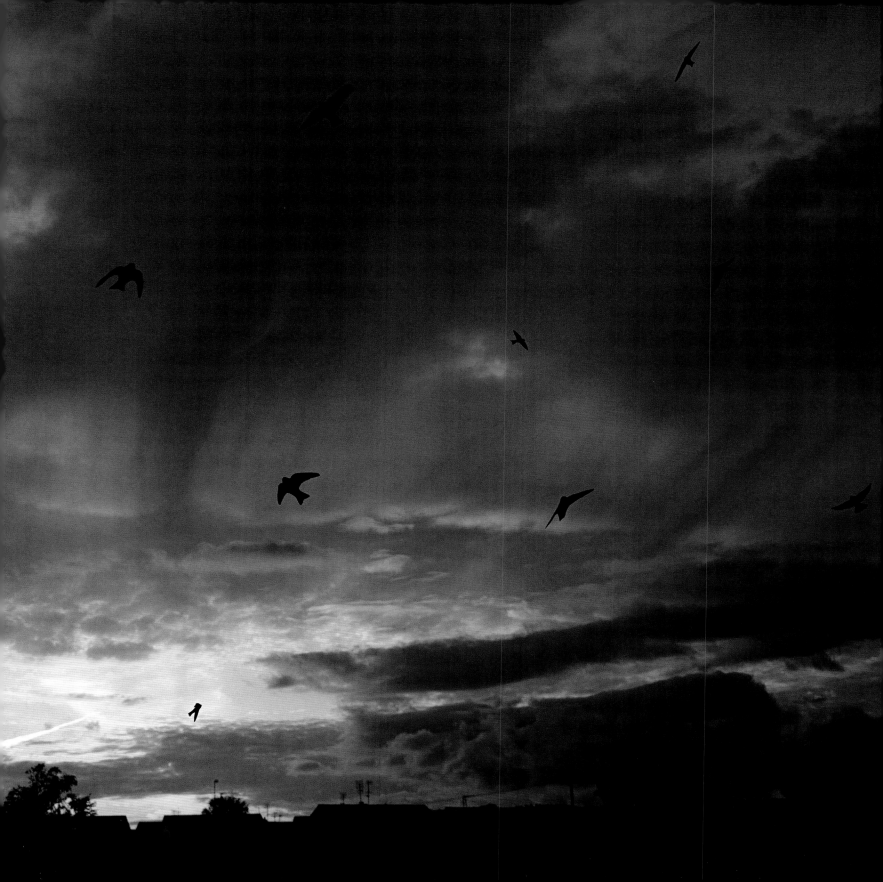

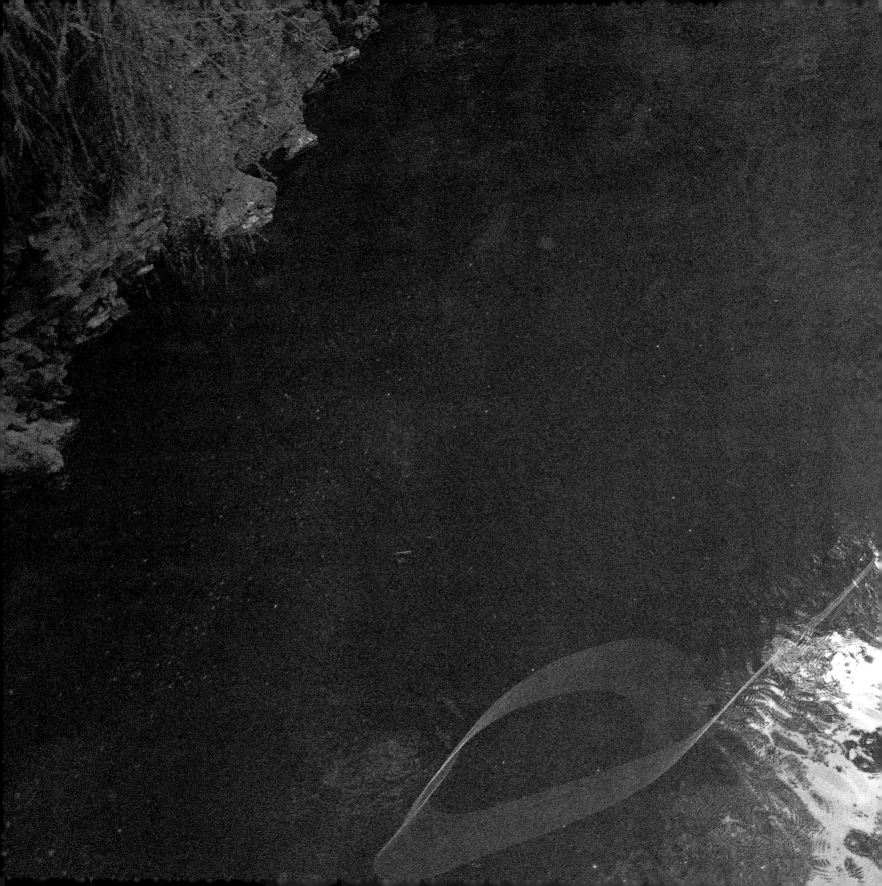

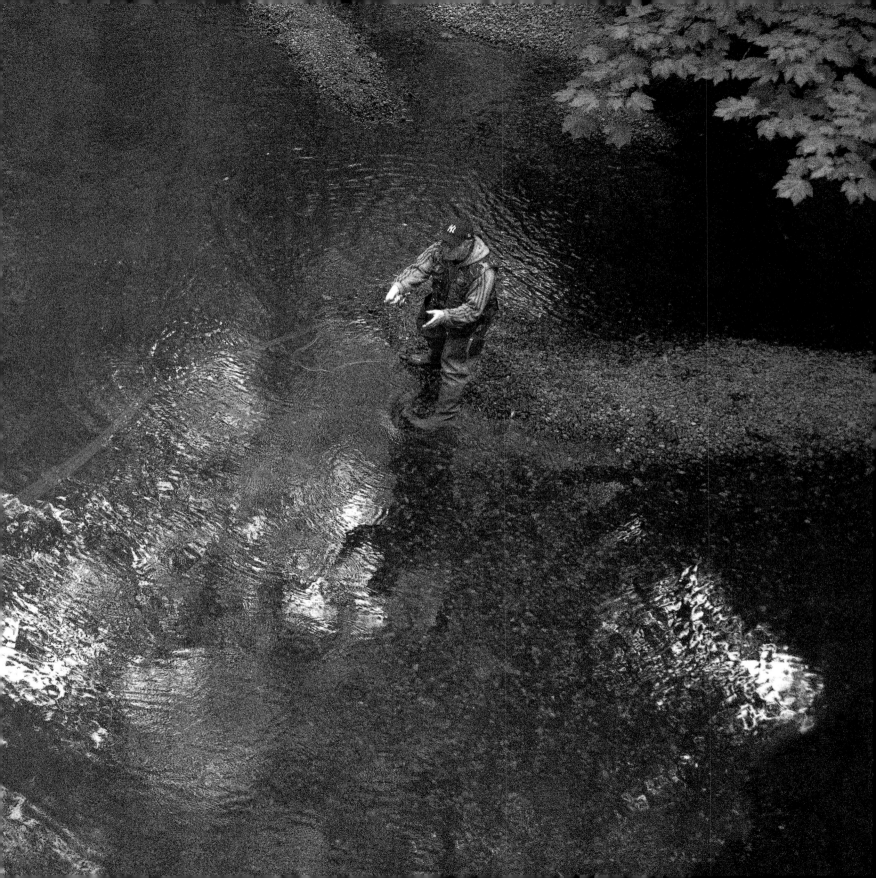

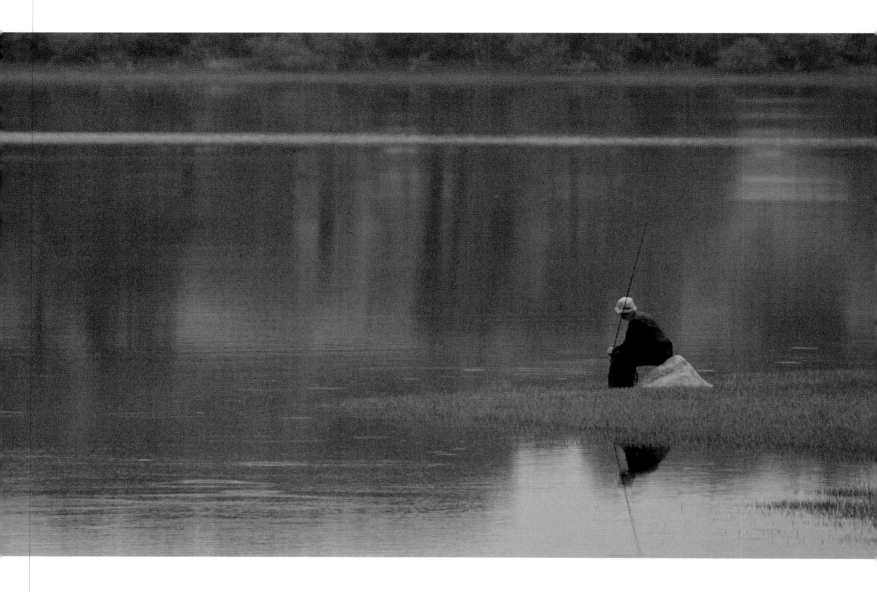

**PREVIOUS PAGES:** Fly fishing in a deep pool on the Vartry River (P8). The source of the river is in Calary Bog, at the foot of the Great Sugar Loaf. It was dammed in 1865 to create the Vartry Reservoir, which continues to provide water for the greater Dublin area.

**ABOVE:** Resting after a day's fishing on Vartry Reservoir (P8).

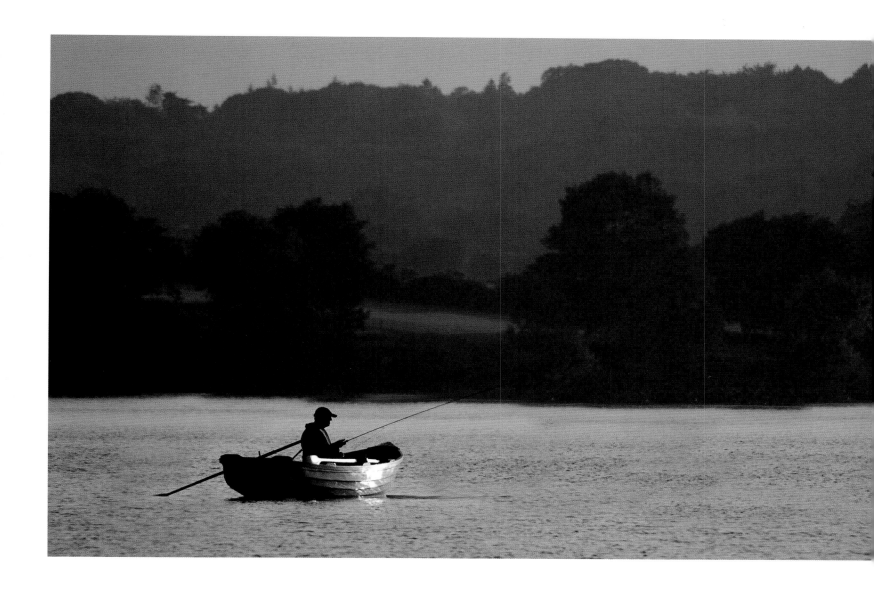

**ABOVE:** Trout angler on the Vartry Reservoir (P8).

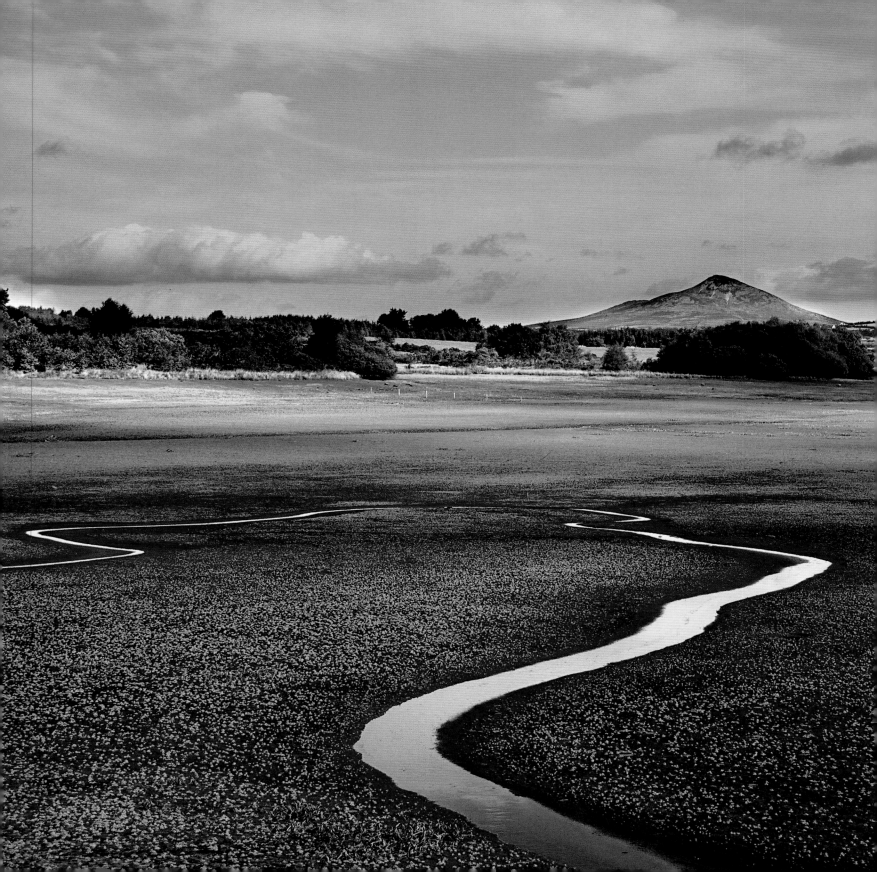

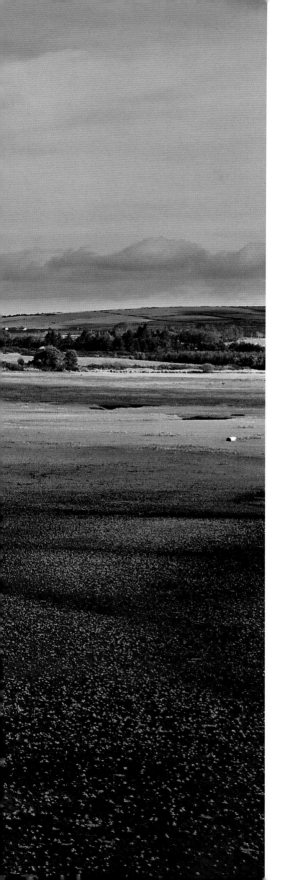

**OPPOSITE:** The dried-out bed of the Upper Vartry Reservoir in late summer (P8).

**BELOW:** Sunset on the Vartry Reservoir (Q8).

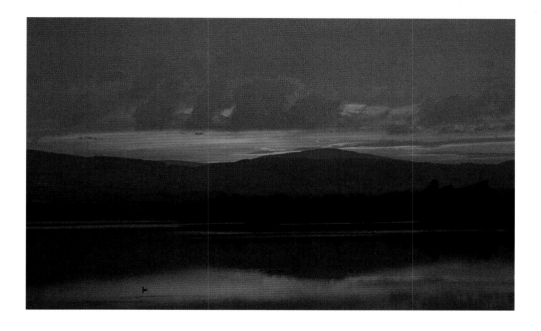

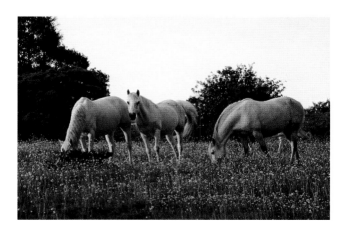

**LEFT:** White horses in a meadow near Roundwood (P8).

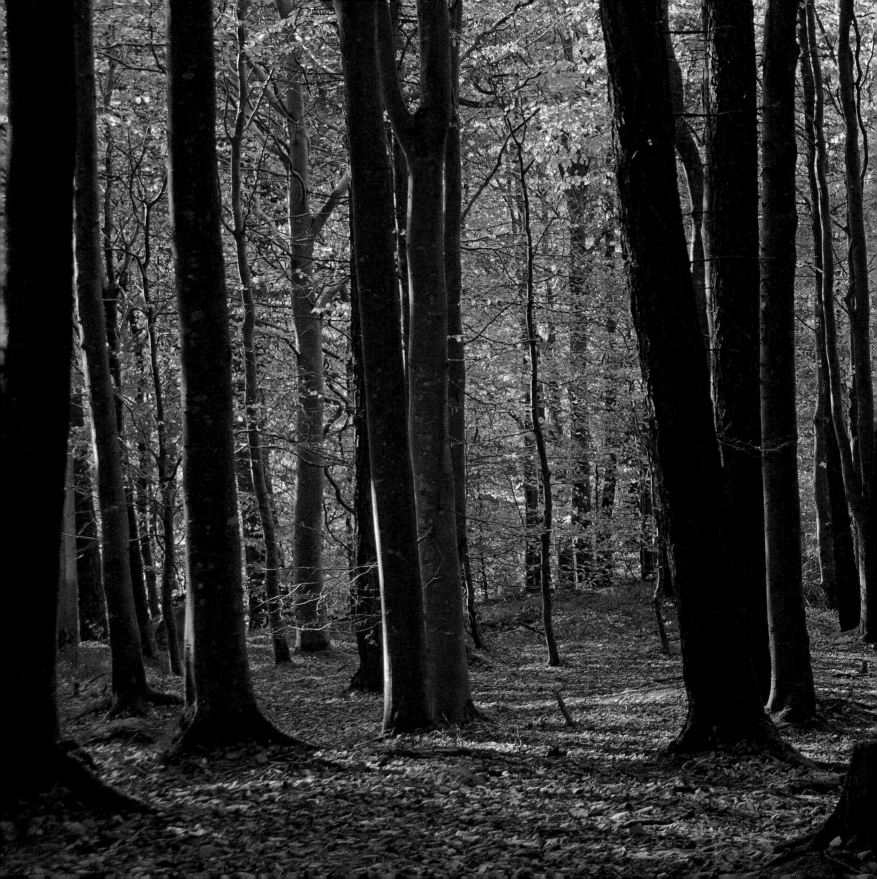

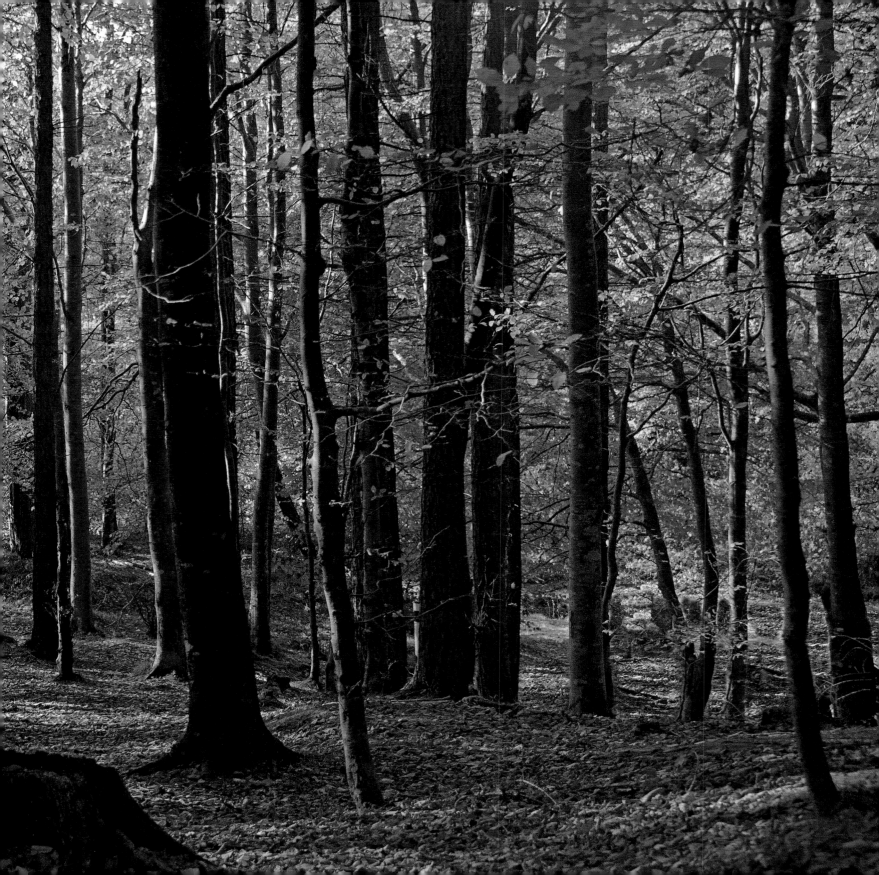

**PREVIOUS PAGES:** Autumn woodlands in the Devil's Glen (R10).

**RIGHT:** The Vartry River in the Devil's Glen (R10).

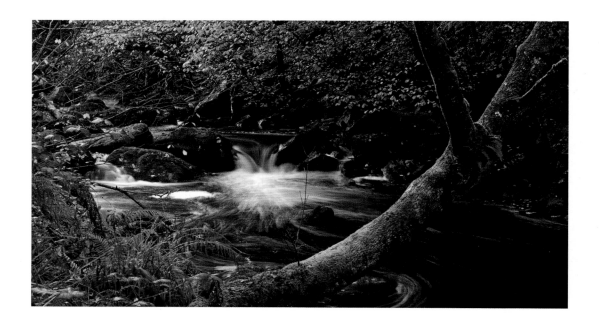

**RIGHT:** New leaves and bluebells in the Devil's Glen (R10).

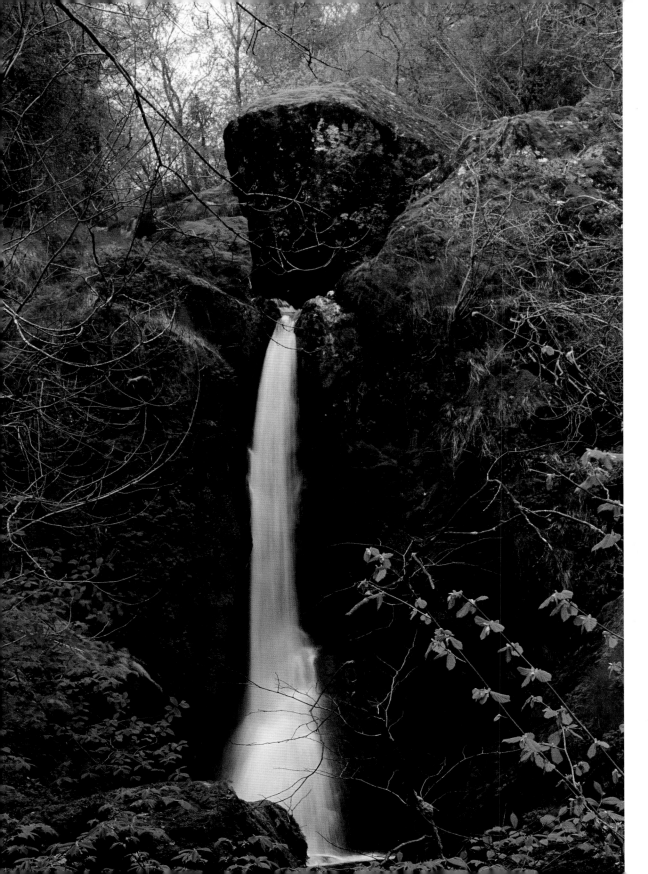

**LEFT:** The waterfall in the Devil's Glen (Q10). There are some wonderful walks in the Devil's Glen. Take a stroll from the car park along the top of the gorge to the waterfall and return by the river, or enjoy the Seamus Heaney Walk, a beautiful woodland path interspersed with lines from the late poet laureate, carved on wooden plaques.

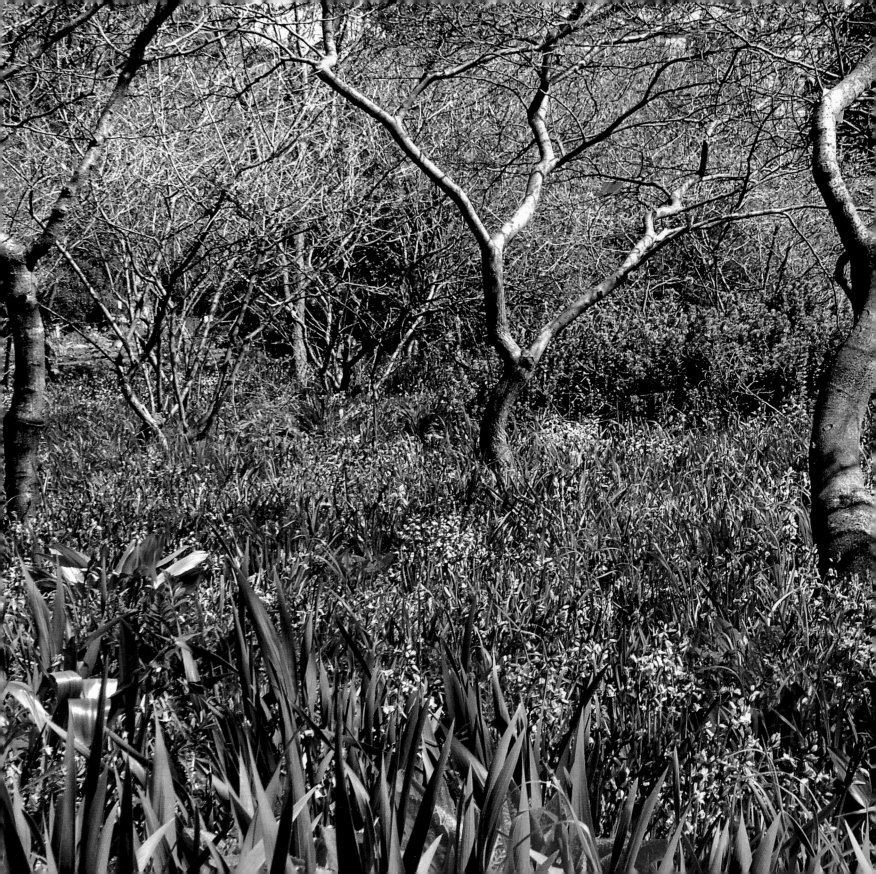

**OPPOSITE:** Bluebells in the Devil's Glen (R10).

**BELOW:** The Vartry River in the Devil's Glen (R10).

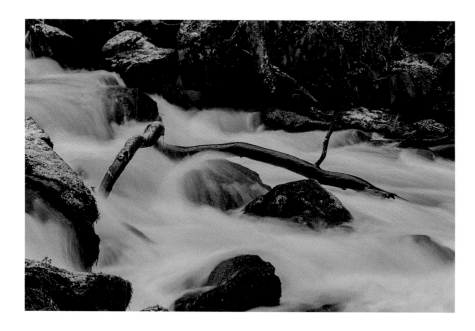

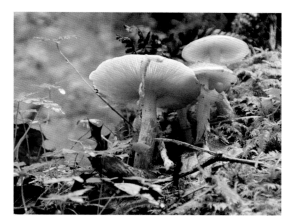

**LEFT:** Cluster of mushrooms in the Devil's Glen (R10).

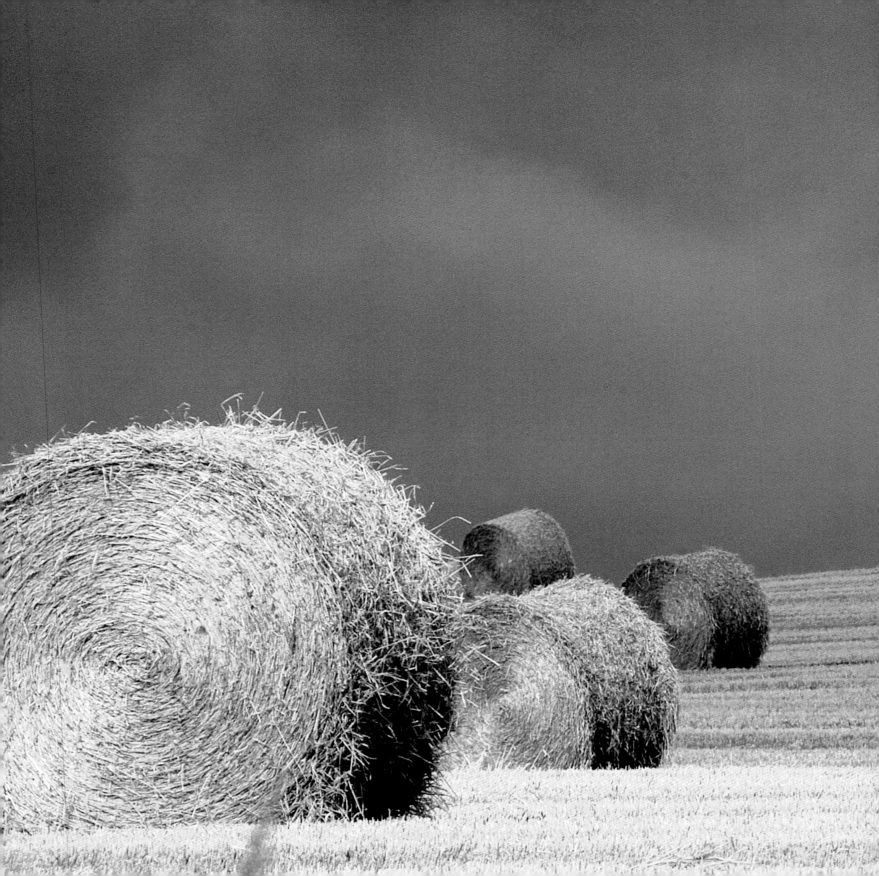

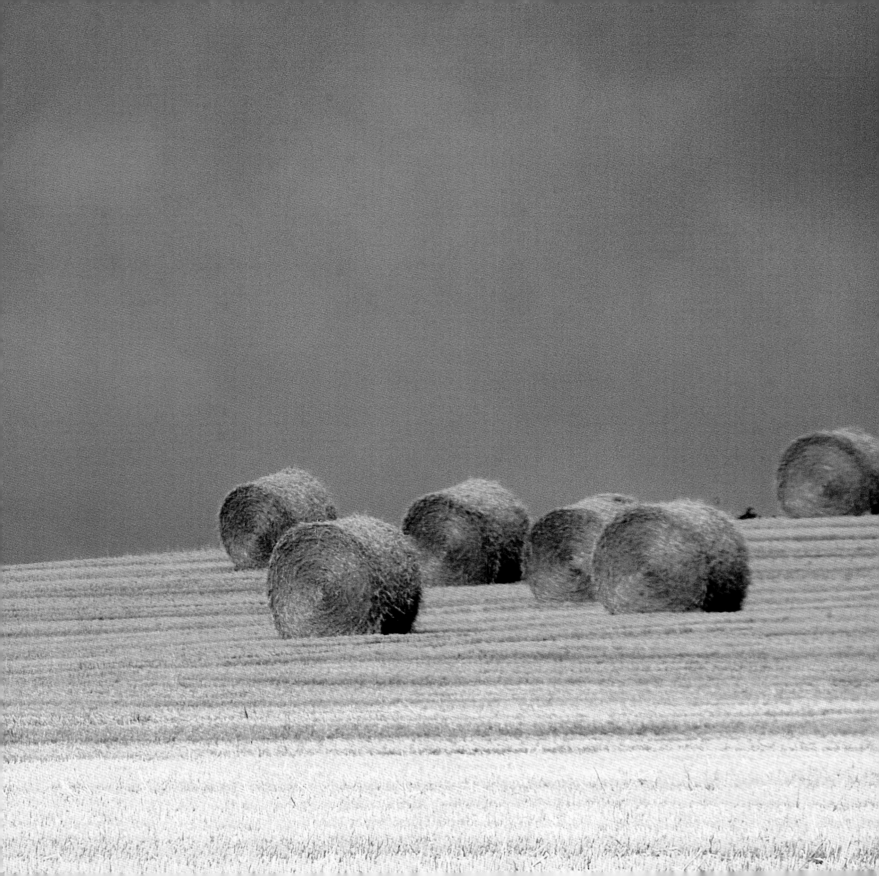

**PREVIOUS PAGES:** Bales of hay near Ashford (S11).

**RIGHT:** The farmers' market in Ashford (S10).

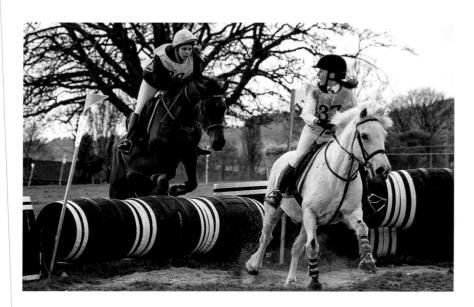

**ABOVE:** Horse trials at Bel Air Equestrian Centre near Ashford (S11).

**OPPOSITE:** Mount Usher Gardens (S11) are laid out on 22 acres along the banks of the Vartry River. Voted Britain and Ireland's number one garden by the BBC, Mount Usher has over 5,000 species of rare and exotic plants.

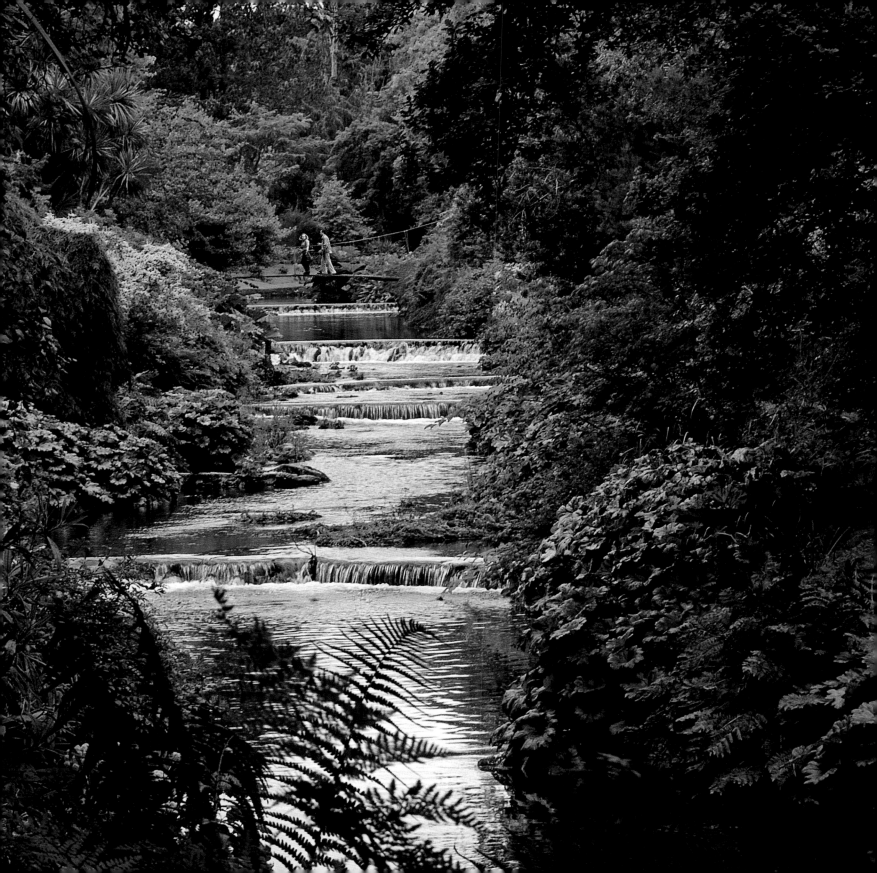

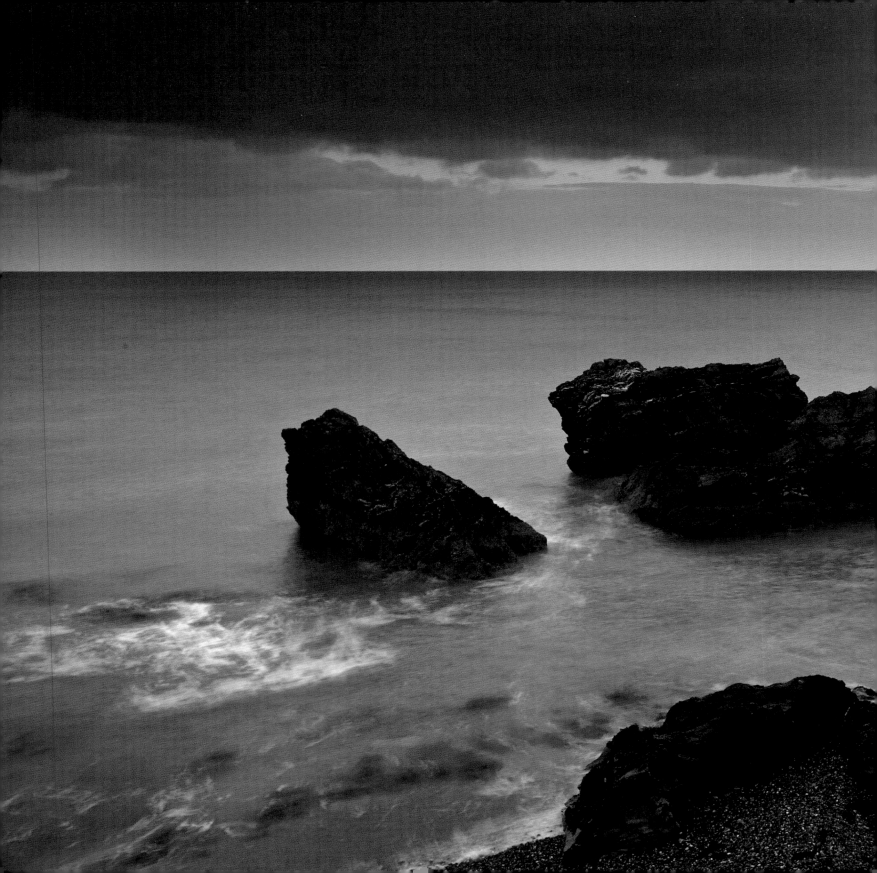

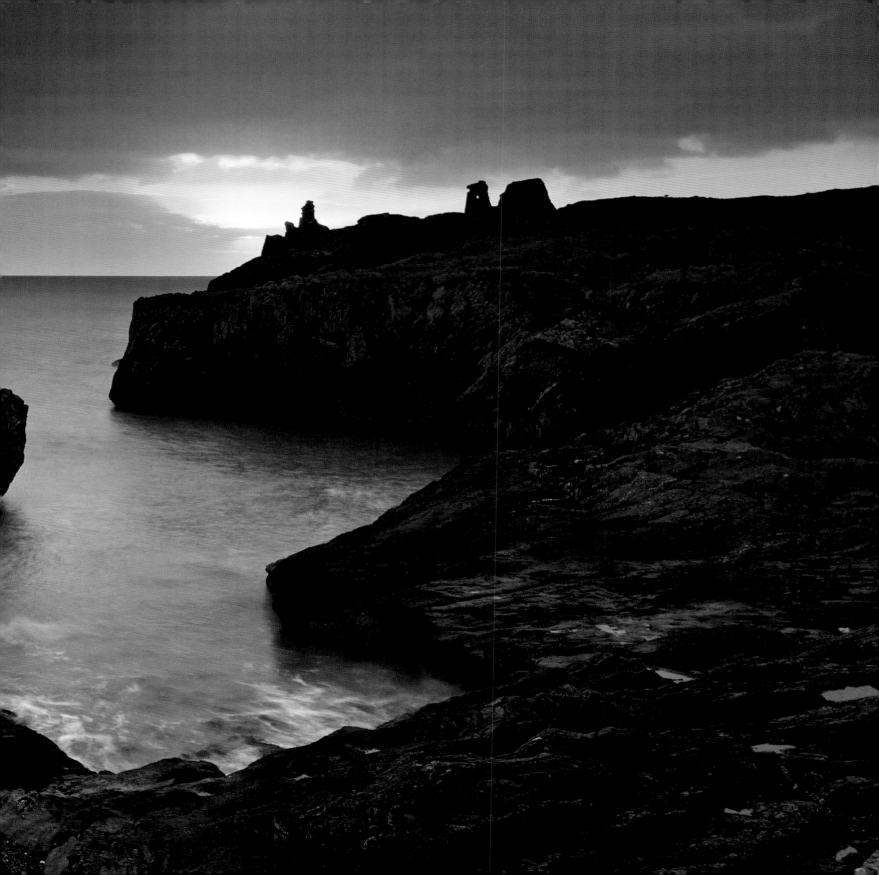

**PREVIOUS PAGES:** Ruins of the Black Castle (U12) at sunrise, near Wicklow town. The Black Castle was built by the Norman Baron Maurice Fitzgerald for protection of the east coast. The castle was constantly under attack from local chieftains, notably those of the O'Byrne and O'Toole clans; in 1301 they succeeded in destroying it.

**BELOW:** The Old Lighthouses on Wicklow Head (V12), viewed from Magheramore. There were originally two lighthouses on Wicklow Head; unfortunately both were inadequate and had to be replaced. The one on the left is now a designated heritage house and is available for short-term rent from the Irish Landmark Trust.

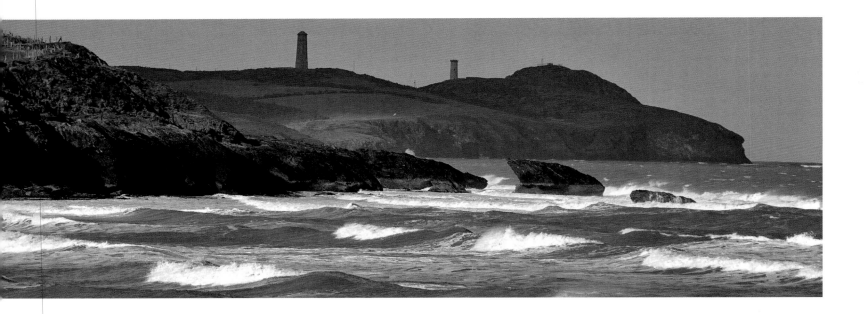

**RIGHT:** Bridge Street, Wicklow town (U12).

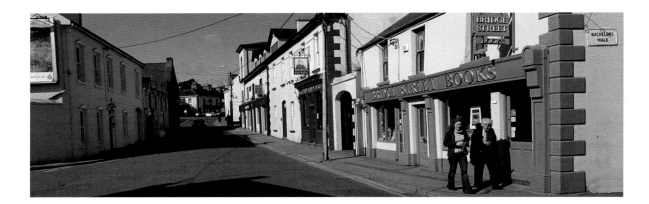

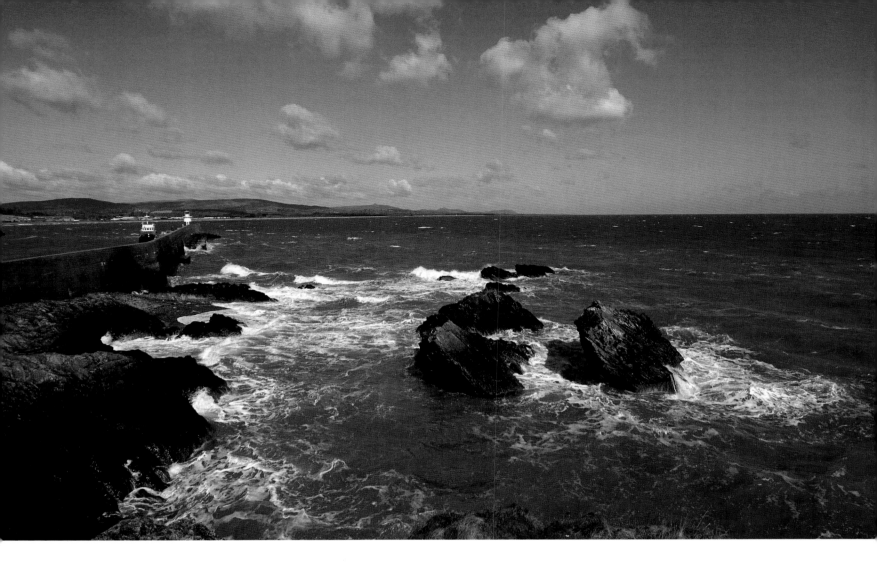

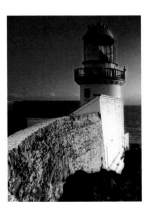

**LEFT:** The new lighthouse on Wicklow Head (V12).

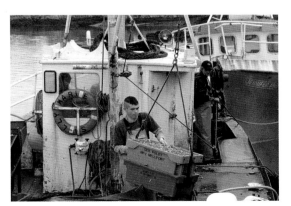

**ABOVE:** Wicklow Harbour (U12).

**LEFT:** Landing the catch at Wicklow Harbour (U12).

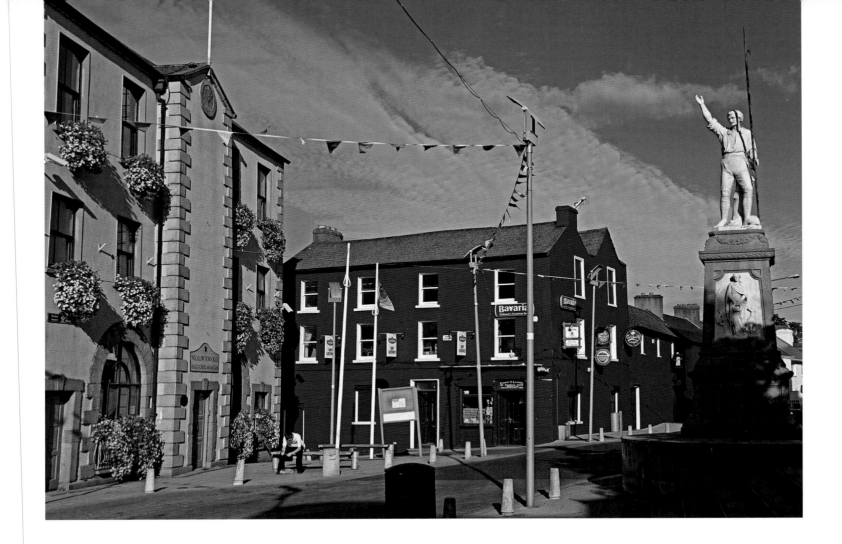

**ABOVE:** The Town Hall, Wicklow (U12).

**RIGHT:** Wicklow Gaol and Museum (U12). Built in 1702, Wicklow Gaol is now a museum. The gaol's history depicts the appalling conditions prisoners endured in the past. The museum records include details of prisoner transportation to America and New South Wales, Australia; there is also information on the 1798 Rebellion, the Great Famine and other events of historical interest.

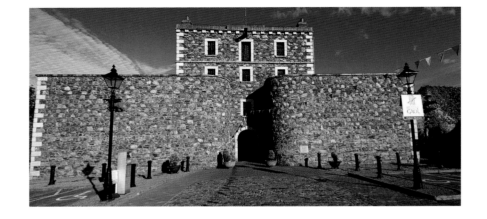

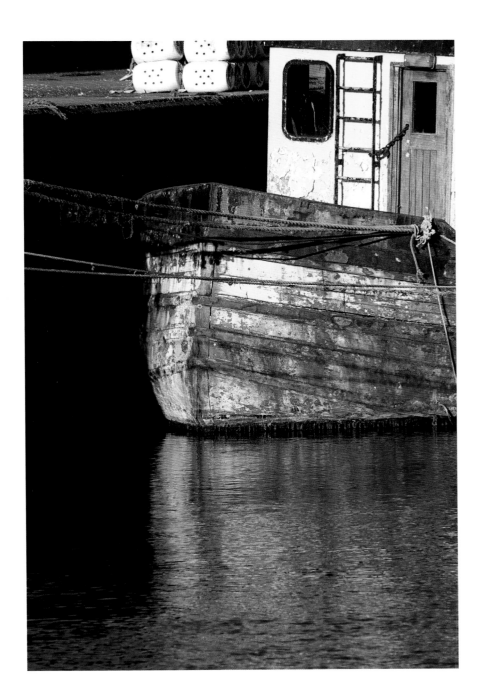

**LEFT:** A rusting fishing boat in Wicklow Harbour (U12).

**BELOW:** The harbour, Wicklow town (U12).

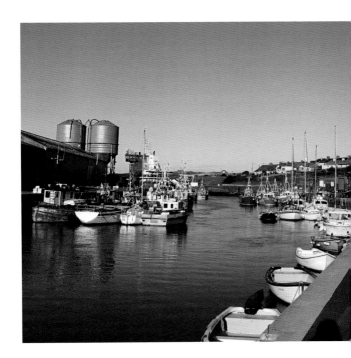

**OPPOSITE:** Father and son on Magheramore Beach (U14).

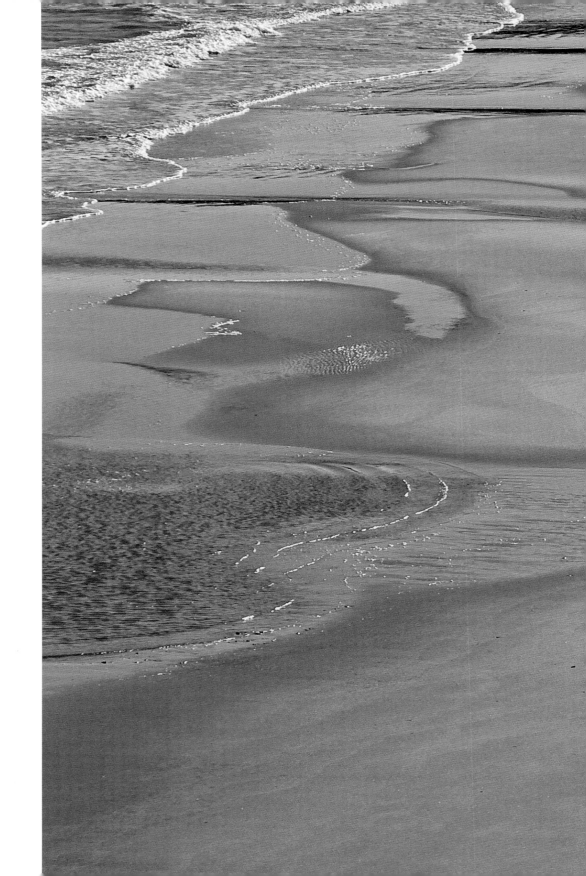

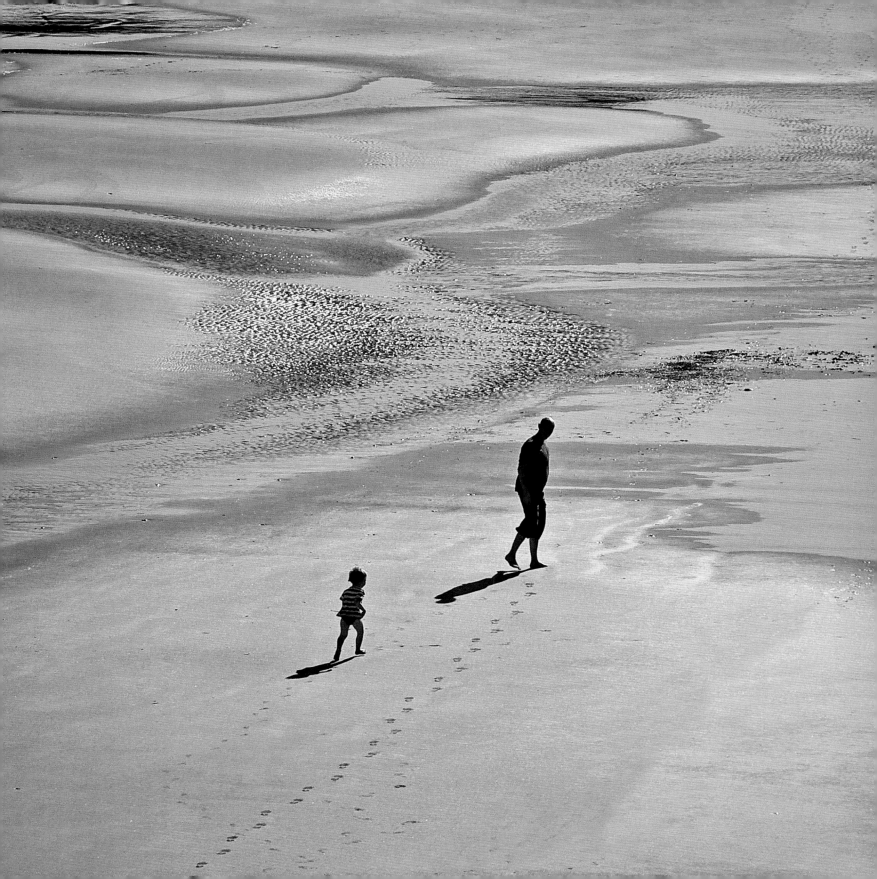

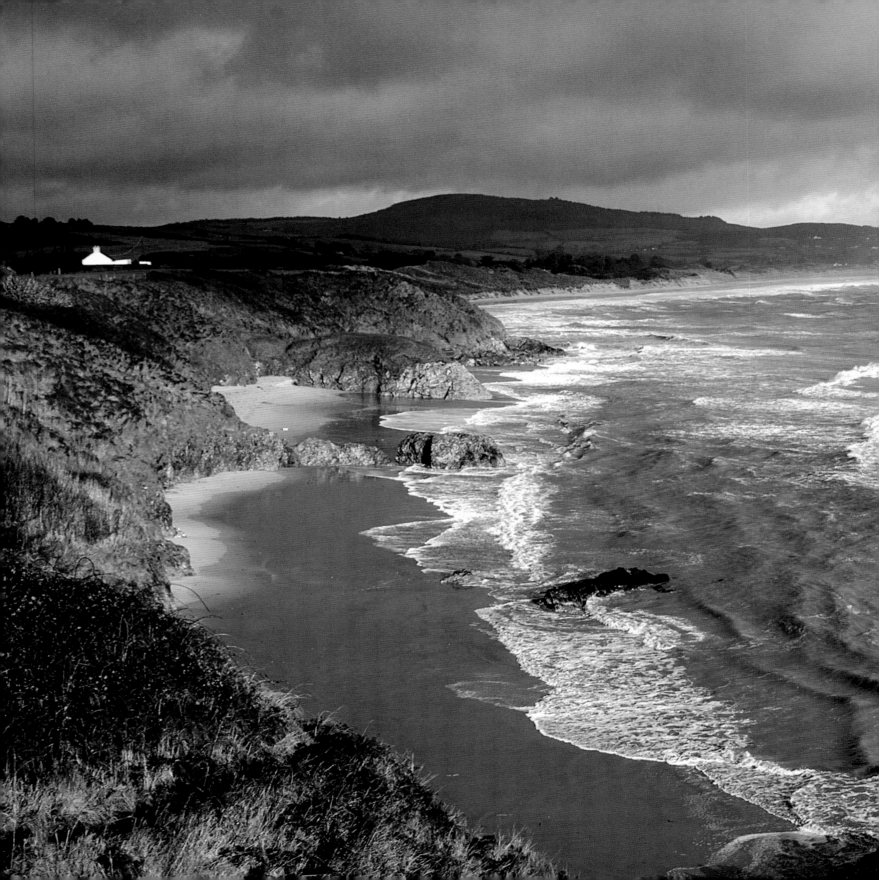

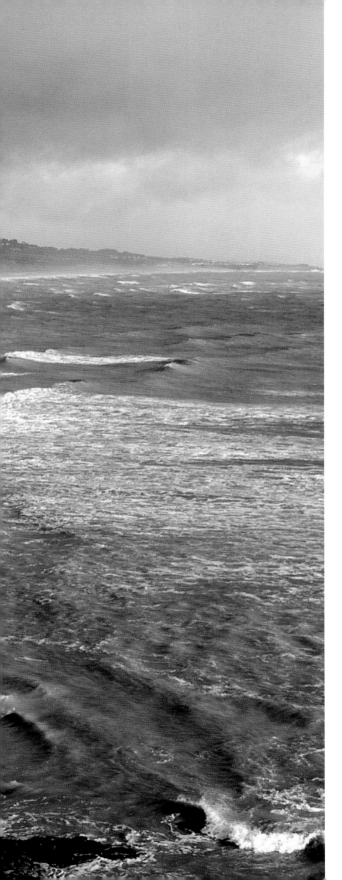

**OPPOSITE:** The 3.2km beach at Brittas Bay (U16).

**BELOW:** Sand dunes at Dunbrony, south of Mizen Head (T17).

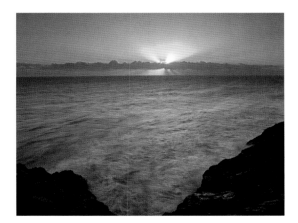

**LEFT:** Sunrise on the Irish Sea, from Wicklow Head (V12). Wicklow Head is the most easterly point of Ireland. The sun rises earlier here than anywhere else in the country.

**RIGHT:** Golf at the European Club south of Brittas Bay (T17).

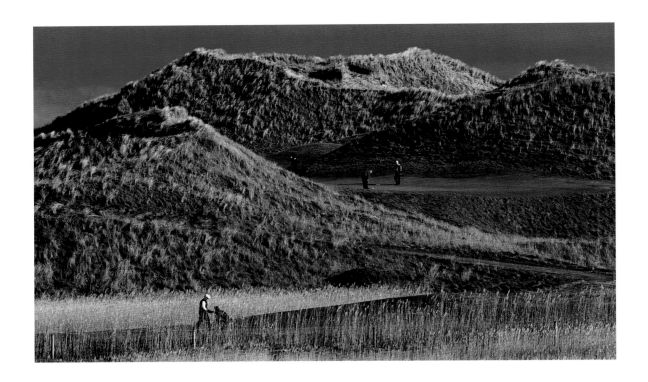

**RIGHT:** A quiet walk on Magherabeg Beach (U14).

**OPPOSITE:** Surfer at Magheramore Beach (U14), one of the best surfing beaches on the east coast.

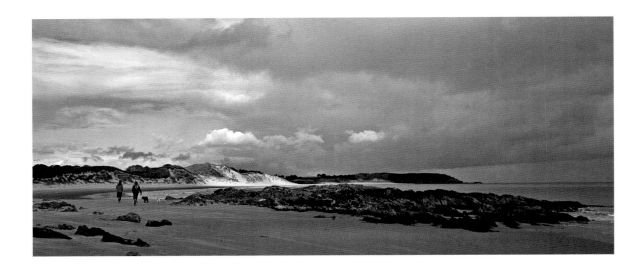

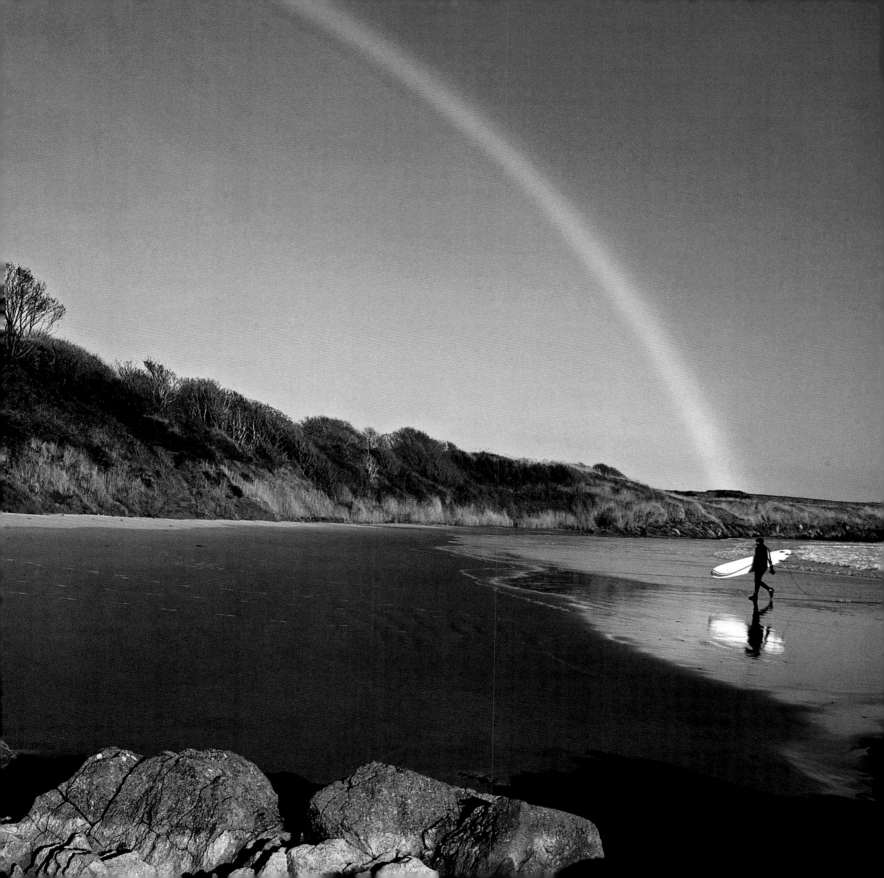

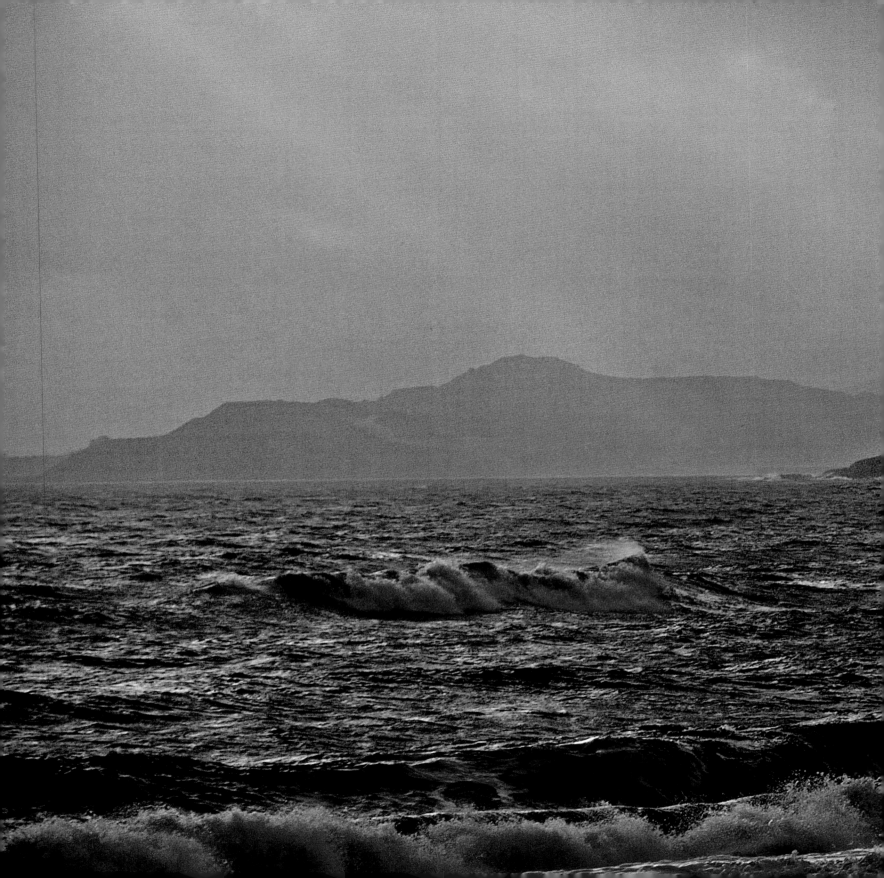

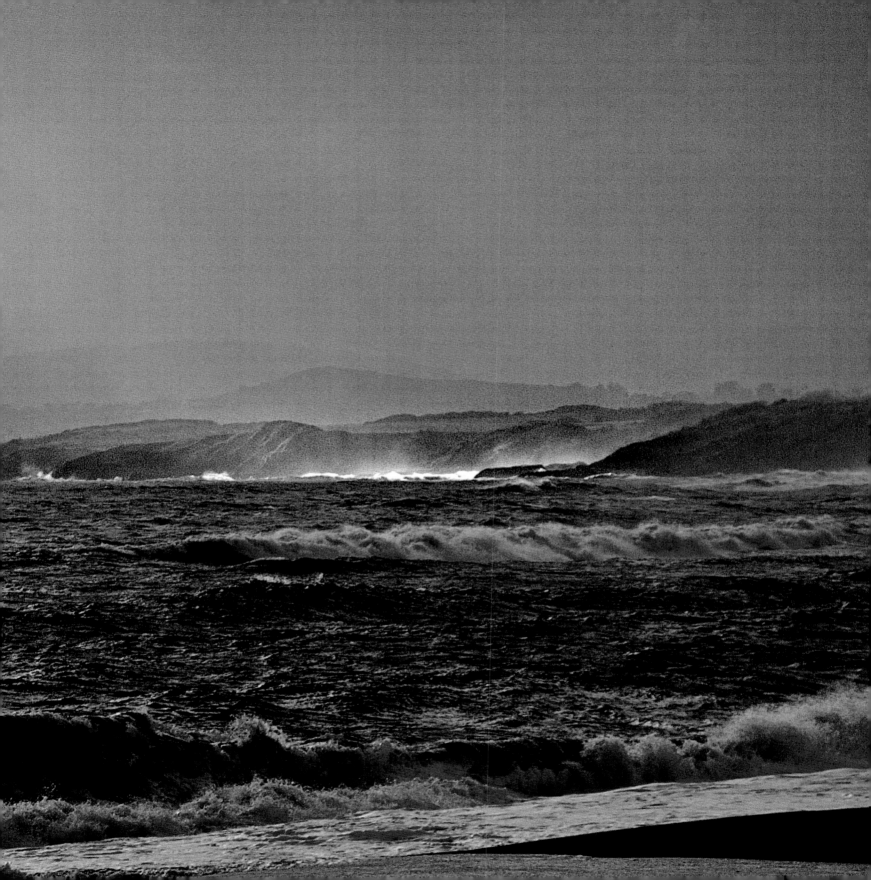

**PREVIOUS PAGES:**
A ray of sunlight catches a headland north of Arklow (T18).

**RIGHT:** The sea at Pennycomequick Bridge near Arklow (T18).

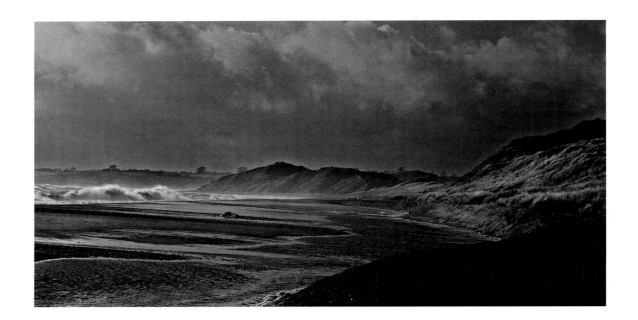

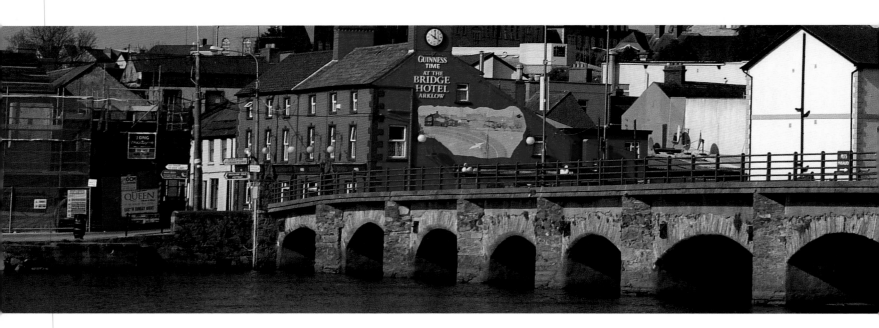

**LEFT:** Main Street, Arklow, before the rush hour (R20).

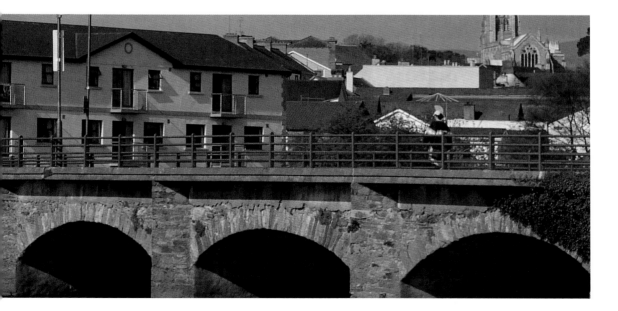

**LEFT:** The bridge over the Avoca River in Arklow (R20).

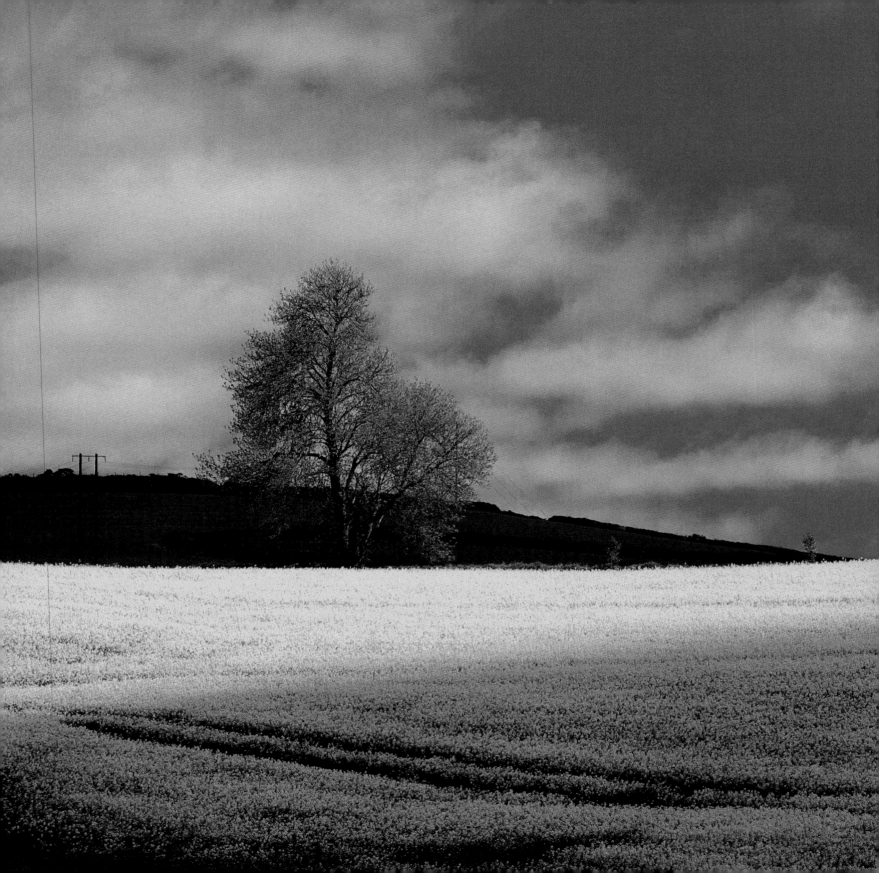

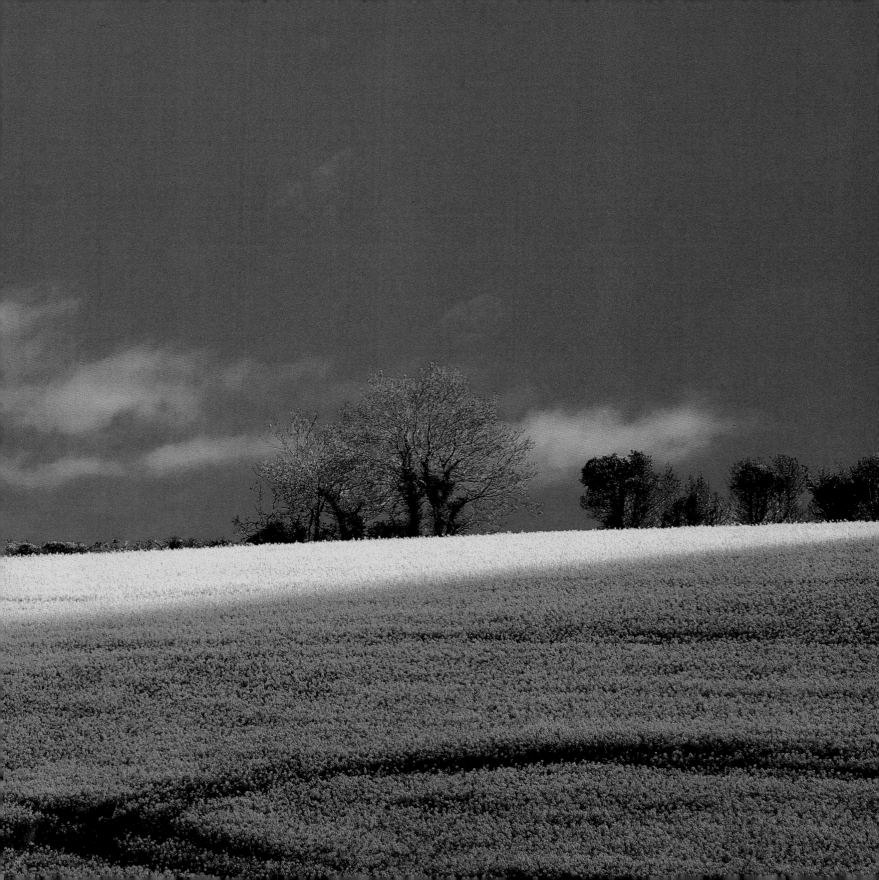

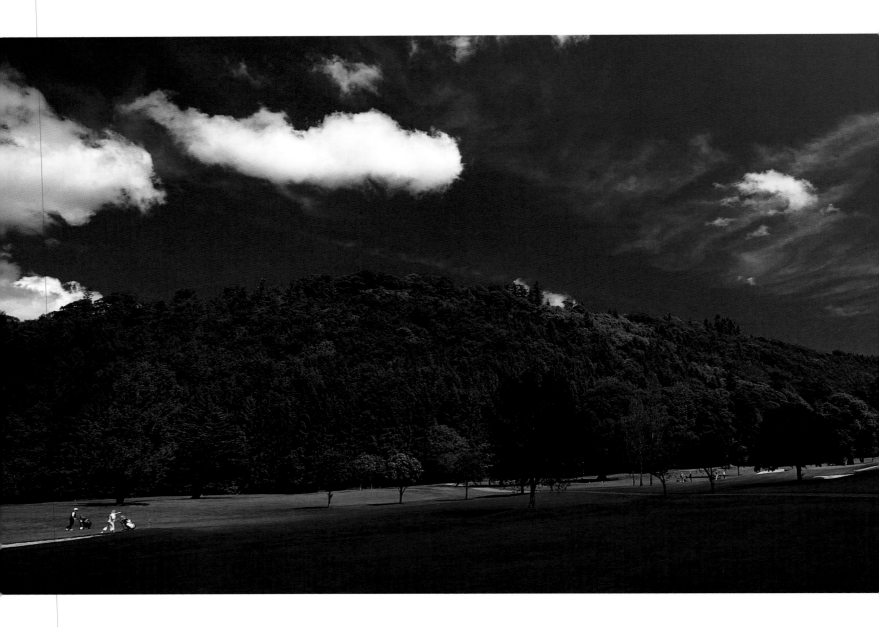

**PREVIOUS PAGES:** Field of rapeseed near Avoca (Q16). The fields between Redcross and Avoca produce crops of golden rapeseed during the month of May, accentuating the rolling hills.

**ABOVE:** Golf at Woodenbridge Golf Club (P18).

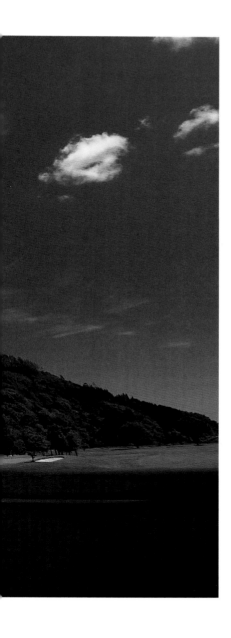

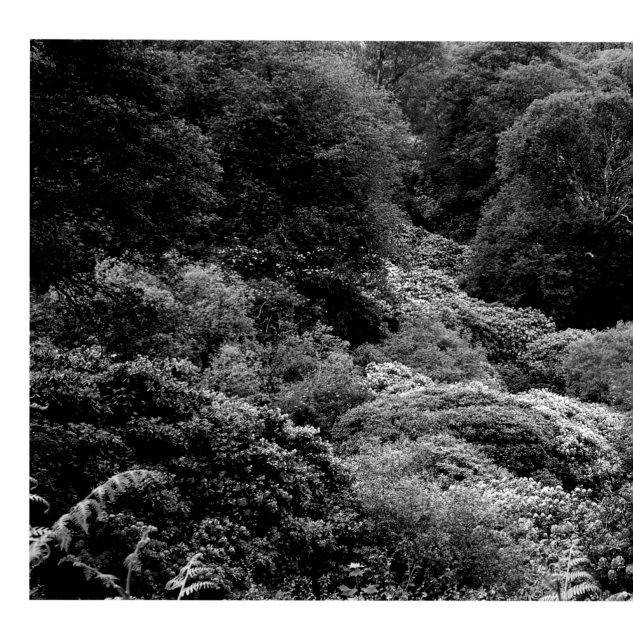

**ABOVE:** Rhododendron in bloom at
Glen Art near Woodenbridge (P18).

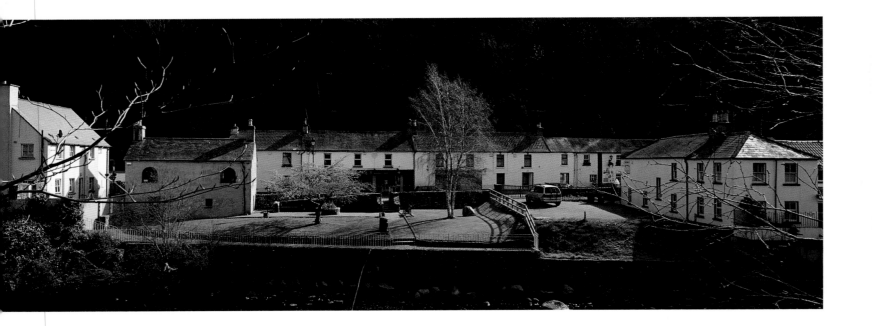

**ABOVE:** The village of Avoca (P17). The BBC series *Ballykissangel* was filmed here.

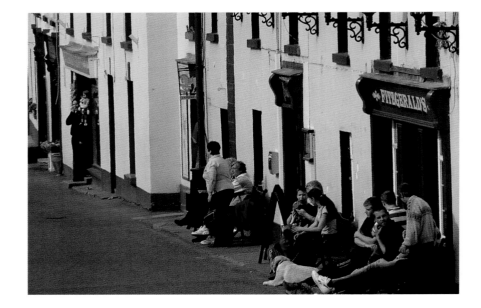

**RIGHT:** Enjoying a beer outside the pub in Avoca (P17).

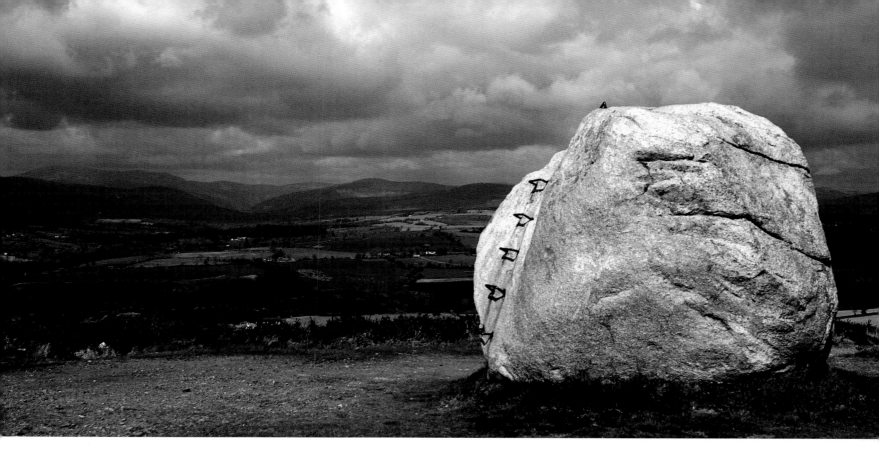

**LEFT:** Avoca Copper Mines (P16). Copper mining began in the Avoca River valley around 1720 and continued intermittently until 1982.

**ABOVE:** The Motte Stone in Avoca (P16). This huge, white granite boulder is known locally as 'Finn MacCumhail's hurling ball'. Local legends claim it would answer questions put to it, and that it sometimes has a halo around it as though emitting light or energy. Today the Motte Stone has huge metal bars in it to provide a ladder to the top.

**OPPOSITE:** Lugnaquilla, Wicklow's highest mountain (932m) taken from Aghavannagh (J15).

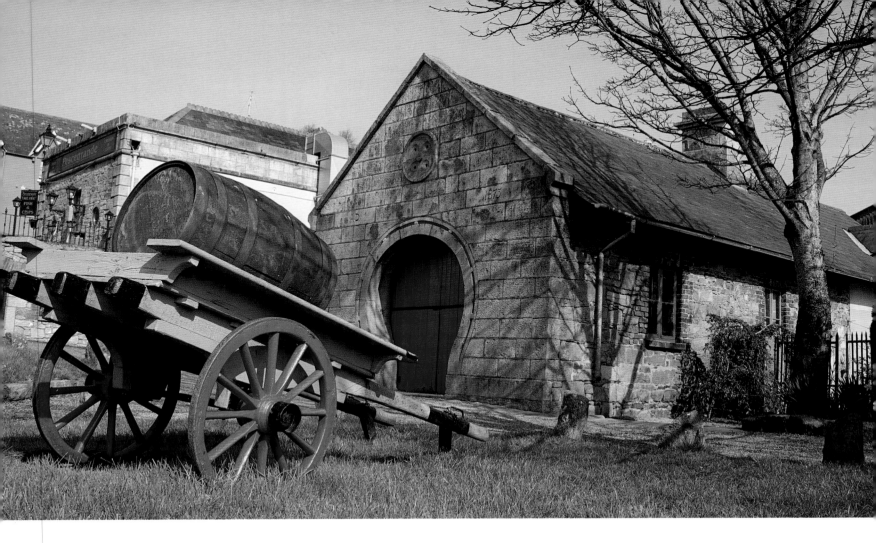

**ABOVE:** The old forge in Aughrim (M17). Aughrim has won the Irish Tidy Towns Overall Award numerous times.

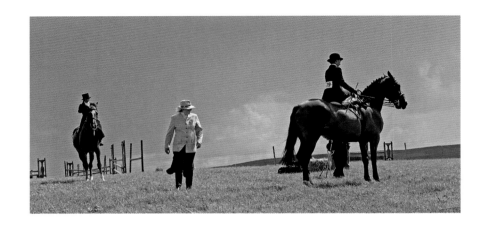

**RIGHT:** Judging the side-saddle at Tinahely Show (J20).

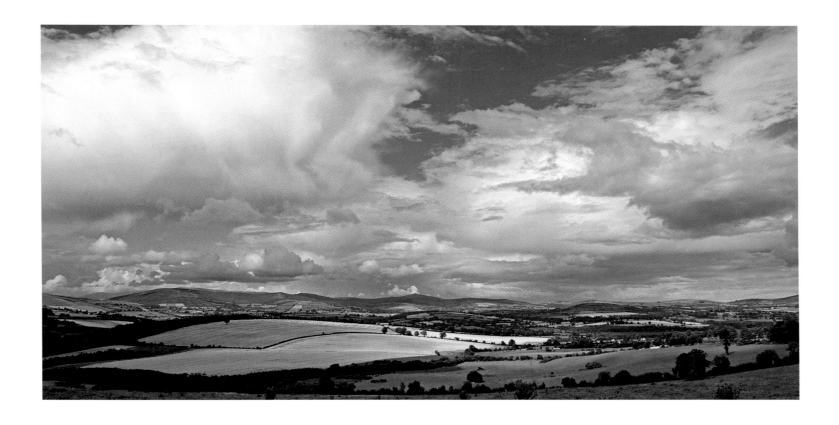

**ABOVE:** The view from Deputy's Pass, Tinahely (K20).

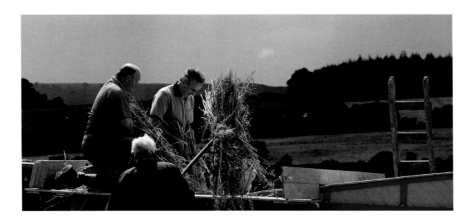

**LEFT:** Threshing in Tinahely (J20).

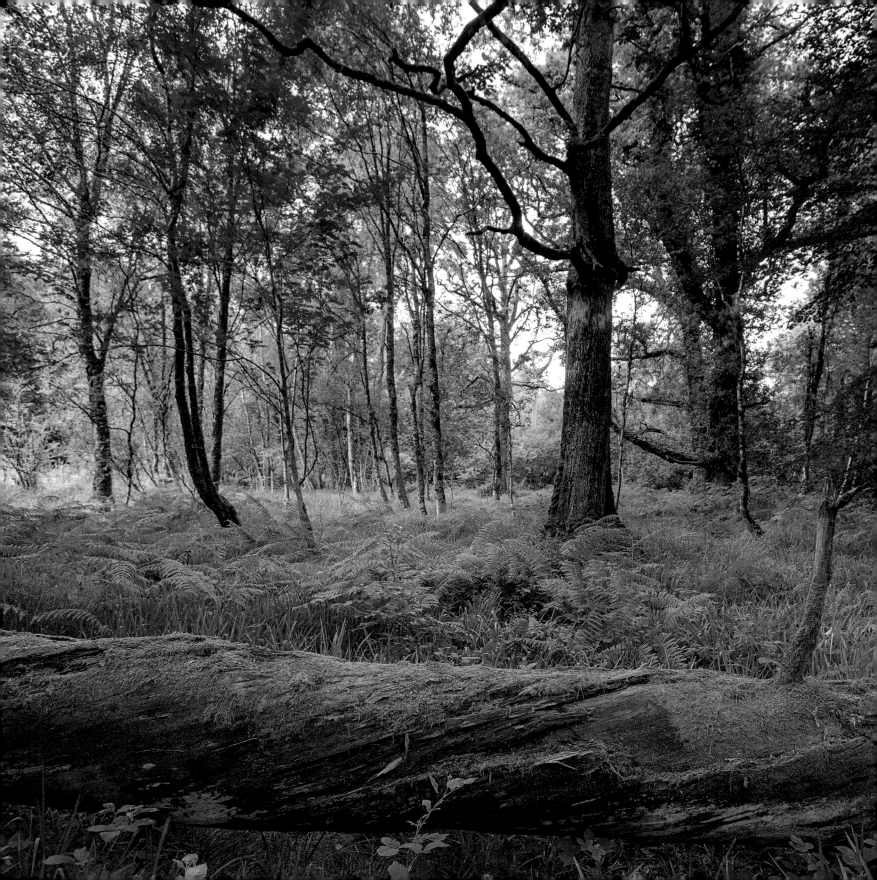

**OPPOSITE:** The great Forest of Tomnafinnoge Woods (I21) at Tinahely is the last surviving fragment of the great oak woods of Shillelagh which once clothed the hills and valleys of south Wicklow. As early as 1444 these woods supplied timber for the construction of King's College, Cambridge, and later for Westminster Abbey, London and St Patrick's Cathedral and Trinity College in Dublin. In 1634, the woods were estimated to cover several thousand acres, but from then on they were heavily exploited, especially for shipbuilding. The remaining fragment covers about 100 acres and is now a forest park, open to the public.

A vintage tractor at the Tinahely Show (J20), which is held on the August bank holiday Monday every year.

Spring in the park, Shillelagh (H22).

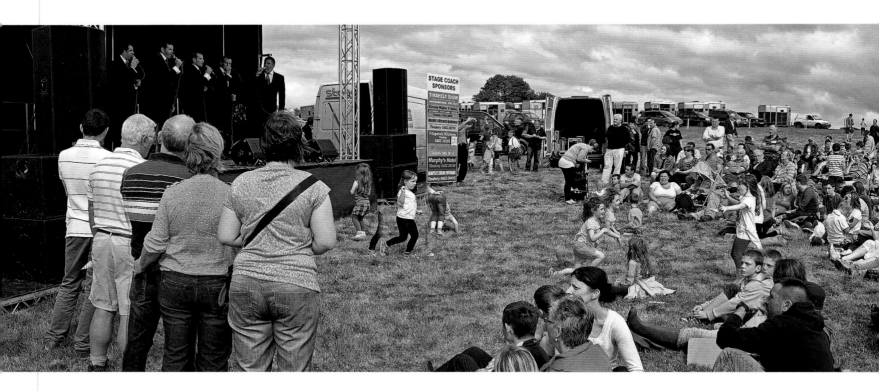

**RIGHT:** A shopfront in Carnew (I24).

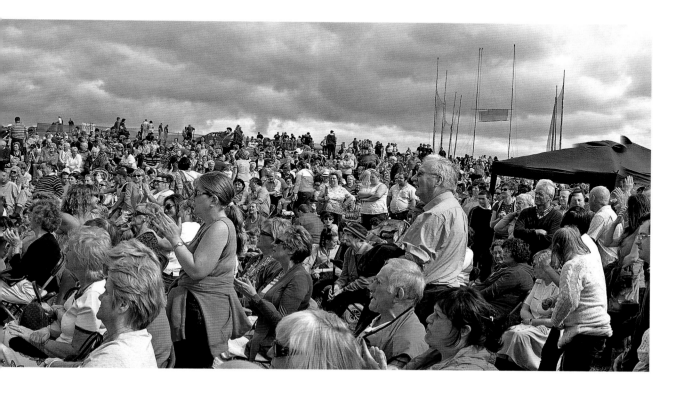

**LEFT:** The Willoughby Brothers entertaining the crowd at the Tinahely Show (J20).

**RIGHT:** Dog trials, Tinahely (J20).

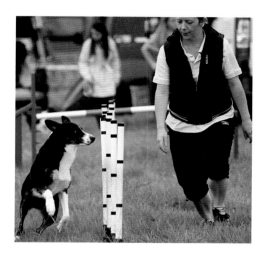

**LEFT:** Cottages on the main street of Carnew (I24).

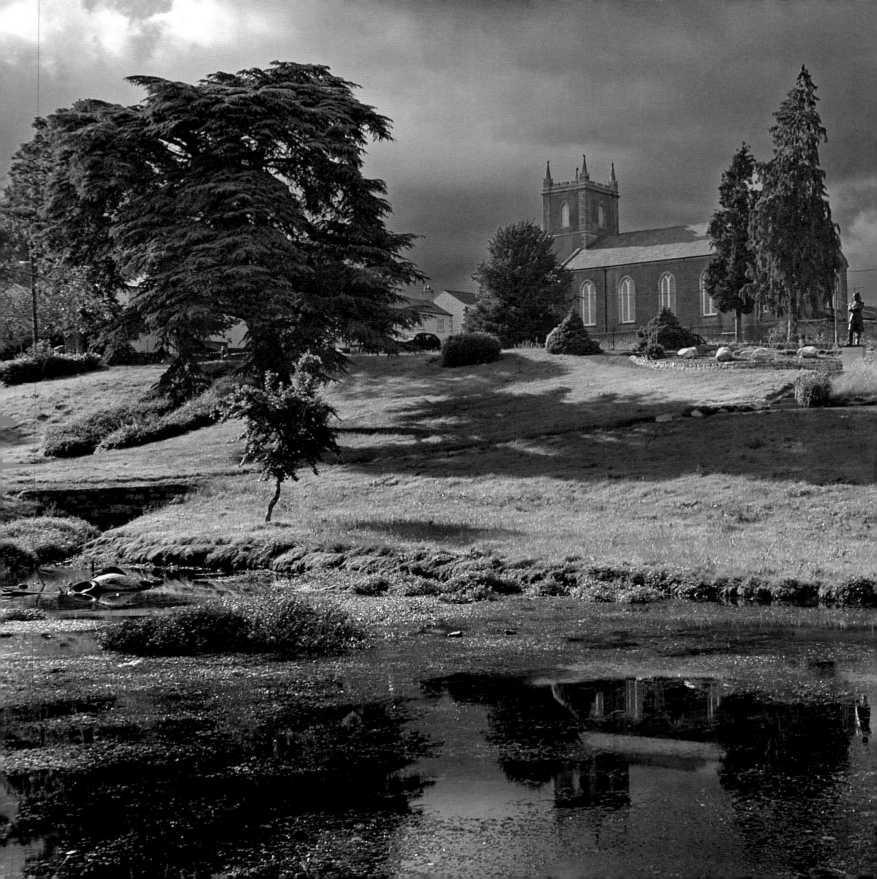

**OPPOSITE:** A thunderstorm approaching the Parnell National Memorial Park in Rathdrum (P14).

**RIGHT:** The Rhododendron Walk at Kilmacurragh Arboretum (R14). The arboretum at Kilmacurragh, which is managed by the National Botanic Gardens, has a wonderful collection of exotic trees and shrubs.

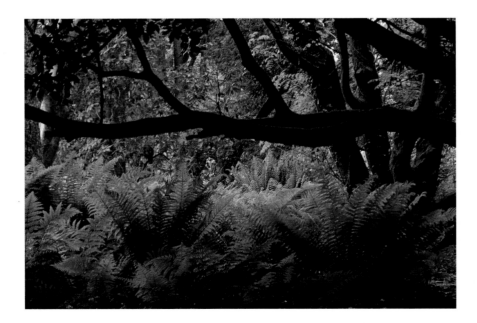

**ABOVE:** Ferns in Kilmacurragh (R14).

**OPPOSITE:** Rhododendron petals in Kilmacurragh (R14).

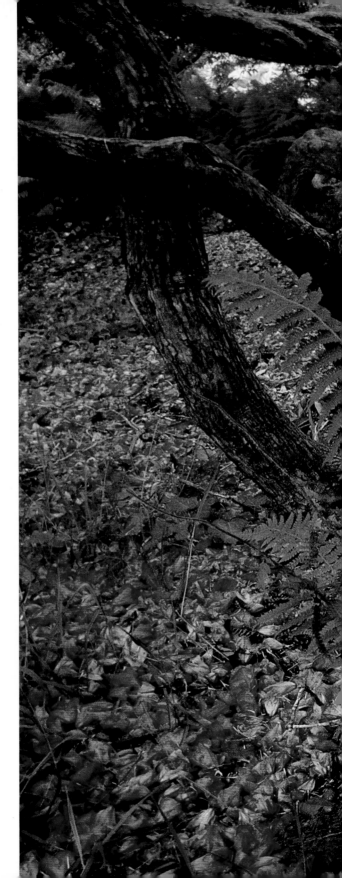

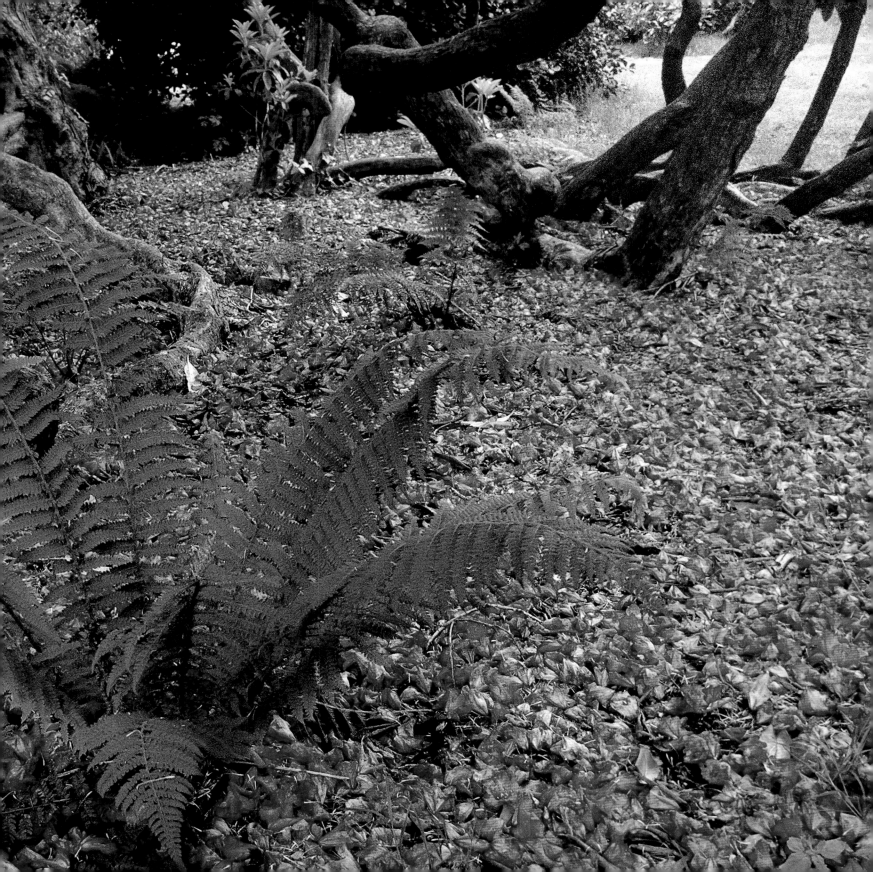

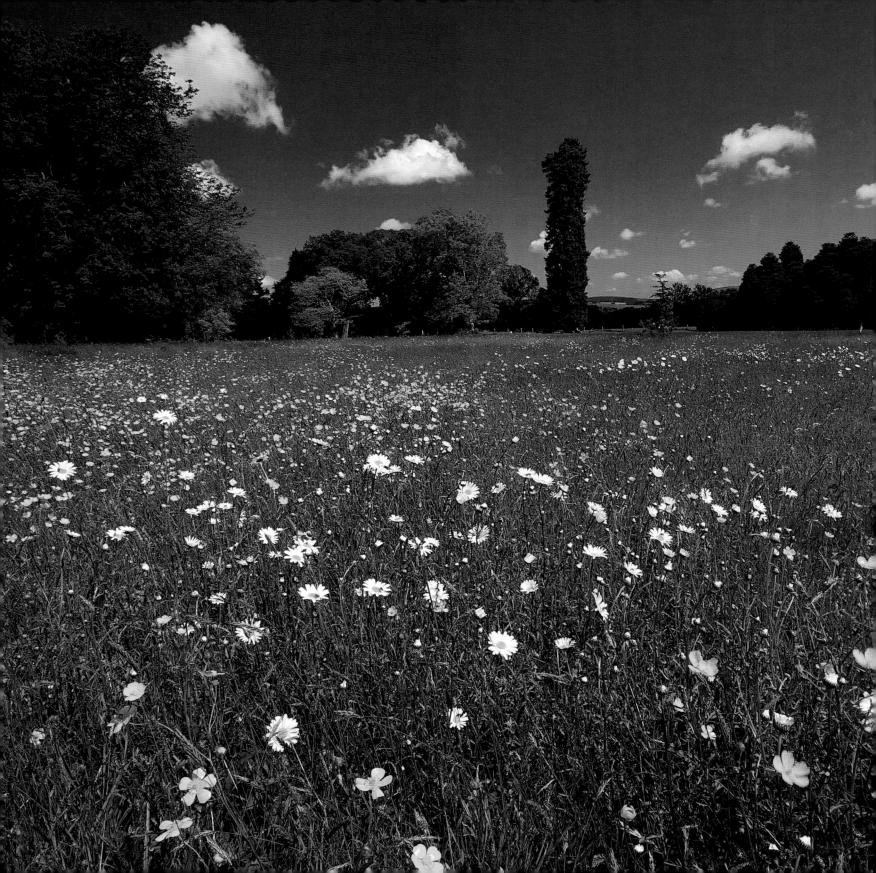

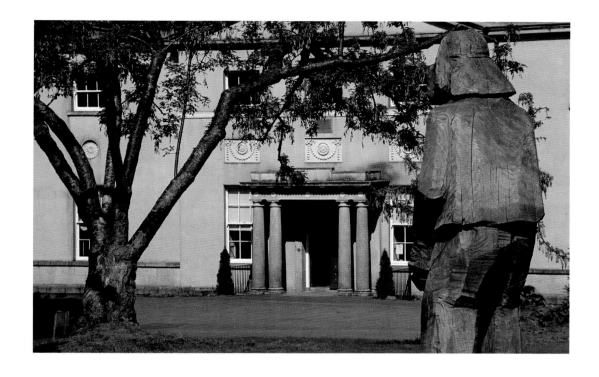

**LEFT:** Statue of Charles Stewart Parnell and Parnell's house in Avondale (P15).

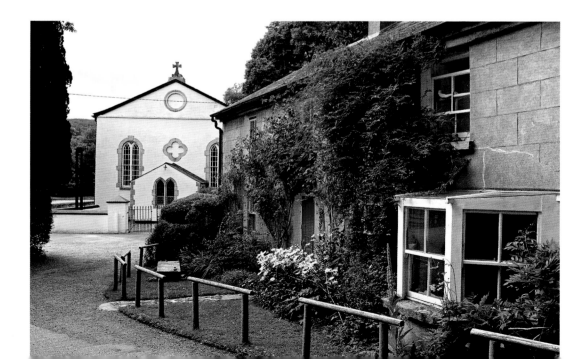

**LEFT:** Cottage and church at Clara Vale (O12).

**OPPOSITE:** A preserved meadow at Kilmacurragh (R14).

**RIGHT:** The bridge and church at Clara Vale (O12).

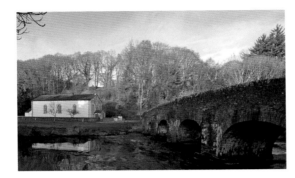

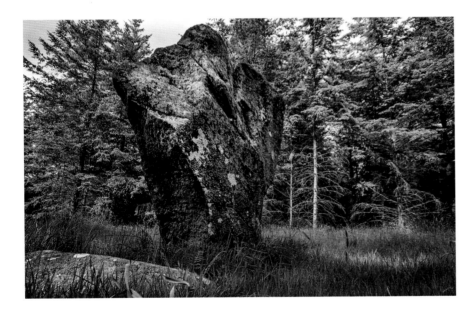

**ABOVE:** Knickeen Ogham Stone near the Glen of Imaal (H12). The marks on the edges of this standing stone are characters from an alphabet which was used in fifth-century Ireland. Known as ogham, the 25-letter alphabet was supposedly inspired by Ogma, the god of eloquence.

**OPPOSITE:** Derrybawn Bridge on the Glendasan River near Laragh (N11). This fine stone bridge was built *c.* 1700.

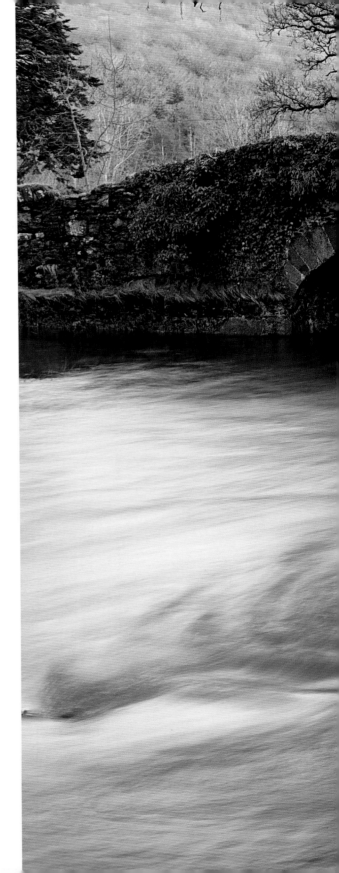

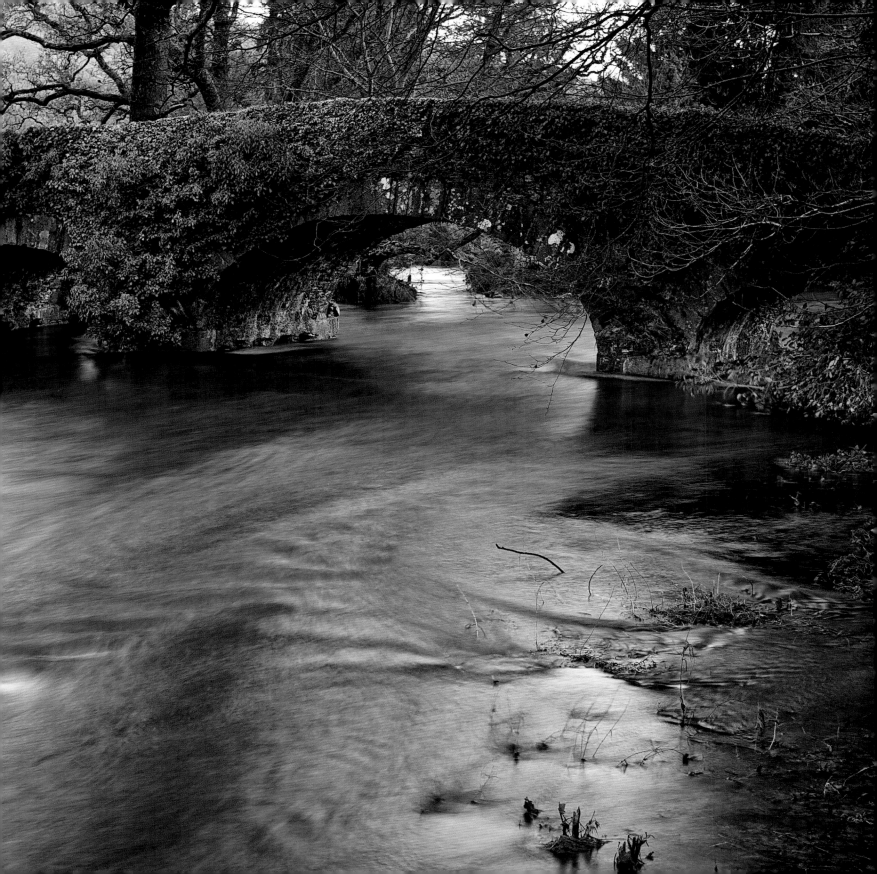

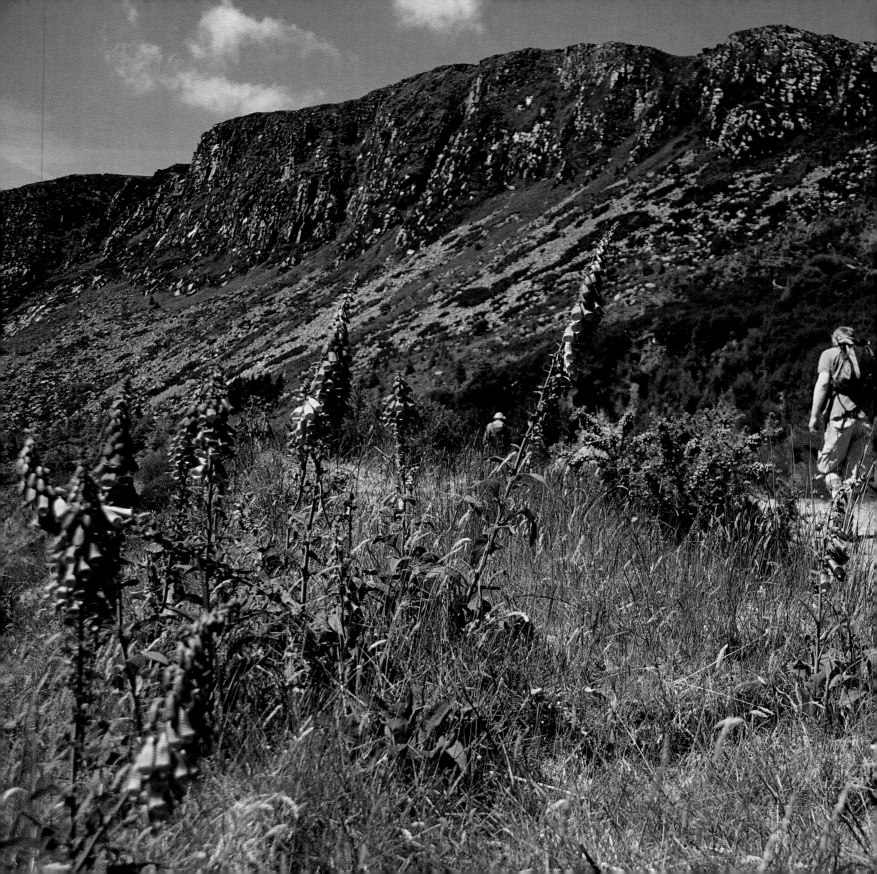

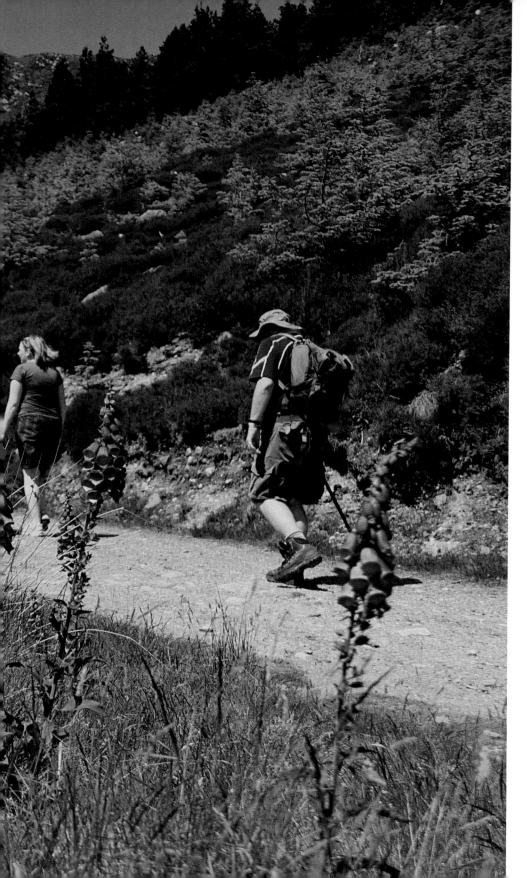

**OPPOSITE:** Hiking in the Fraughan Rock Glen, Glenmalure (J12).

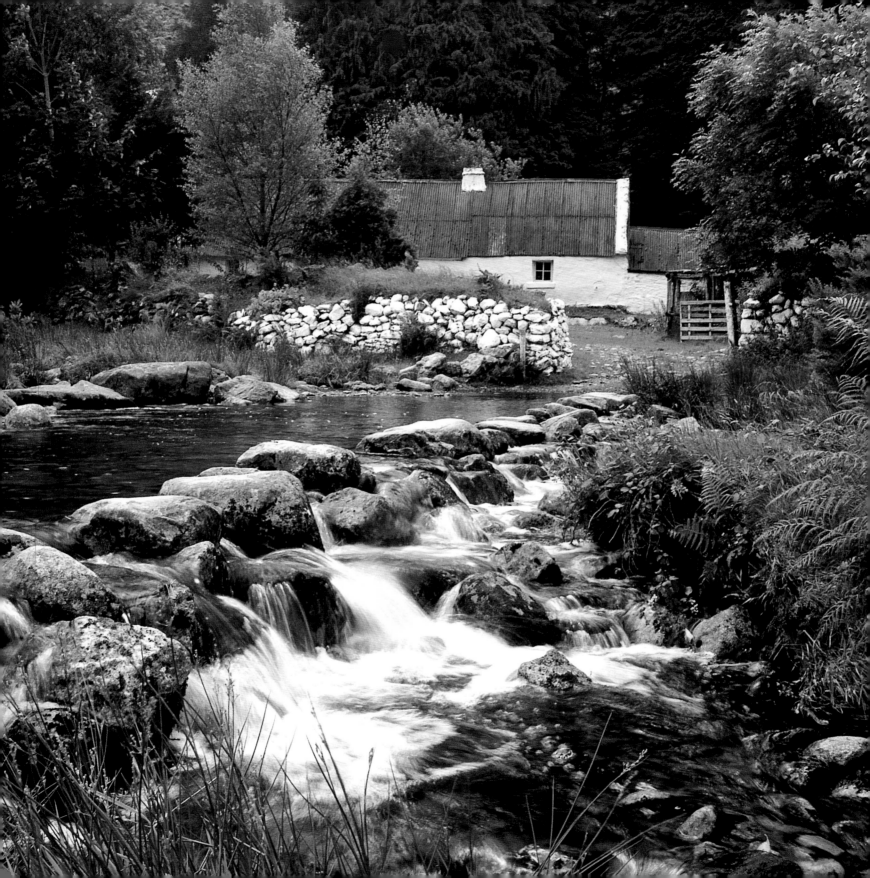

**LEFT:** The Shay Elliott memorial on the road between Laragh and Glenmalure (J12). Shay Elliott was the first Irishman to wear the yellow jersey in the Tour de France (1963).

**LEFT:** The Fraughan Rock Glen, Glenmalure (J12).

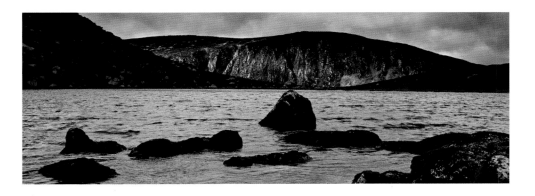

**LEFT:** Arts Lough and the Fraughan Rock Glen (J12) in Glenmalure.

**OPPOSITE:** A cottage in Glenmalure (L12).

**OPPOSITE:** Glendalough's Upper Lake at sunrise (M11)

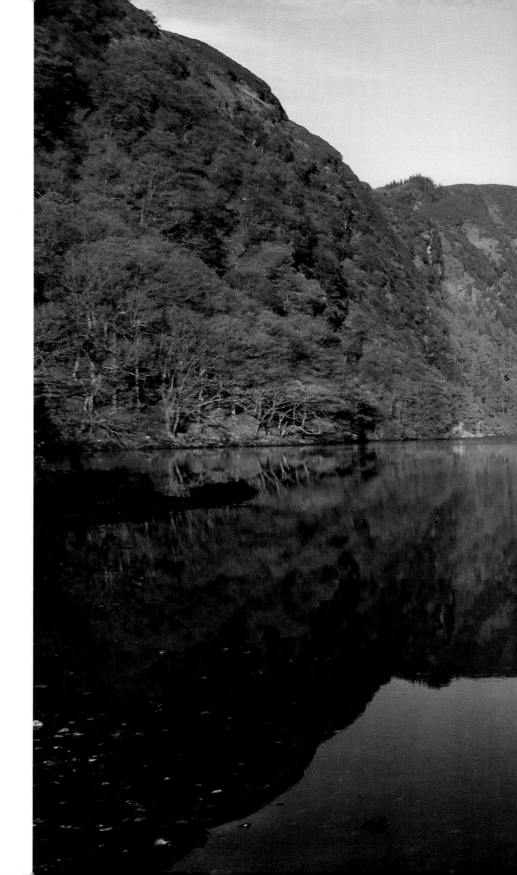

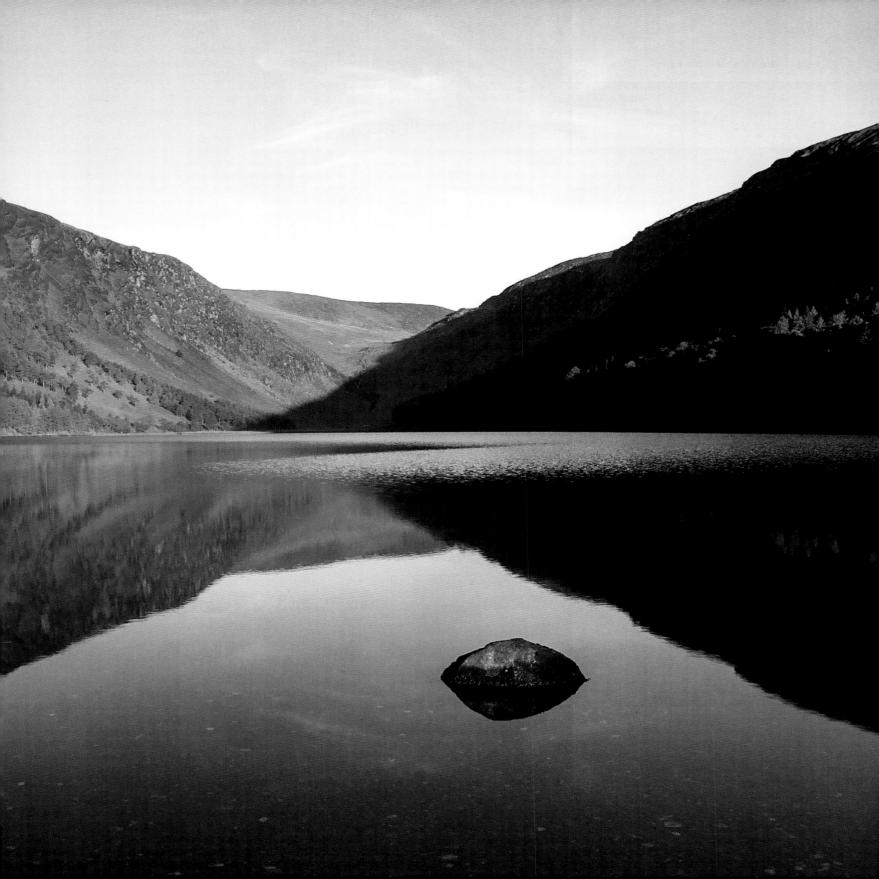

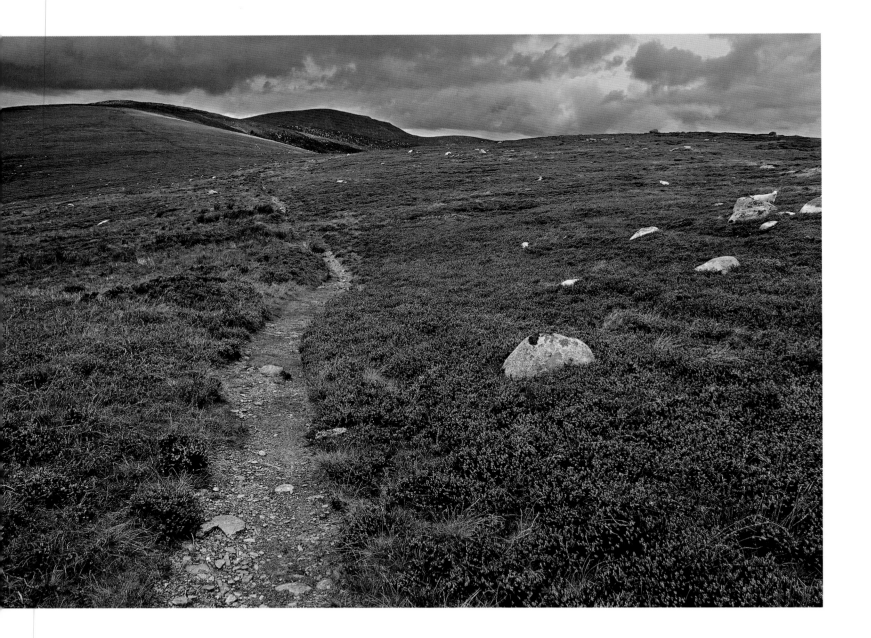

A track over the Brockaghs (M10).

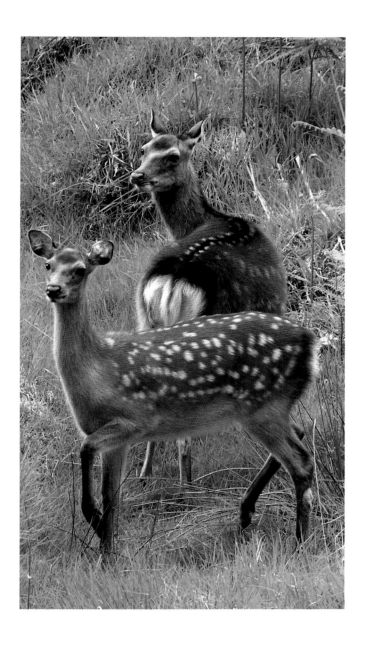

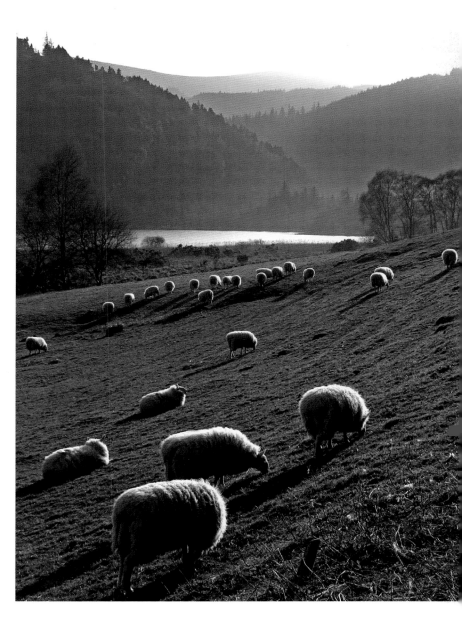

Sika deer in Glendasan (M10).

Sheep at the Lower Lake, Glendalough (M11).

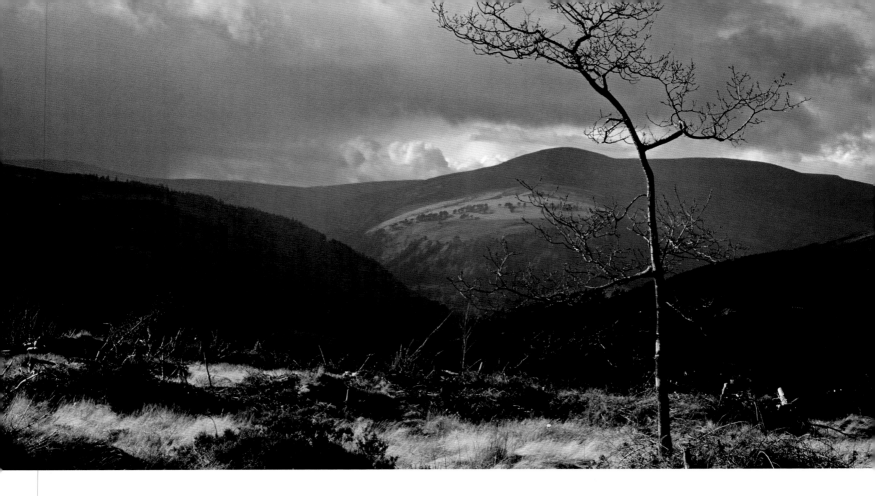

**ABOVE:** Camaderry Mountain seen from Trooperstown Hill (O11).

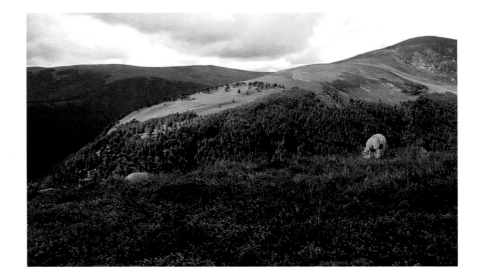

**RIGHT:** Camaderry seen from the Brockaghs (M10).

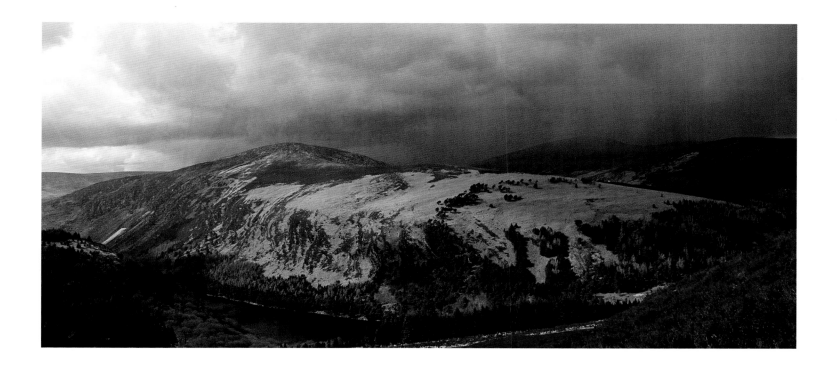

**ABOVE:** Camaderry Mountain in Glendalough (L10).

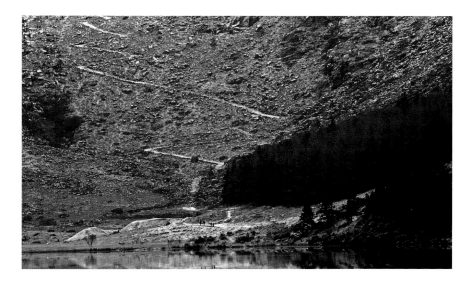

**LEFT:** The Miners' Track in Glenealo Valley above Glendalough (L11).

**RIGHT:** Poulanass Waterfall, Glendalough (M11).

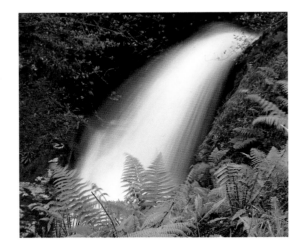

**BELOW:** A morning walk on the shore of the Upper Lake in Glendalough (M11).

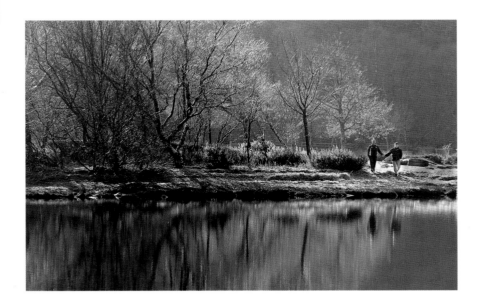

**OPPOSITE:** St Kevin's Pool on St Kevin's Way near the Wicklow Gap (J8). The Way follows a medieval pilgrim route from Hollywood in west Wicklow to Glendalough, which was used by pilgrims from the west and the midlands.

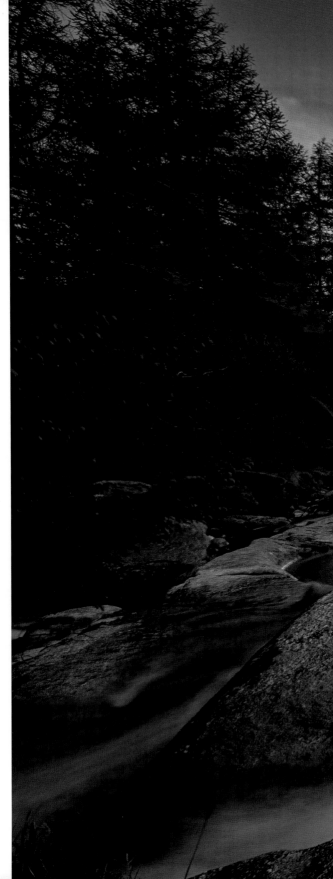

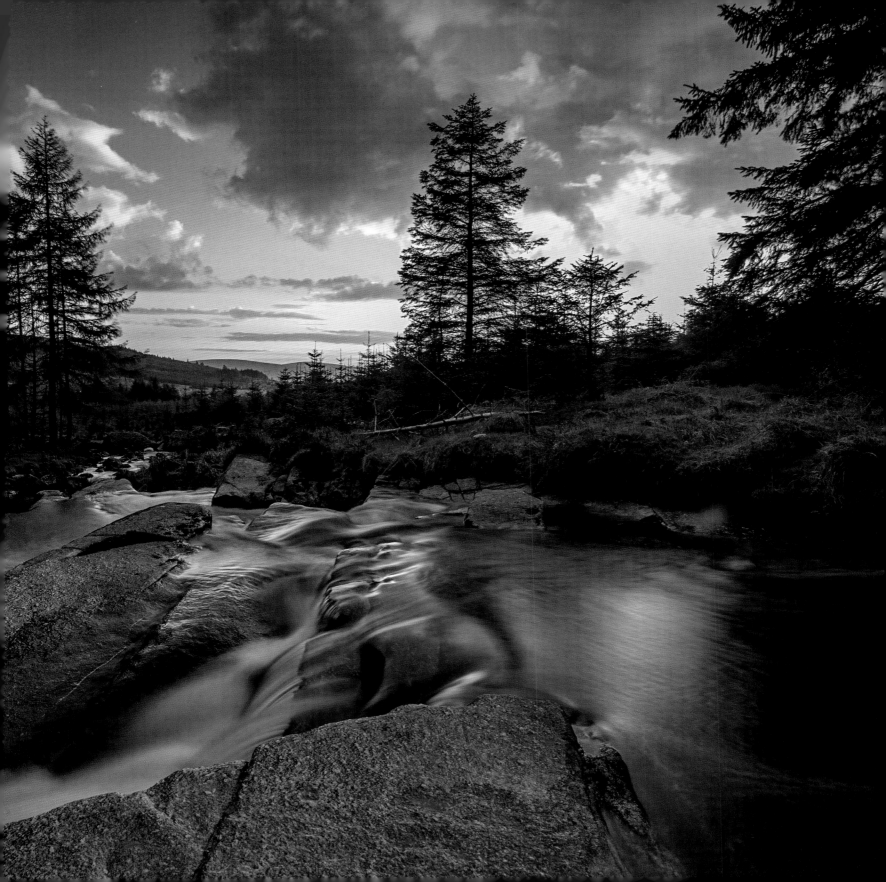

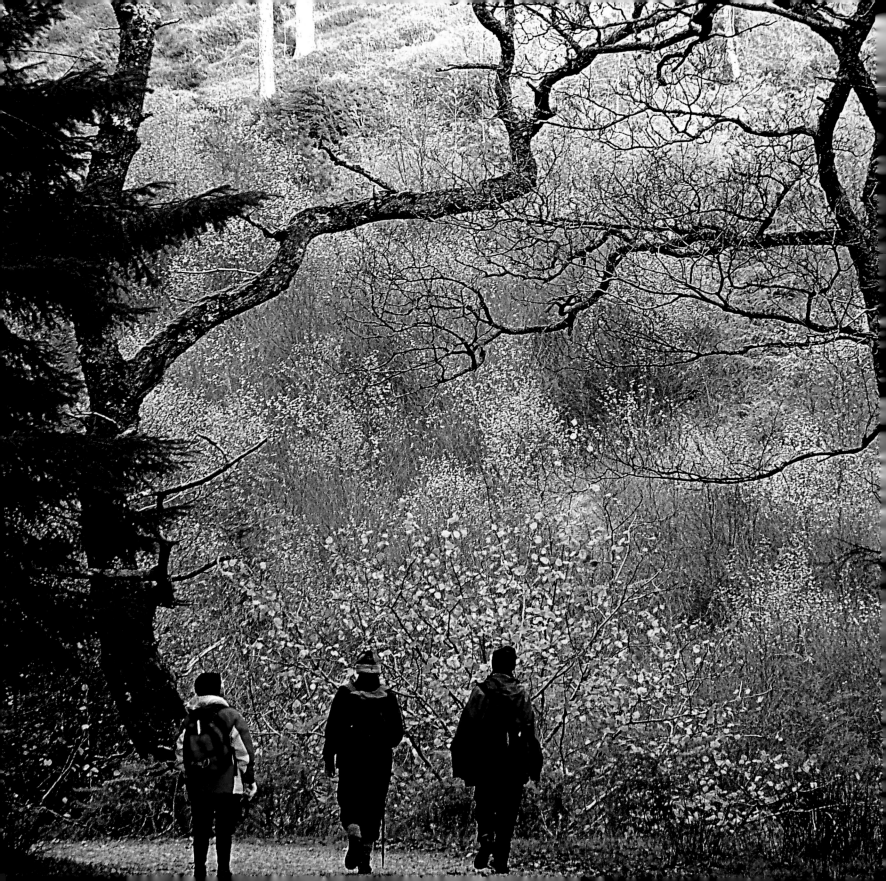

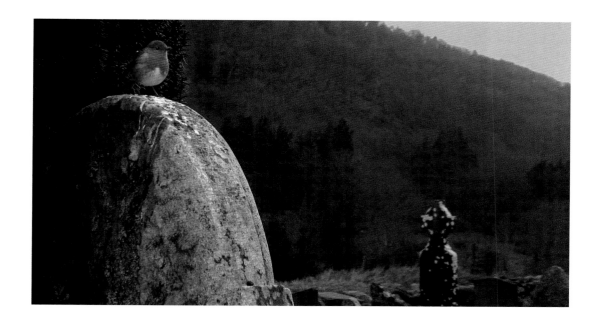

**OPPOSITE:** Walkers in Glendalough (M11).

**LEFT:** A robin on a tombstone in Glendalough (M11).

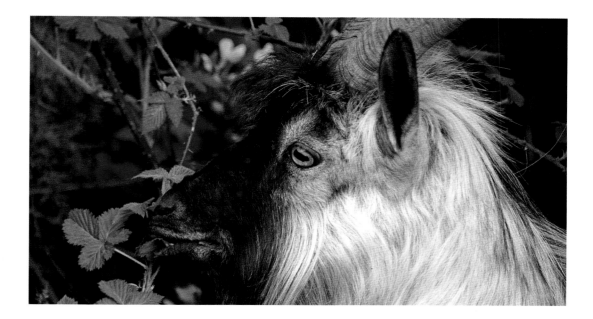

**LEFT:** A feral goat in Glendalough (M11). The goats in Glendalough belonged to the mining community. When the mines ceased the goats remained and became wild.

**RIGHT:** Mountain biking on the Wicklow Gap (L10).

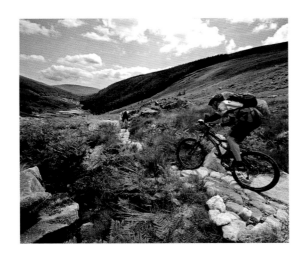

**BELOW:** Walkers on Camaderry (M10). With innumerable tracks throughout the county, Wicklow is a hillwalker's paradise.

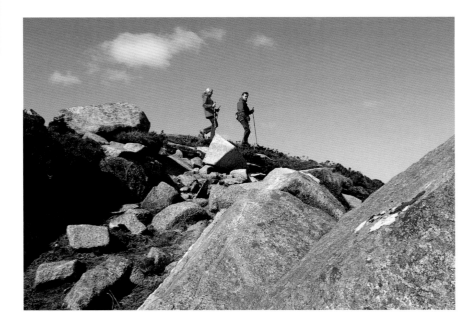

**OPPOSITE:** The Upper Lake, Glendalough (M11).

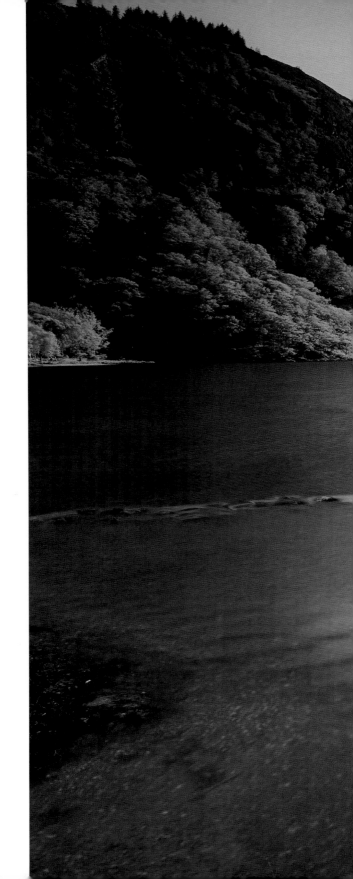

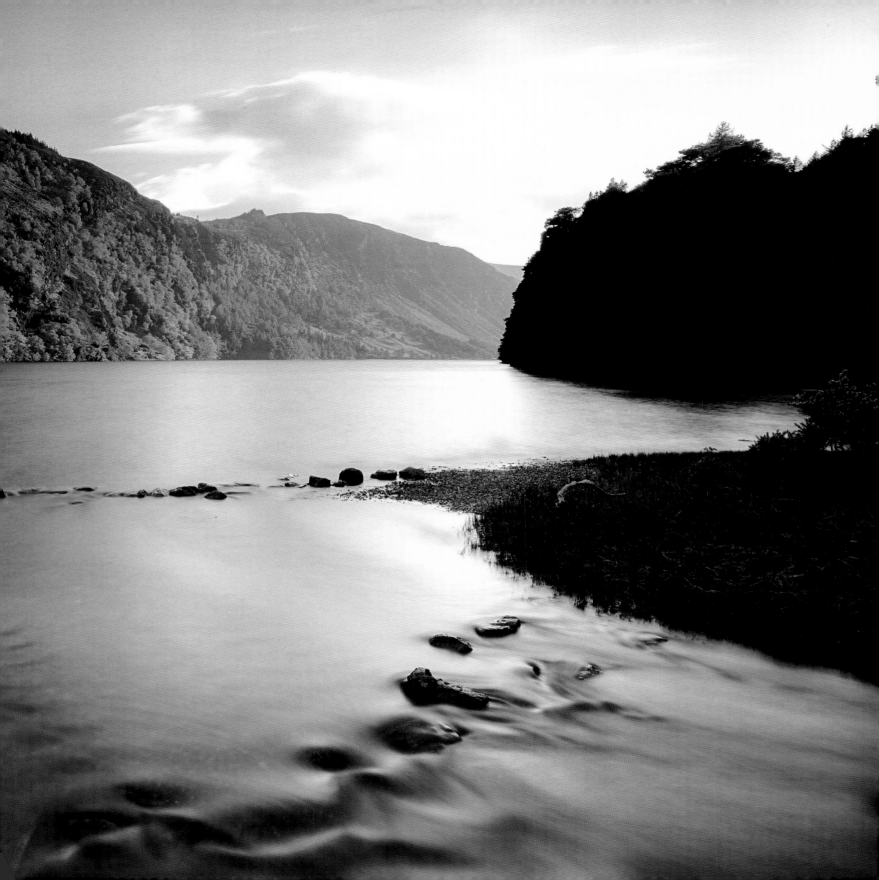

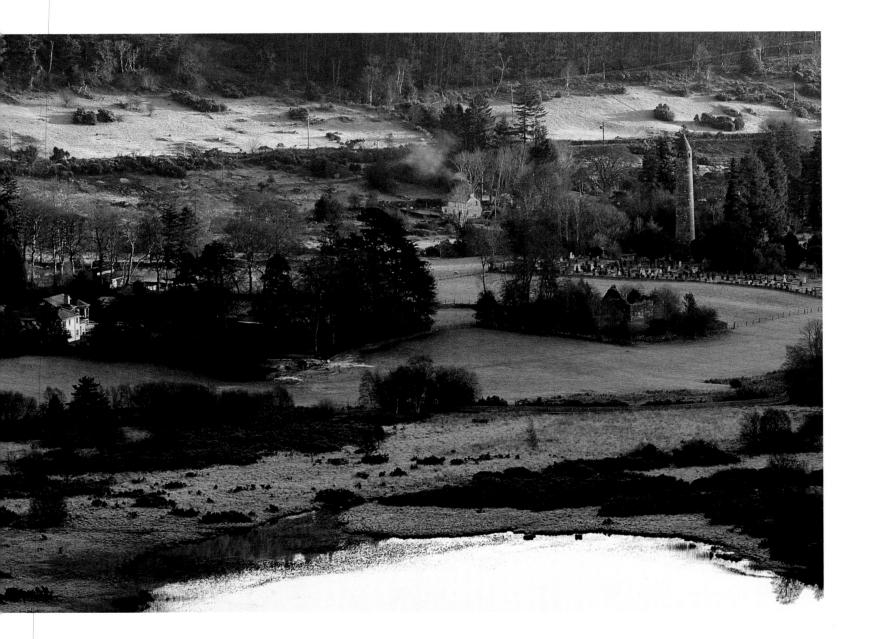

A frosty morning in Glendalough (M11).

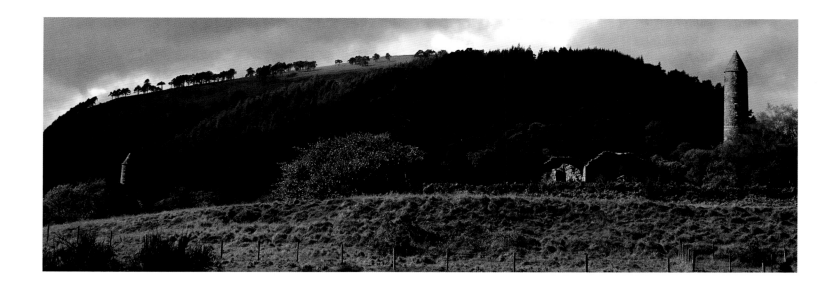

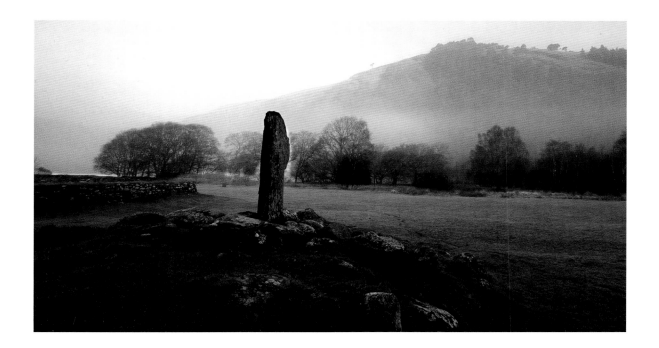

**ABOVE:** The monastic city, Glendalough (M11).

**LEFT:** Stone cross, Glendalough (M11).

**RIGHT:** The cathedral and round tower, Glendalough (M11).

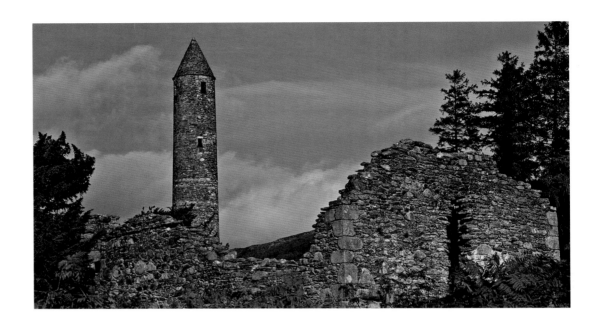

**RIGHT:** St Kevin's Kitchen, Glendalough (M11).

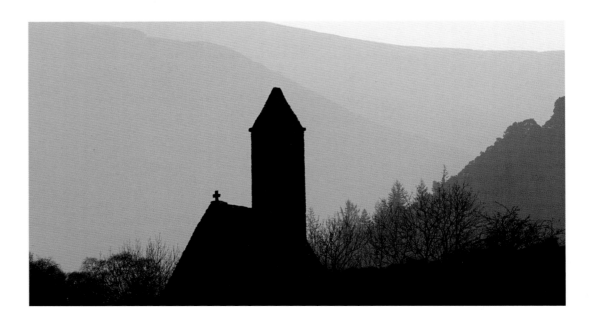

**OPPOSITE:** The round tower in Glendalough (M11).

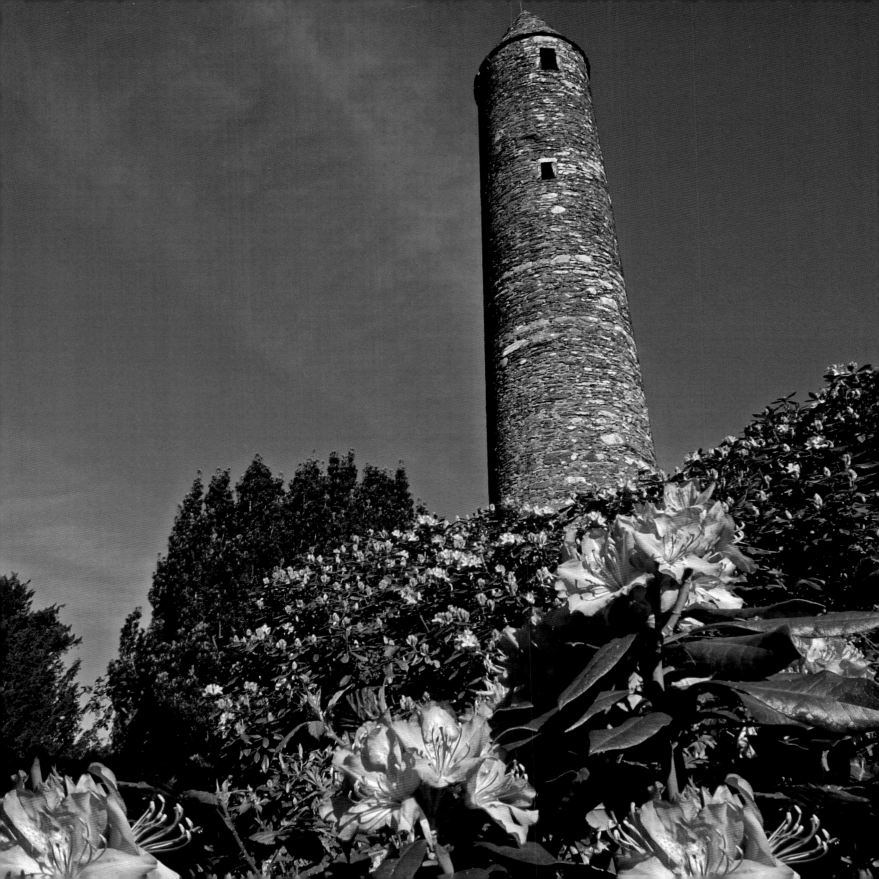

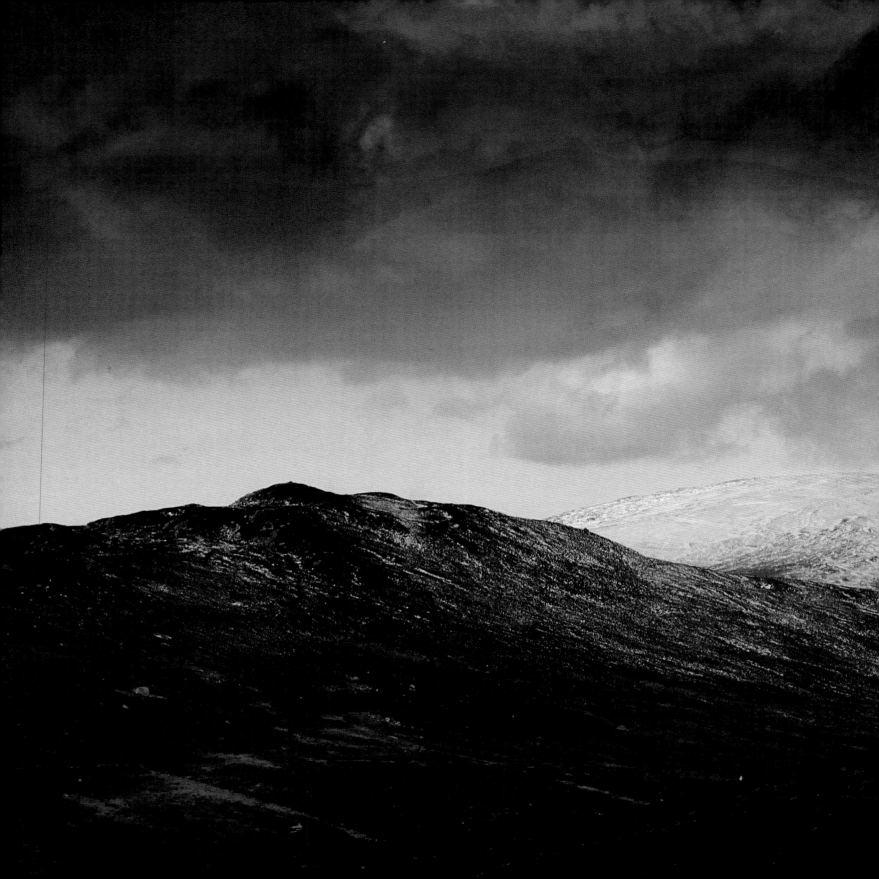

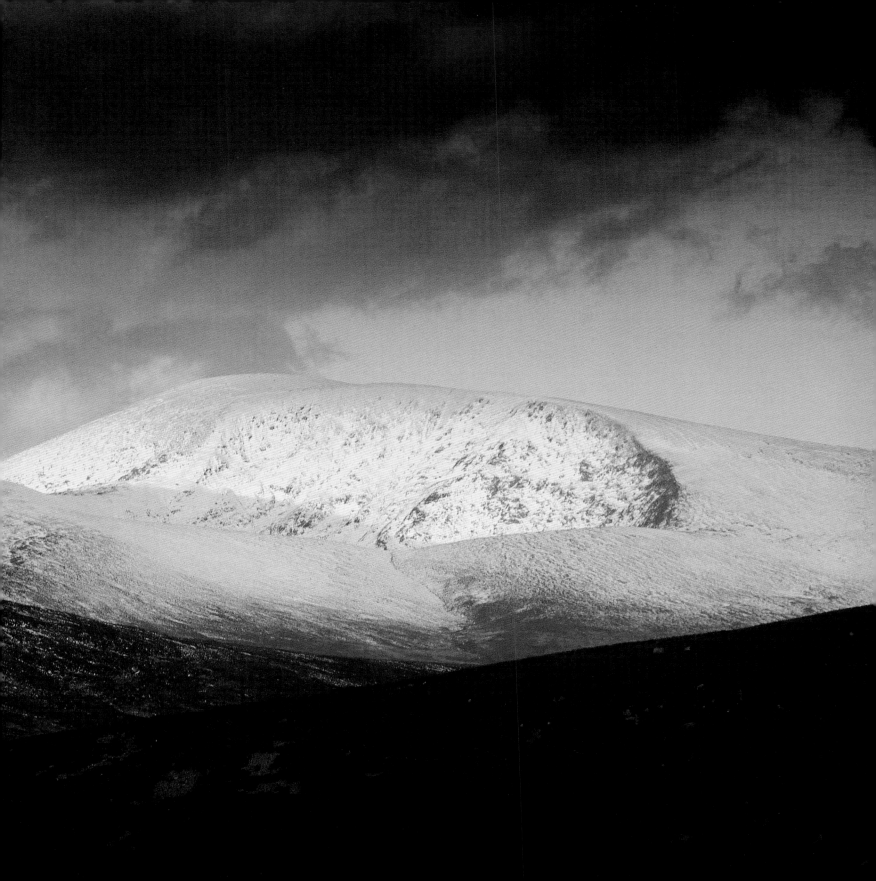

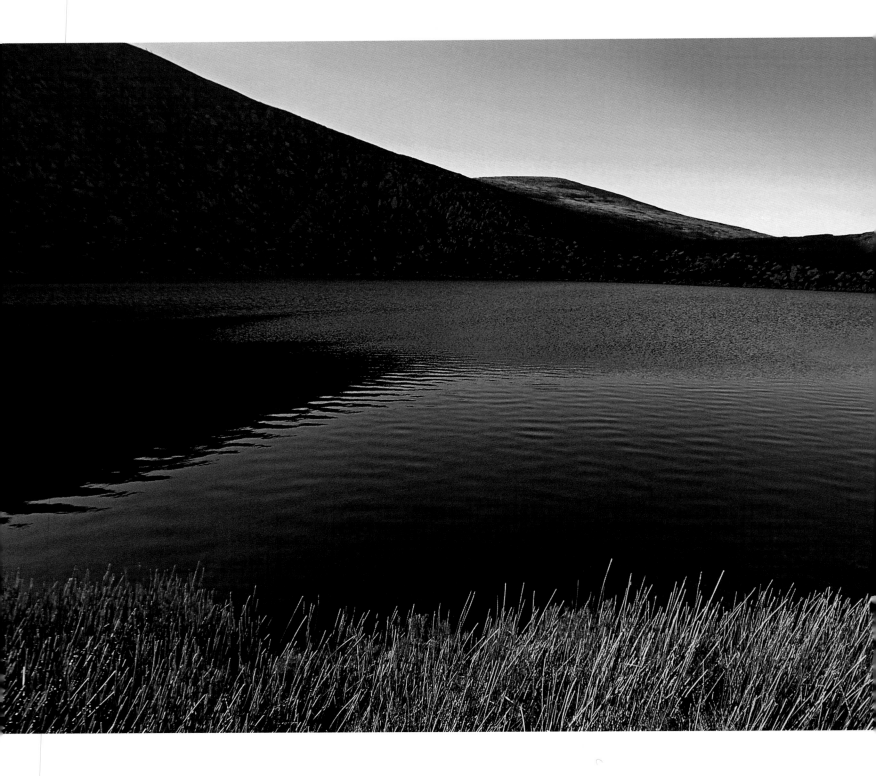

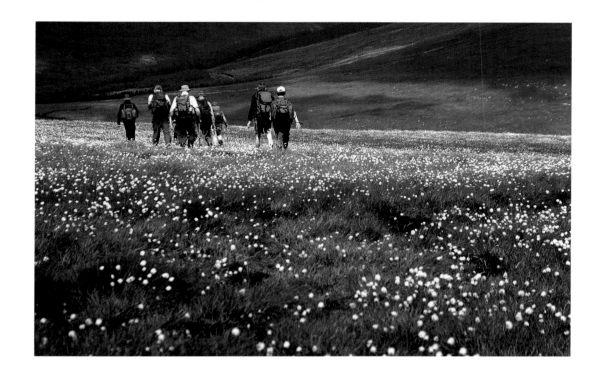

**PREVIOUS PAGES:** Winter snow on Tonelagee, from the Sally Gap near Pier Gates. Knocknacloghoge is in the foreground (O6).

**OPPOSITE:** Lough Ouler on the side of Tonelagee (L8).

**LEFT:** Walkers in a field of bog cotton on Tonelagee Mountain (L9).

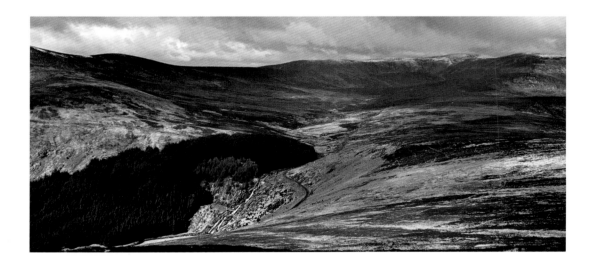

**LEFT:** Glenmacnass Waterfall (M8) with Mullaghcleevaun in the background.

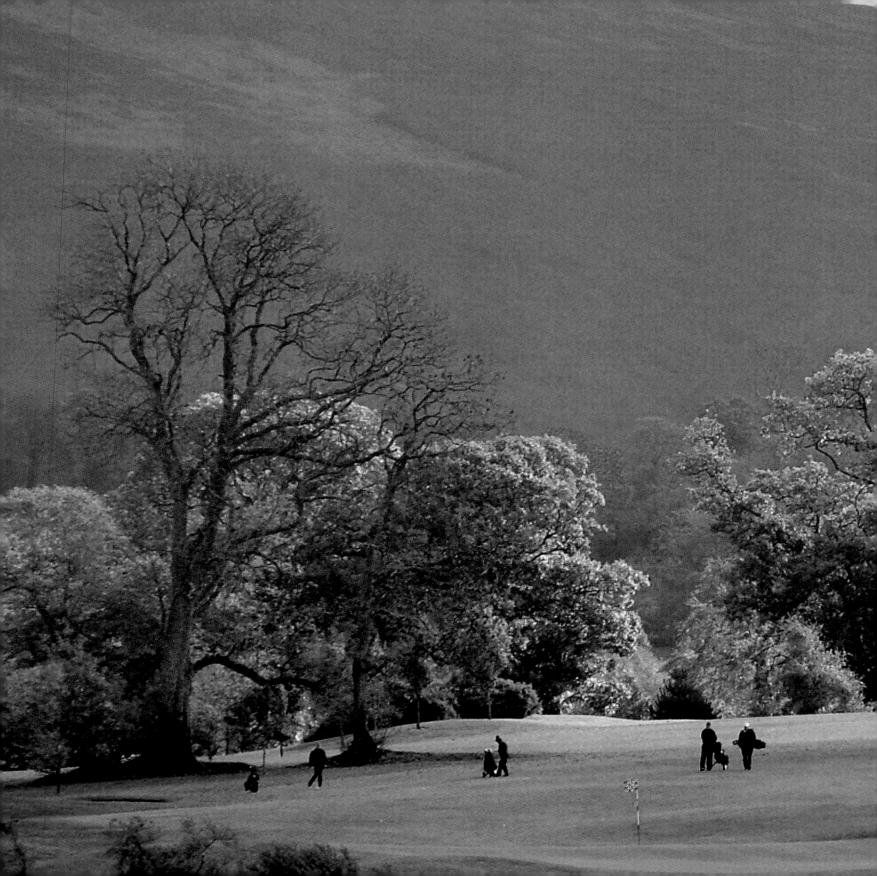

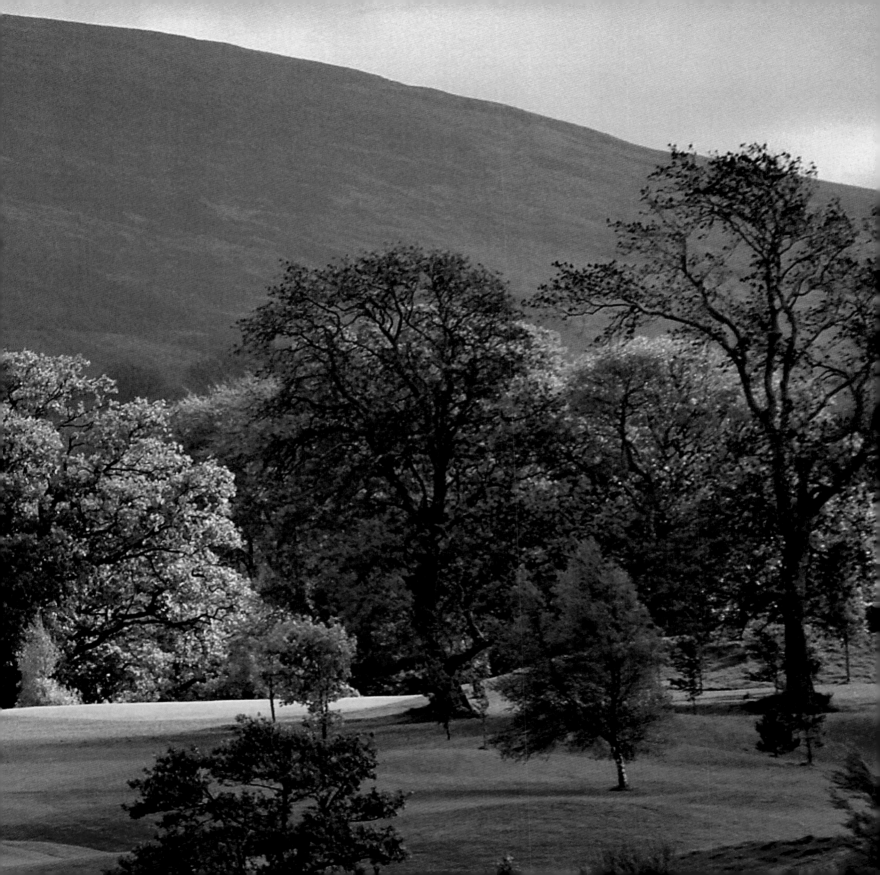

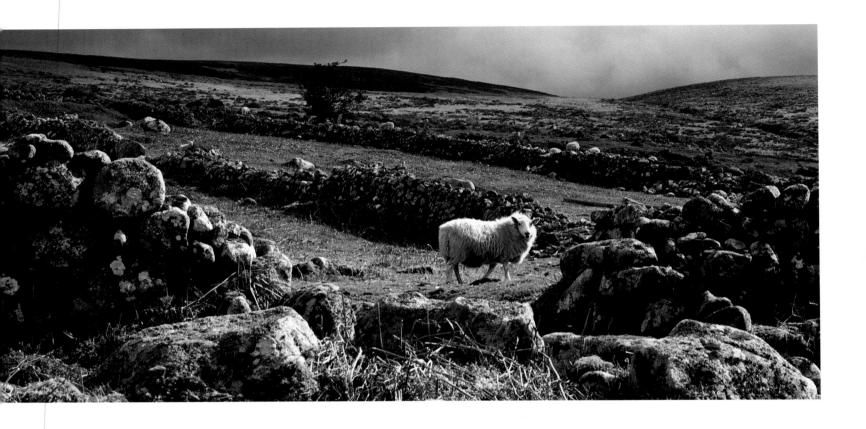

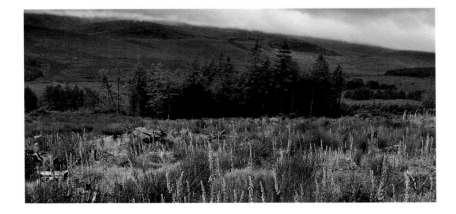

**ABOVE:** A small farm holding in Ballyknockan, west Wicklow (I6).

**RIGHT:** Foxgloves at Ballynultagh Gap in West Wicklow ((J5).

**PREVIOUS PAGES:** Golf at Tulfarris Golf and Country Club (G6).

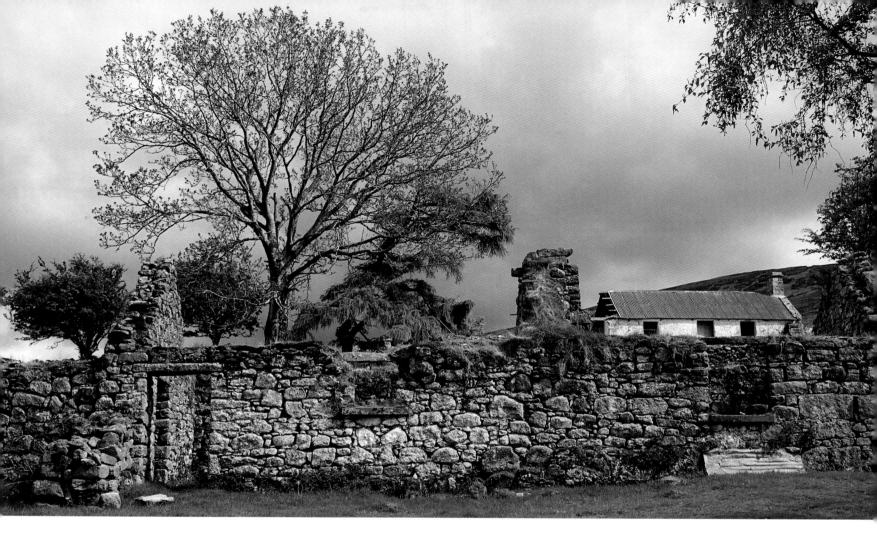

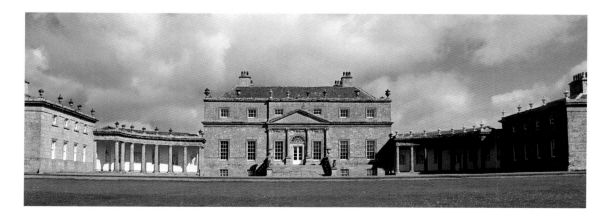

**ABOVE:** Ruins of abandoned houses in Ballyknockan (I6).

**LEFT:** Russborough House (G5) was built in 1755 for the Earl of Milltown. It was occupied by the earls up until 1914 when the widow of the sixth earl died. It now houses the Beit Collection of paintings and is open to the public.

**OPPOSITE:** Fishing boats on the Poulaphuca Reservoir (G4).

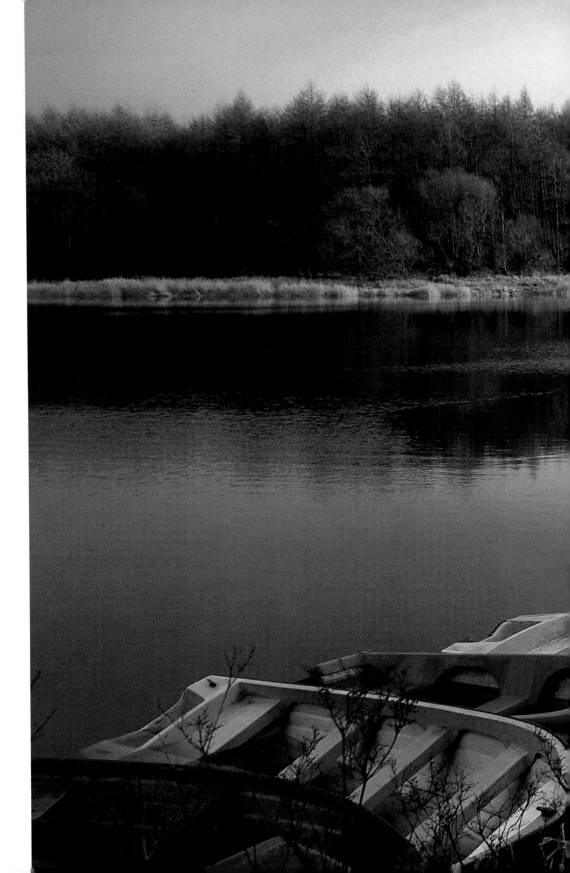

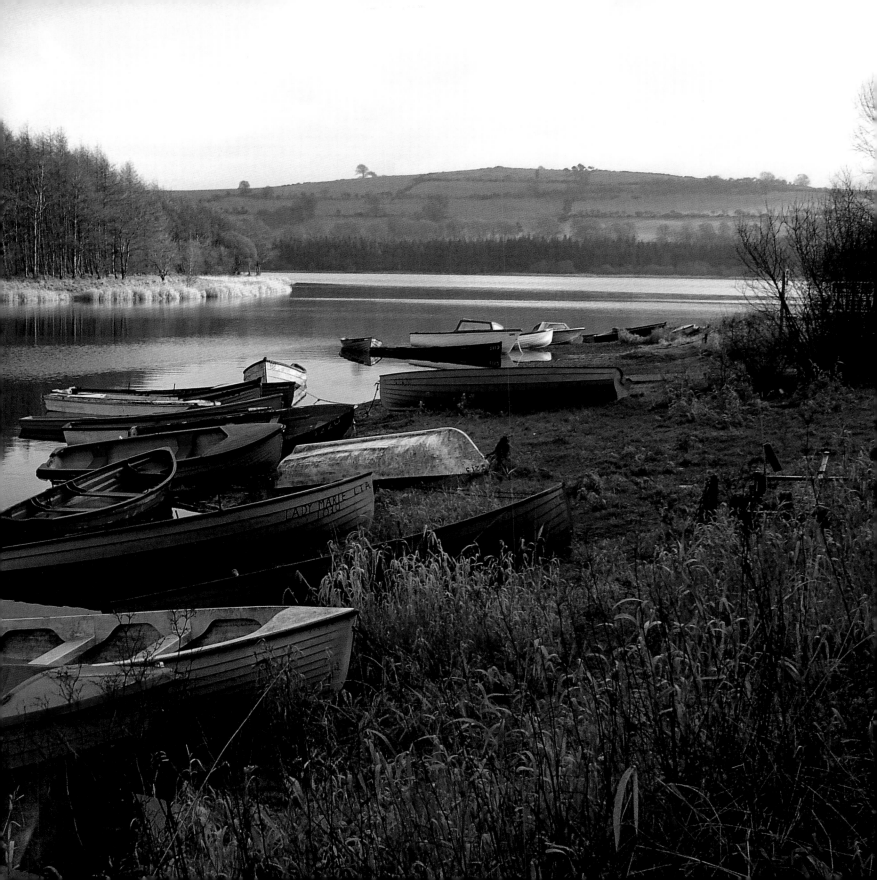

**RIGHT:** A winter's day on Poulaphouca Reservoir (G5).

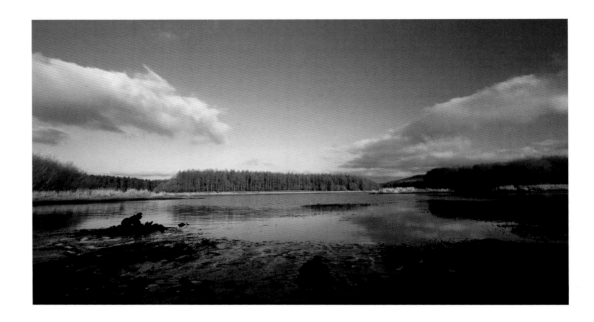

**RIGHT:** Attending to a horse in the stables at the Blessington Equestrian Centre, Lacken (I5).

**OPPOSITE:** Sculling on Poulaphouca Reservoir (H4). The Poulaphouca Reservoir was created by damming the Liffey between 1937 and 1947. It involved the demolition of seventy-six houses and three bridges.

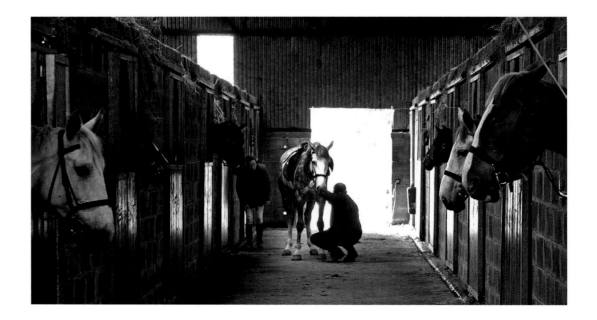

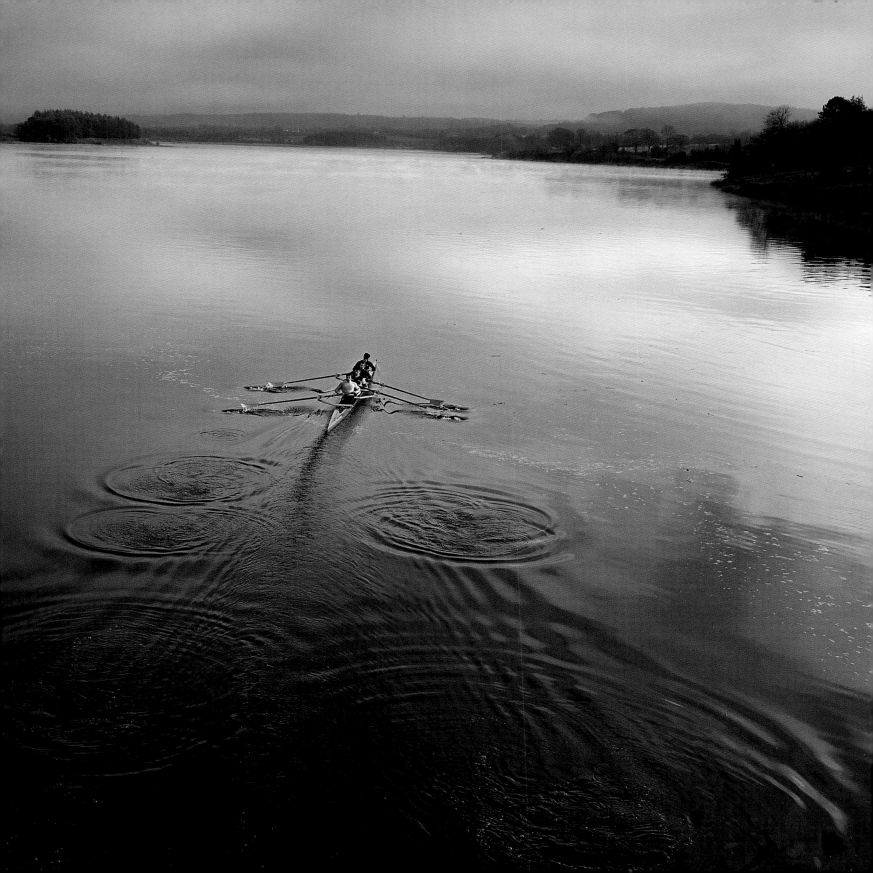

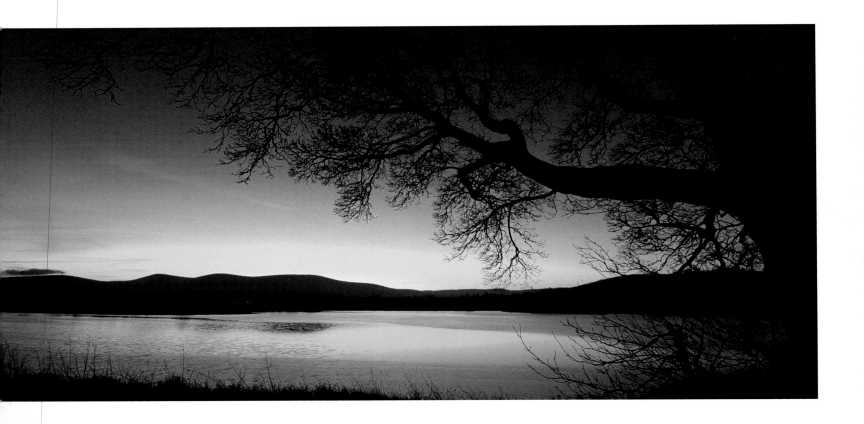

**ABOVE:** Sunrise on Poulaphouca Reservoir, known locally as the the Blessington Lakes (G5).

**RIGHT:** Blessington Lakes seen from Lacken (I5).

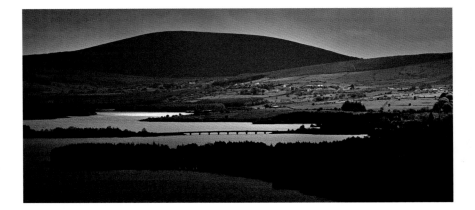

**OPPOSITE:** Canoeing on Blessington Lakes (I5).

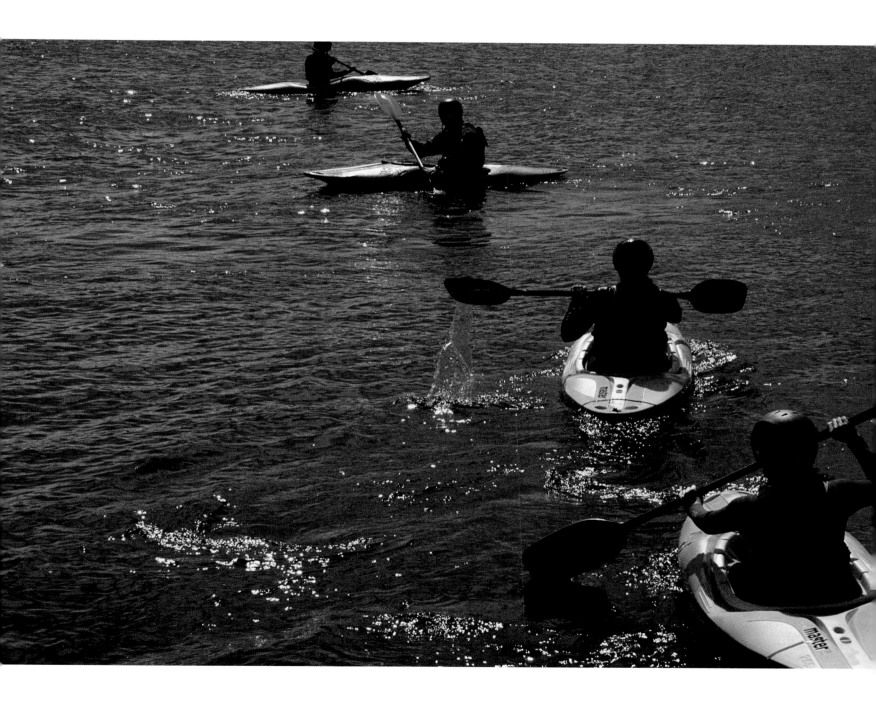

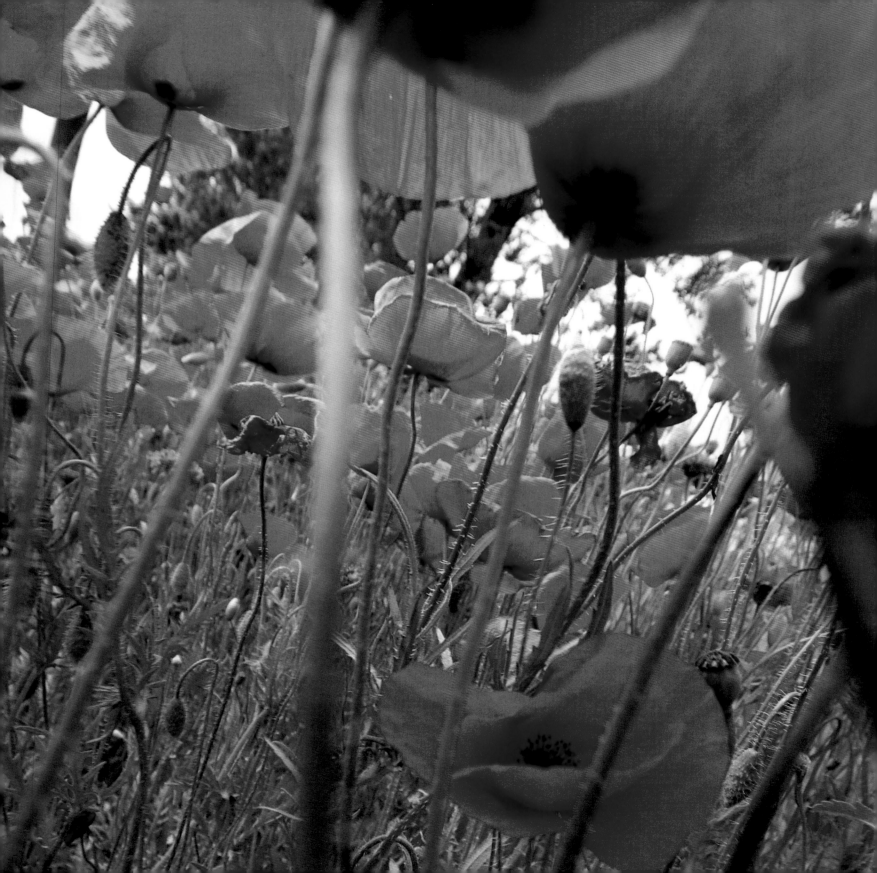

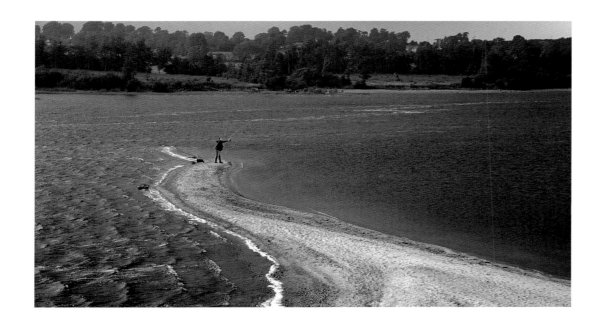

**OPPOSITE:** Poppies in a field near Blessington (H3).

**LEFT:** Fishing at Valleymount on the Poulaphuca Reservoir (H6).

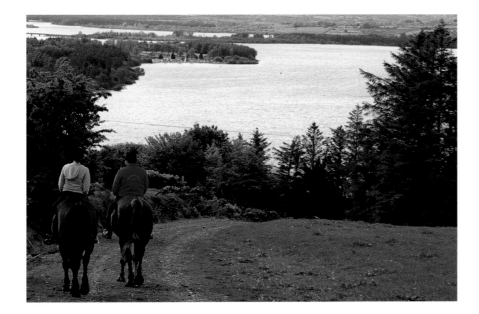

**LEFT:** Horse riding at Lackan (I5).

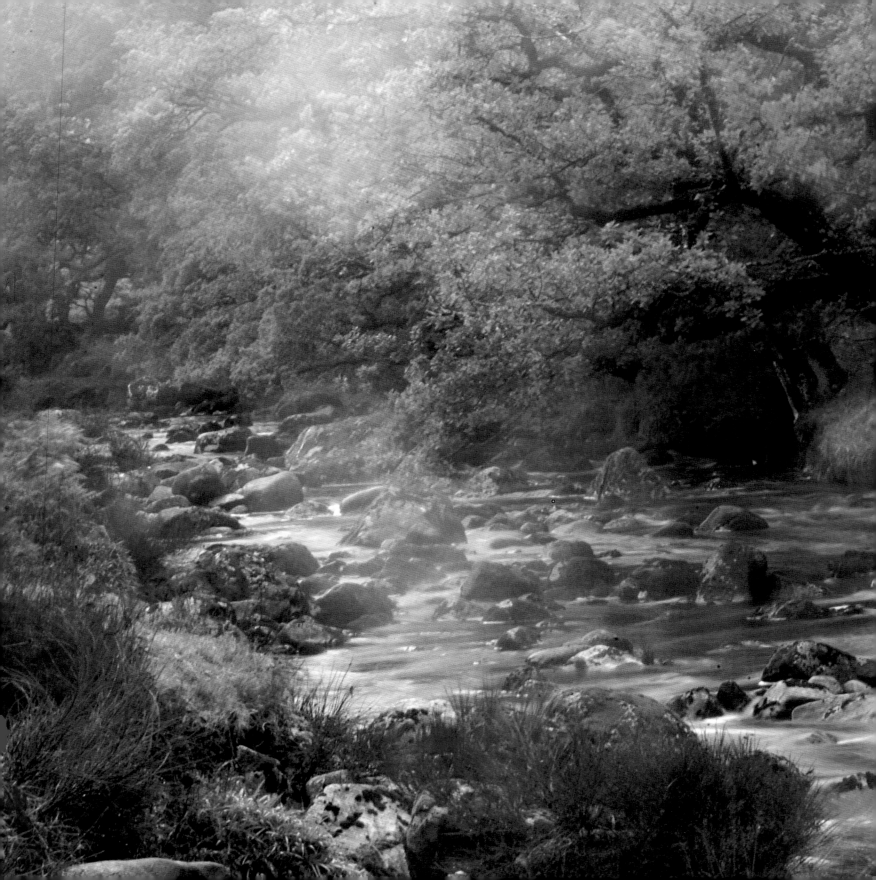

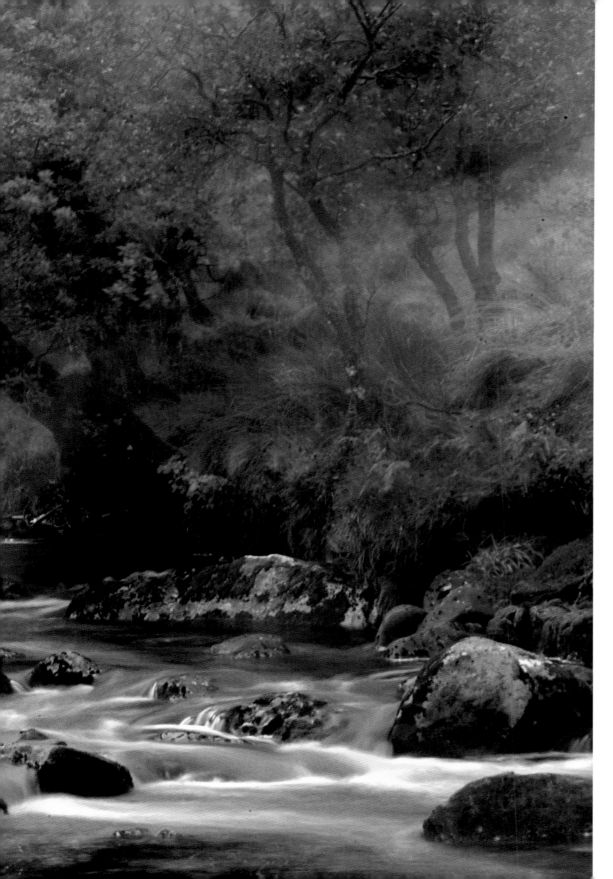

**OPPOSITE:** The River Liffey
on a soft day at Kippure (L4).

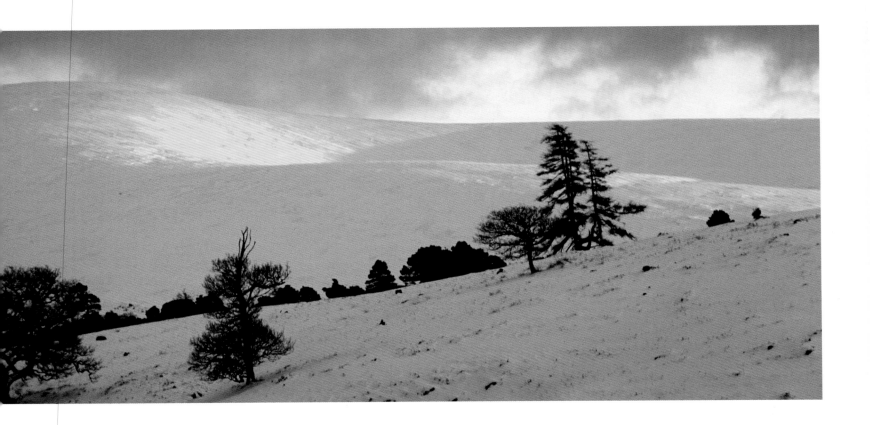

**ABOVE:** Sun setting on Mullaghcleevaun in winter, from Kippure Estate (L4).

**RIGHT:** A 5,000-year-old passage grave on Seefin Mountain (K3).

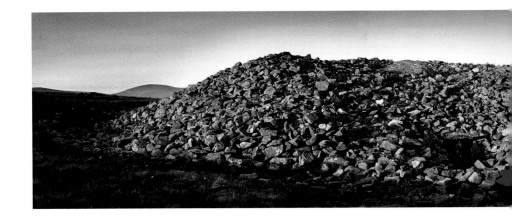

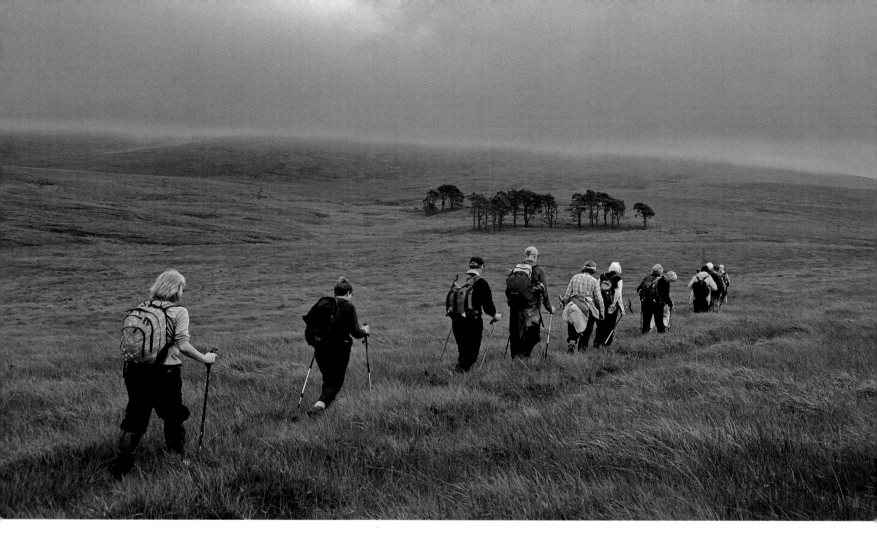

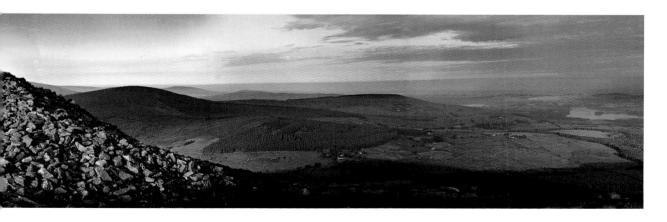

**ABOVE:** Hillwalking in the Coronation Plantation (L4), which was planted in Kippure Estate in 1831 to celebrate the crowning of William IV as King of England.

**RIGHT:** Autumn grasses on the Coronation Plantation.

**ABOVE:** The River Liffey at Kippure Estate in autumn (L4).

**OPPOSITE:** A snowstorm approaches the Coronation Plantation (L4).

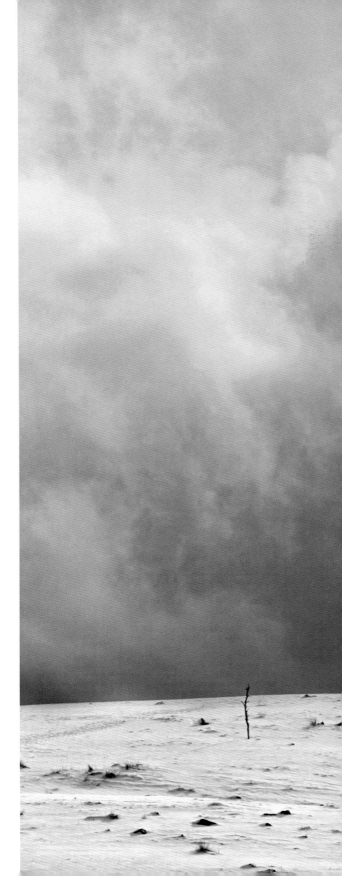

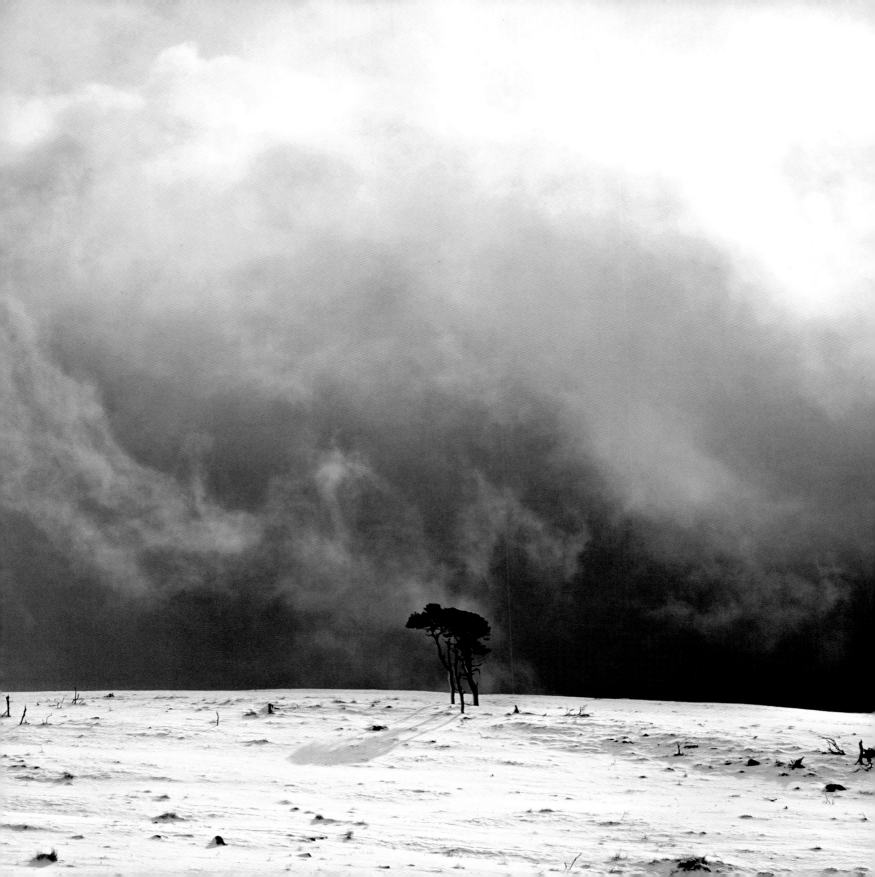

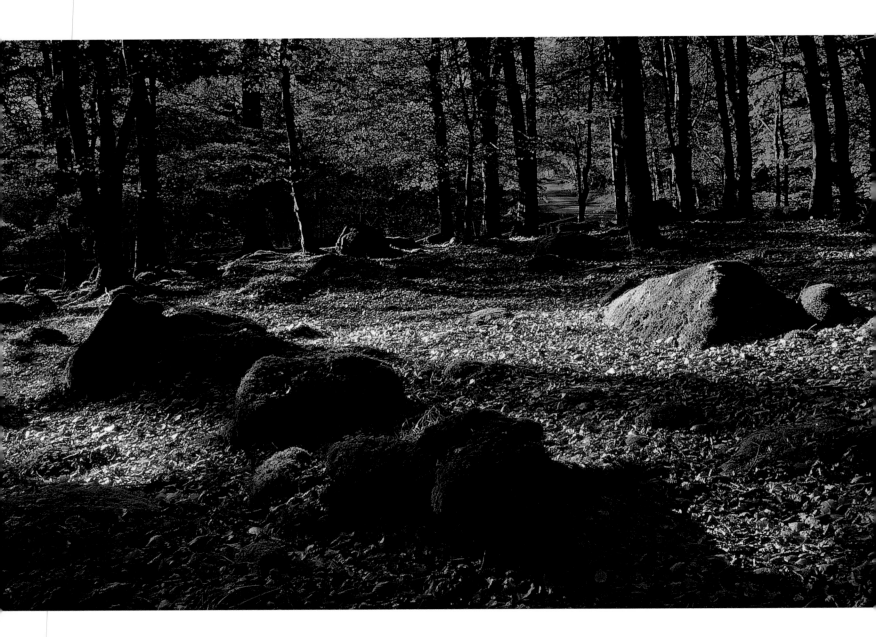

Woodlands at Cloghleagh (J3).

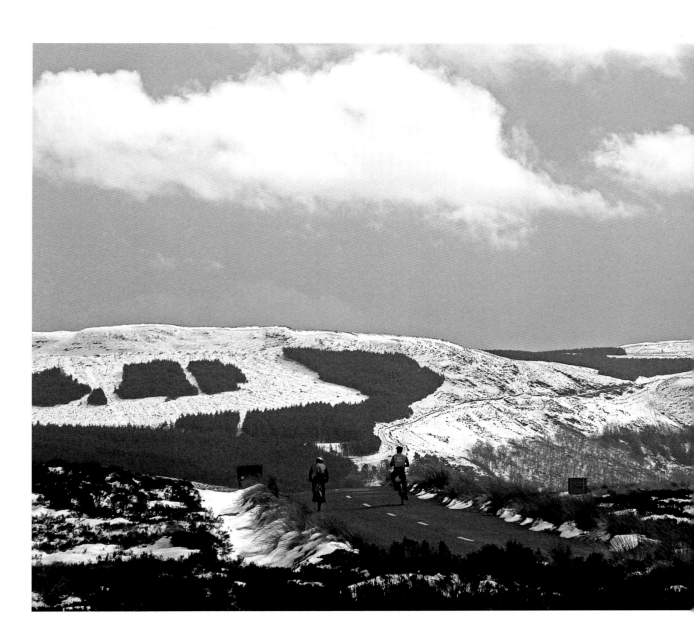

Cyclists at the Sally Gap in winter (N5).

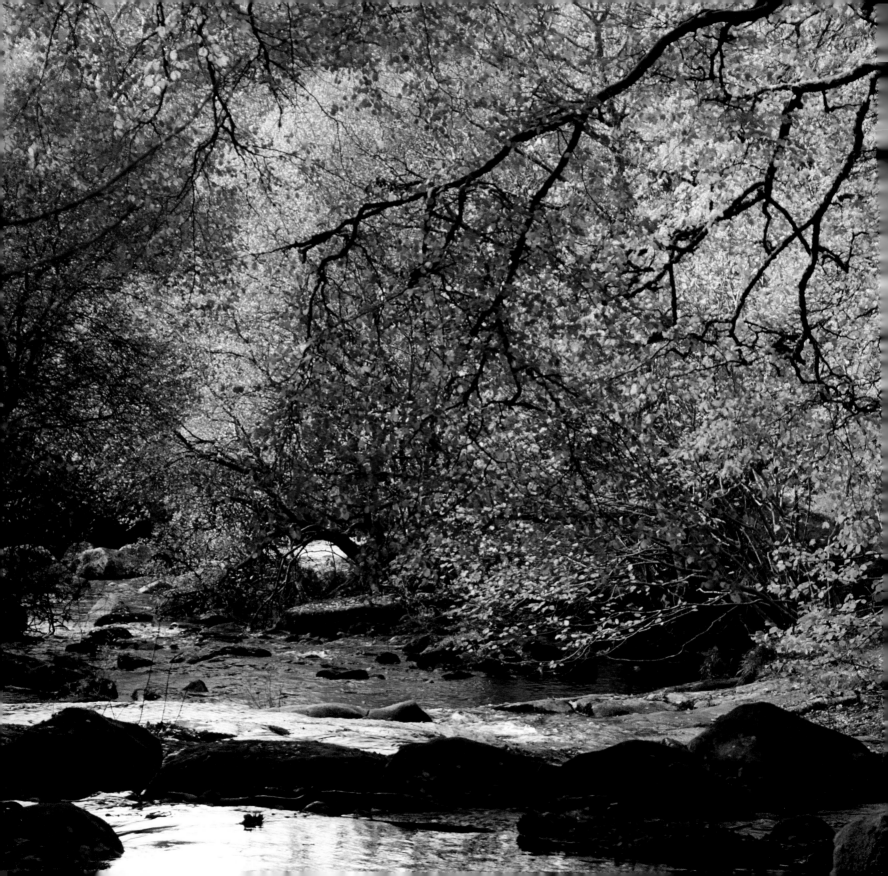

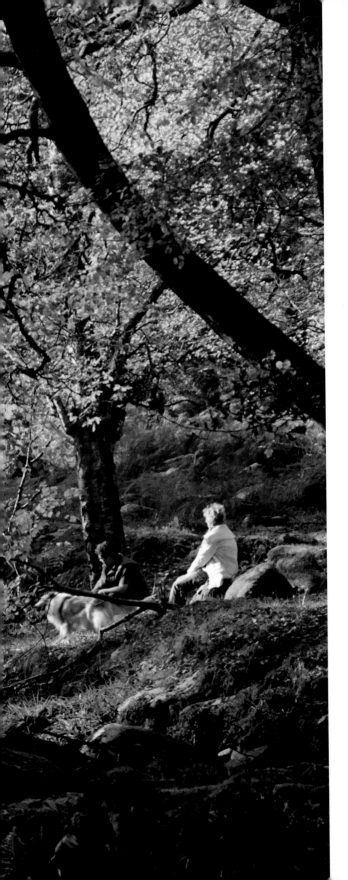

**OPPOSITE:** A couple and their dog enjoying autumn in Cloghleagh (J3).

**BELOW:** A waterfall on the Shankill River at Cloghleagh (J3).

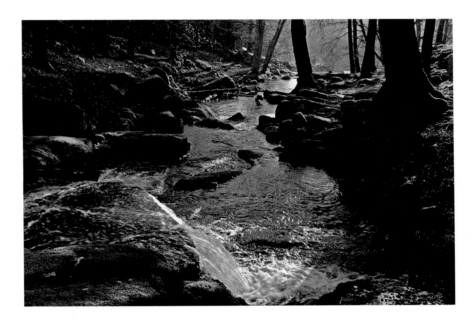

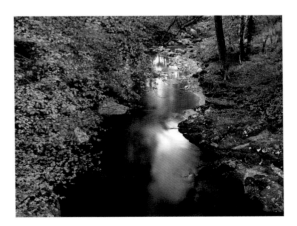

**LEFT:** Ballydonnell Brook at Ballylow Bridge (K4).

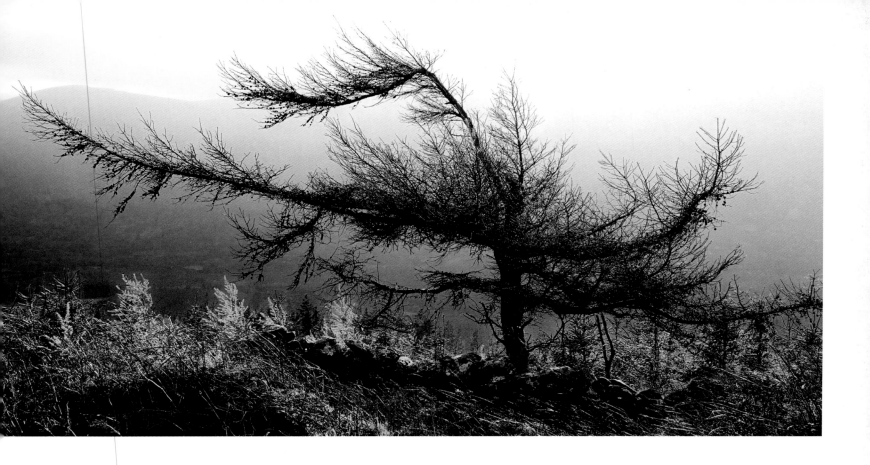

**ABOVE:** A winter tree in Kippure Estate (N1).

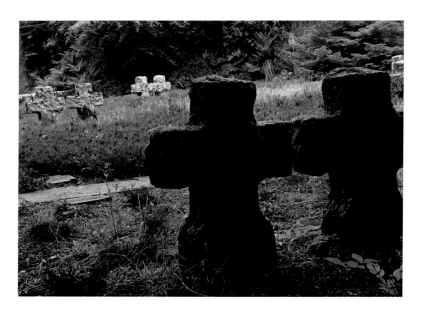

**LEFT:** The German War Cemetery at Glencree (N2). There are 134 graves in this cemetery, mostly Luftwaffe personnel shot down over Irish territory by the British during the Second World War. There are also forty-six German civilians buried here. In July 1940 they were being transported by Britain to Canada for internment when their ship, the SS *Arandora Star*, was torpedoed by a German U-boat (*U47*) off the Donegal coast.

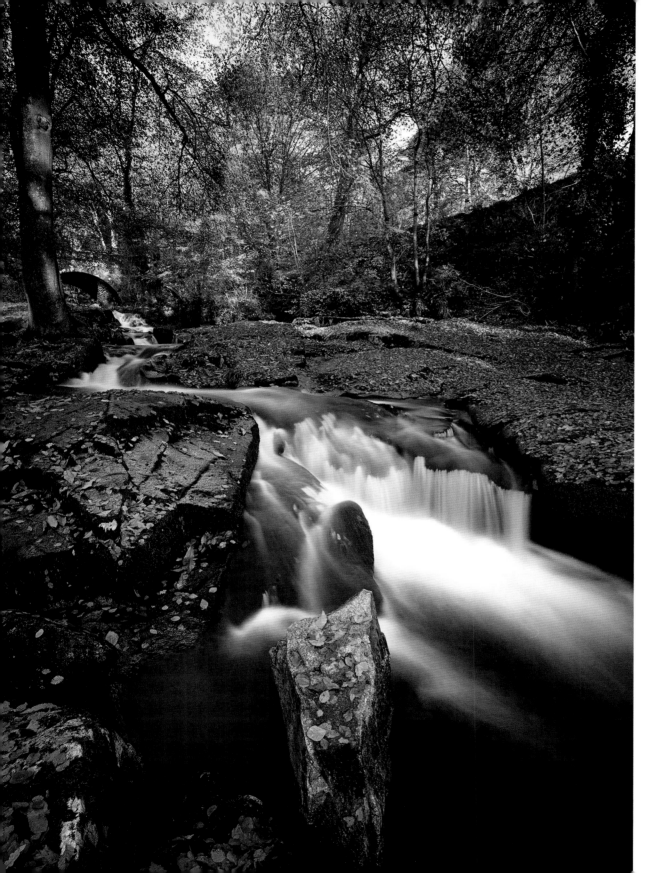

**LEFT:** Autumn at Cloghleagh Bridge (J3).

**FOLLOWING PAGE:** Heather on Maulin Mountain (P4).

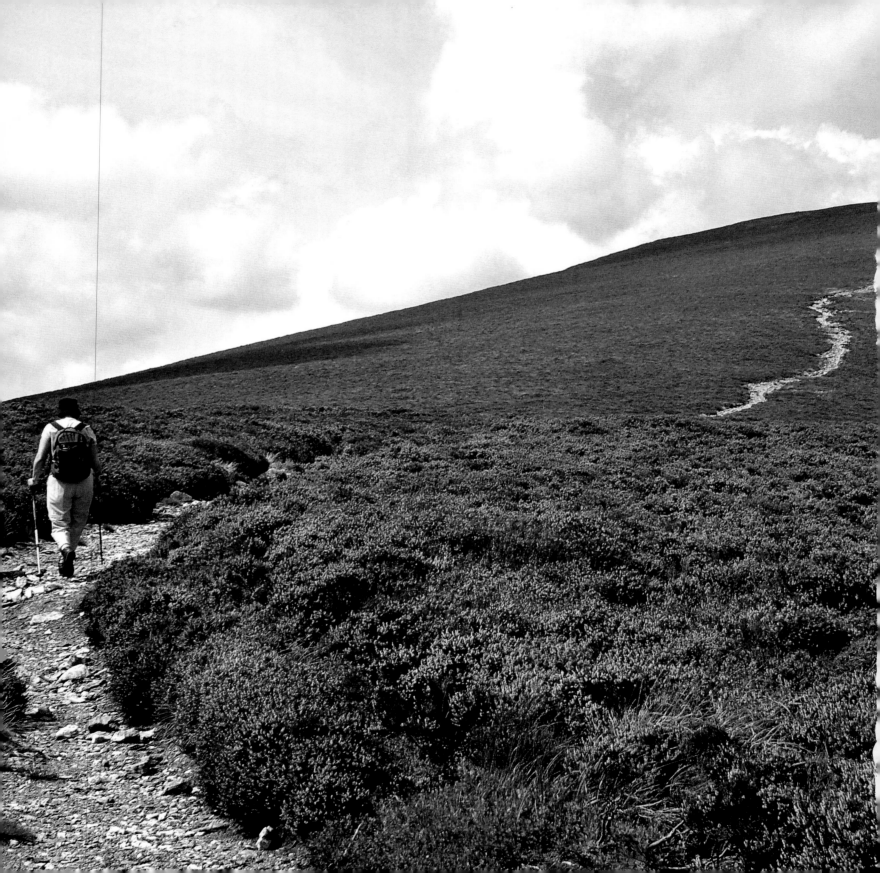